Sketchbook Confidential 2

More secrets from the private sketches of 38 master artists

edited by Pamela Wissman *and*
Stefanie Laufersweiler

NORTH LIGHT BOOKS
CINCINNATI, OHIO
www.artistsnetwork.com

Table of Contents

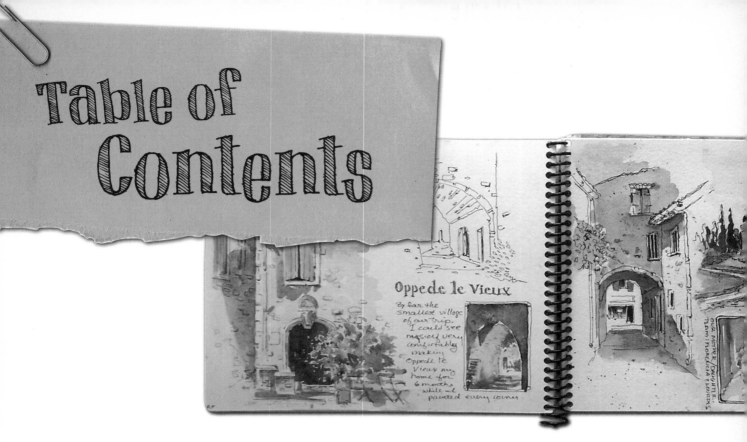

Oppede le Vieux

By far the smallest village of our trip. I could see myself very comfortably making Oppede le Vieux my home for 6 months while I painted every corner.

Lourmarin
Charming, easy to
traverse, and somewhat
pricey~ Lourmarin
is a nice place to
spend our Tuesday
afternoon. Plane trees
provide welcome shade
and cafés provide
a comfortable place
to people-watch.

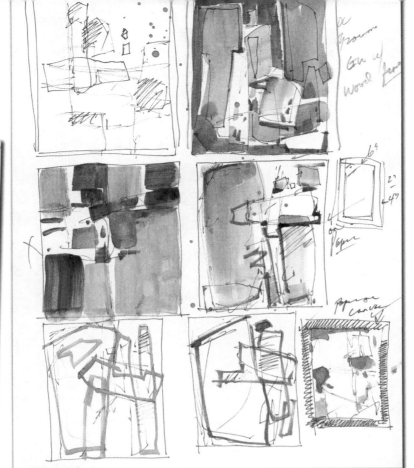

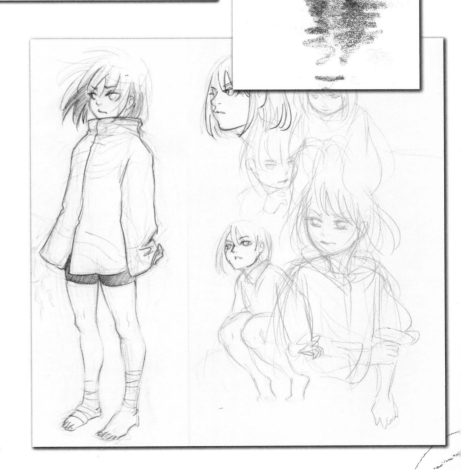

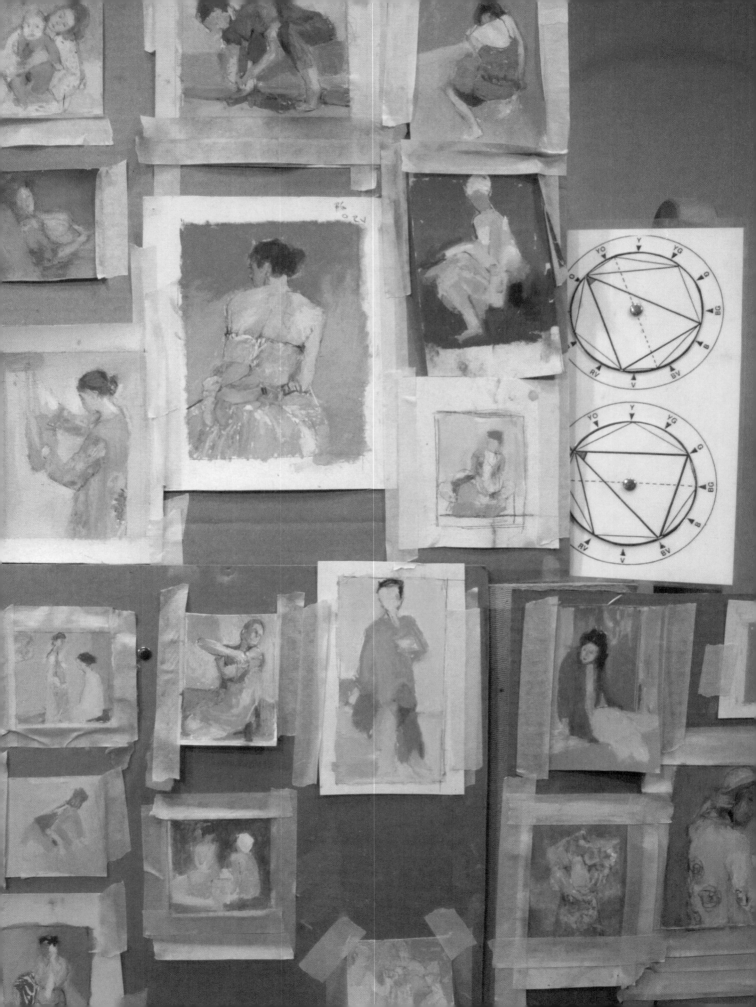

Introduction

Welcome! On these pages, you'll see the workings of some of art's most creative minds and hearts, pulsing with ideas, energy and inspiration. Just like the first SKETCHBOOK CONFIDENTIAL, this book takes you inside the personal worlds of a wide variety of diverse artists through their sketches, allowing you to take a sneak peek into this seldom-seen step in the creative process. Some of these artists sketch with traditional drawing materials, others use paint or collage, some are very loose, and others are more complex, but in the end, each sketch is a unique brainstorm—a way to get down a creative idea and perhaps work through it (or not—some sketches are fine as they are, having no need for further development). As always, whatever form they come in, they reveal something about the lives of the artists and shed light on the rest of their work.

Thank you to all of the amazing artists presented who participated in this project, as well as Stefanie Laufersweiler, Kathy Kipp, Guy Kelly and all the editors and production staff at F+W Media. You're a joy to work with.

Pamela Wissman

Senior Content Director
North Light Books

5

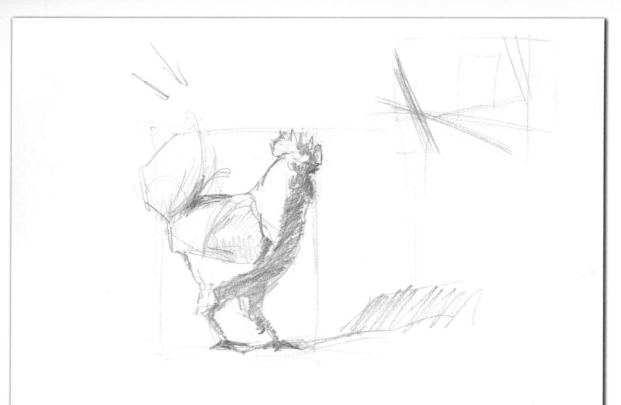

Joe Anna Arnett

After earning her BFA from the University of Texas, Joe Anna Arnett worked as a senior art director at a New York advertising firm before resuming her fine art studies at the Art Students League of New York. Since then, she has been featured in North Light's THE BEST OF FLOWER PAINTING, written her own book, PAINTING SUMPTUOUS VEGETABLES, FRUITS & FLOWERS IN OIL, and appeared on Passport & Palette, a PBS art instruction and travel series that she's also written for and produced. Arnett exhibited in the Prix de West show at the National Cowboy & Western Heritage Museum for fourteen years.

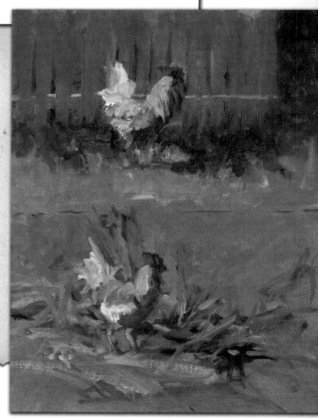

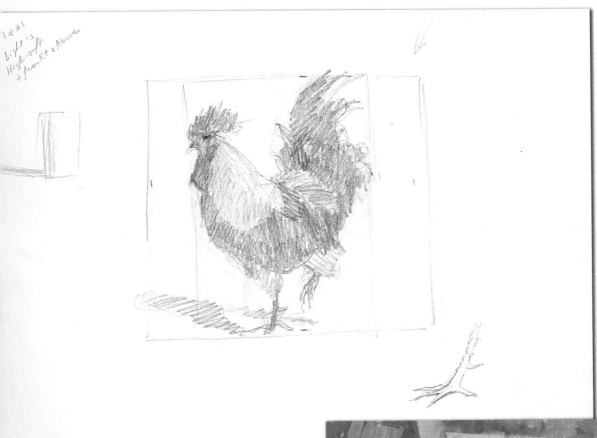

A drawing is a rich thing, a romantic thing, a personal thing. When I see something I like, I start the drawing before I take the record photograph. The photo diminishes. The drawing lifts up. Things that are ordinary, plain and common can become heroic when you devote some of your time and your passion to them. Give me a tumbling-down barn over a chateau any day. A tall, thin, perfect model is not half as interesting as a person who has their life written in their face. There's real beauty there. Sketching forces you to truly see.

If I see something that I think could develop into a painting, I want to get something down about it. If there is no time to paint, or perhaps, no opportunity, the drawing is more valuable to me than a photograph. A photo is a good reference for content and details, but it can't record your idea or the way you feel about something. A photo just reports. So often, I have photographed something, thinking that it could be a wonderful subject. Later, looking at the photo, I wonder what I was thinking. Why did I bother? That is never the case with a drawing.

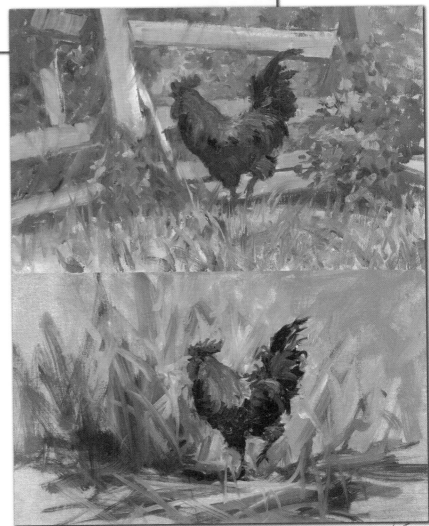

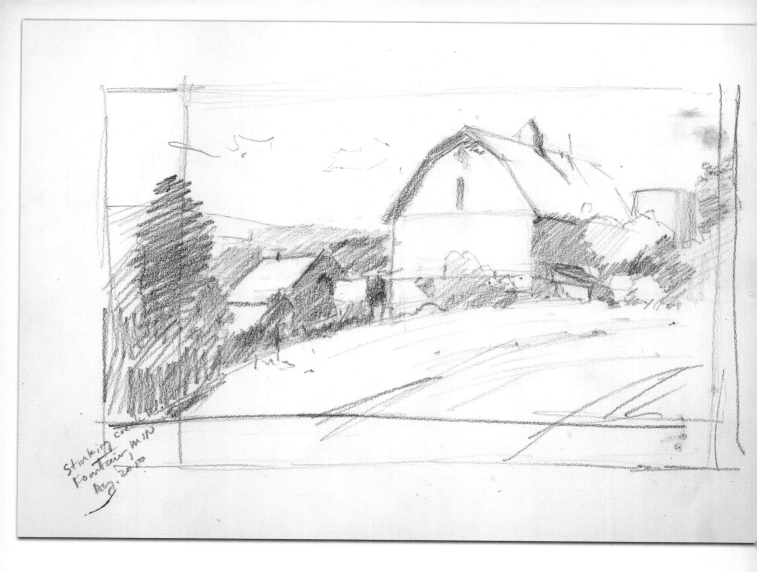

For me, drawing is where creative license begins. This is where I begin to move things, change values, construct or deconstruct. It is the start. Working it out in the drawing stage is a lot more fun and more productive than beginning a painting before you are ready and missing a good opportunity to make it a better piece of art.

There are subjects that are simply fun to draw that would not make a good subject for a painting. Drawing them sort of gets it out of your system. You'll either learn that the subject is worthy of development, or you'll learn that it isn't. It is liberating.

There are subjects that are wonderful and may suggest that they are a piece of a painting, or a detail that you may want to add. I include chickens in some paintings. I have taken a chair and sat in a barnyard doing gesture drawings of roosters and hens just to become acquainted with their movements and forms. This exercise has given me a library of forms to call upon.

With every drawing, I see things that I wouldn't have noticed with a quick look. The experience becomes richer. It's like really getting to know someone, not just making their acquaintance. We are in such a hurry. We insist on sound bites. We twitter a few dozen words. We text with ridiculous abbreviations and flash off e-mail and post quick quips on Facebook. A drawing makes me settle down and center and observe. Life and art are both richer with focus and concentration.

I don't sketch every day. I should draw every day, and every artist I know says the same. I do sketch often and I keep paper and pencil with me, as I love to scribble down ideas whenever and wherever they may occur. The idea could be a few lines with notes about content, or it could be a drawing of something I am considering painting. These would make no sense to anyone but me.

When possible, I love to do life drawing. I rarely hire a model, but I will join whatever groups I can. Life

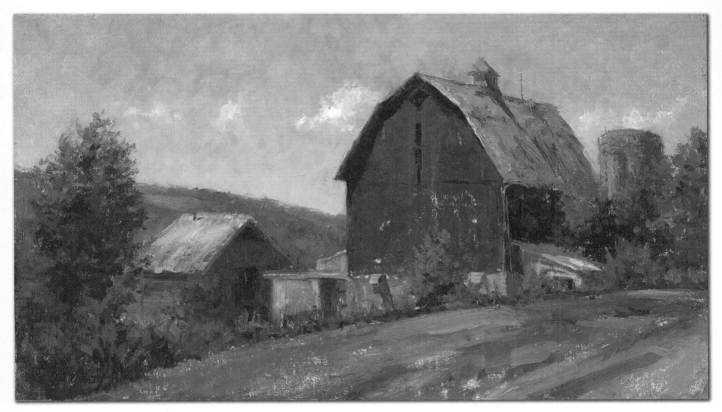

Farm on Stinking Creek Road
Joe Anna Arnett
Oil on linen (finished painting)
Chapman Collection
8" × 14" (20cm × 36cm)

drawing keeps you honest. It is the most difficult drawing, and I not only enjoy it, but also think of it as calisthenics. It keeps me sharp.

When I am sketching I feel connected. I feel a relationship with the subject. I am learning the forms, becoming involved in the shapes. As the work progresses, I begin to feel a sense of power, almost command of the subject. It is hard to describe the sense of accomplishment when you realize that you got it, you caught it, you understand it and it's now a part of you.

With every drawing, I see things that I wouldn't have noticed with a quick look. The experience becomes richer. It's like really getting to know someone, not just making their acquaintance.

JA Arnett

Sketches are the foundation for many finished pieces, and they are also often part of the process of finding my way to a finished piece.

Marla Baggetta

Marla Baggetta has been a professional working artist for twenty-five years. She's a signature member of the Pastel Society of America and a Master Circle recipient in the International Association of Pastel Societies. Her award-winning work has been exhibited in galleries and juried shows nationally. Baggetta's work has also appeared in several art magazines and books, including PURE COLOR: THE BEST OF PASTEL. She teaches both studio and plein air workshops throughout the United States, and lives in Oregon with her husband, artist Mike Baggetta.

Sketching is something I've done since I was a little girl. Kind of just part of me.

I love to sketch in the evening, when I have some quiet time and also when I'm traveling. It kind of annoys people when I do it on an airplane, though, I think!

What's great about sketching is that you're in the moment and just observing. I'm not thinking about anything but my subject. It's a wonderful way to lose track of time. I feel like I'm in a special, very private world. If you have a sketchbook and a pen, you can never get bored.

I use sketches as studies for larger works and complete many pieces using only the sketch as reference. This gives me great creative freedom and clarity. I don't have to be married to the photo reference or a subject. I'm free to just make the best painting. A sketch lets me be in control, be the director.

Sketches are the foundation for many finished pieces, and they are also often part of the process of finding my way to a finished piece. I've grown comfortable with sketching over time. I realize that the fits and starts are a necessary part of making art.

Sketching is about observing and playing. Being quiet and then boisterous. Yin and yang! It teaches me about the visible world, people and mostly myself and what preconceptions I have about things.

Sketching strengthens and deepens all my work. It's like building a playground for myself. After it's built, I can break all the rules in it! I do all my best composing in my sketchbooks.

I'd love to have volume after volume of sketchbooks to
refer to. The ones I've filled are very, very precious to me.
My husband lost one he'd filled and we still miss it.

Des Moines to Portland

ERIC AHO
Artist
Steve Goodman
Claudette Lee
ArtFromtheTrail.
Blogspot.com

- Usher De Voll
(pastels on paper)
cityscapes

Jim Beckner

The son of a painter (watercolorist Joe Beck-
ner), Jim Beckner currently lives in Denver,
Colorado, and has studied art at Colorado
State University (where he "learned to see
shapes and values as opposed to rendering
a subject") and the Art Students League
of Denver. In 2007, he was chosen by the
Denver Art Museum to appear in the book
LANDSCAPES OF COLORADO, and in 2011, Beck-
ner completed a commission for the Colorado
State Capitol permanent collection. Lately
he is focused on a more abstract interpreta-
tion of urban movement and energy, and he
is also experimenting with unconventional
colors on realistic figures.

make
vertical
stripes
more prominent

Include Buildings
at top

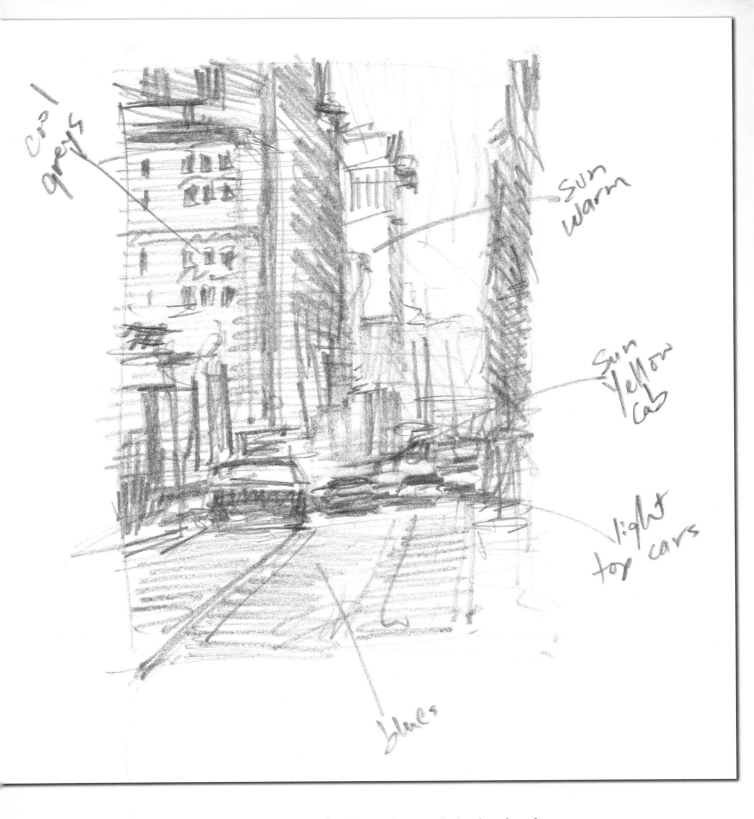

I'm not sure that I "feel" anything while I'm sketching.
Instead, I'm locked in a nonstop, interactive dialogue
between looking, drawing and evaluating.

I'm typically inspired to sketch by an idea. I will sketch a visual idea or concept that comes to mind. The idea may be derived from anything really: a location, the effect of light on a subject, an emotional feeling of a moment or an interesting photograph. I enjoy sketching with a journalistic approach when traveling. I sketch quickly and usually don't develop the drawing to a "finished" degree. I consider them loose summaries, a brief moment captured or a means to a grander idea.

I consider myself a painter primarily, and I sometimes complete paintings without any prior sketches. But occasionally, I need to capture an idea immediately, before it passes, or I may have no other means of remembering. Other times, my idea is not fully developed, and working through sketches provides me clarity and a means of seeing a path to the finished painting, or at least the ability to eliminate weak compositions and incomplete concepts.

When sketching, I'm usually most concerned with composition and immediacy. I'm typically not concerned with details or specifics at all. Value and line are very important in my drawings, partly because there is no color to consider. I seek a composition that is interesting or exciting, but still maintaining the emotional content I'm hoping to express. While I'm actively sketching, I'm not thinking, "How will this drawing look as a painting?" Instead, I'm just attempting to create the best sketch possible given the constraints. However, after completing a group of sketches, I then evaluate them as a group and decide on the best course of action for a painting.

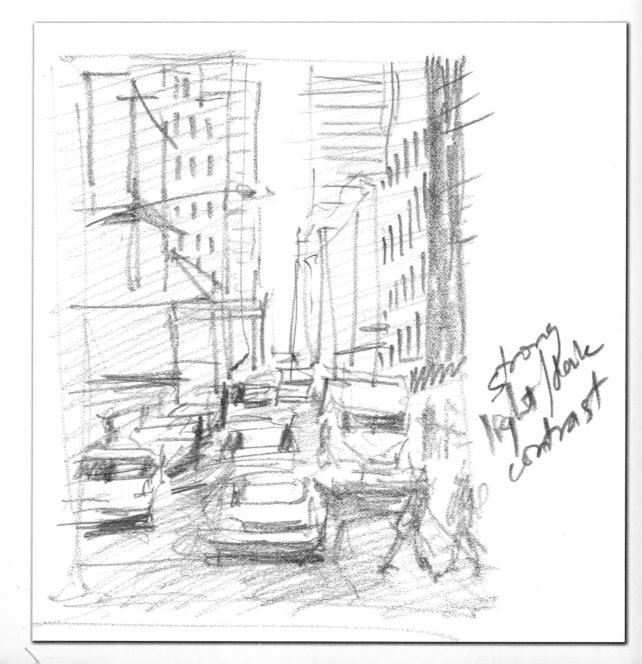

My sketches have a direct relationship to my finished work. The values, lines and shapes will match my final painting very closely. The sketch should provide all the information I need to create a finished work. I may want to add more to the final piece, but I should always be able to simplify my work back to the original sketch and have an interesting composition.

I must say, I'm not sure that I "feel" anything while I'm sketching. Instead, I'm locked in a nonstop, interactive dialogue between looking, drawing and evaluating. All that is around me seems to disappear, and my full attention is focused on processing the decisions needed to complete the sketch.

Sketching gives me an opportunity to stop and intently view a specific location, person or moment. Even if I don't have a personal connection with a subject, I feel as though I build one in a drawing. After studying and staring at a subject for an extended period of time, I feel as if I know it better than anyone.

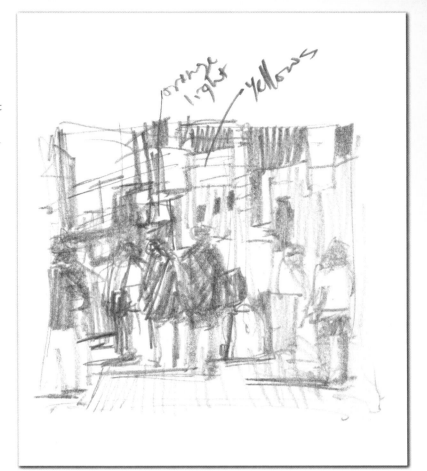

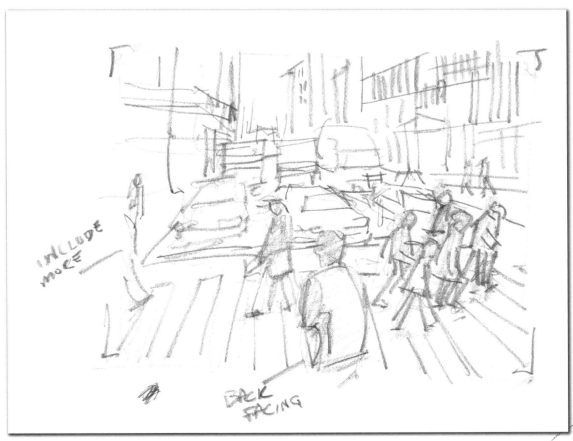

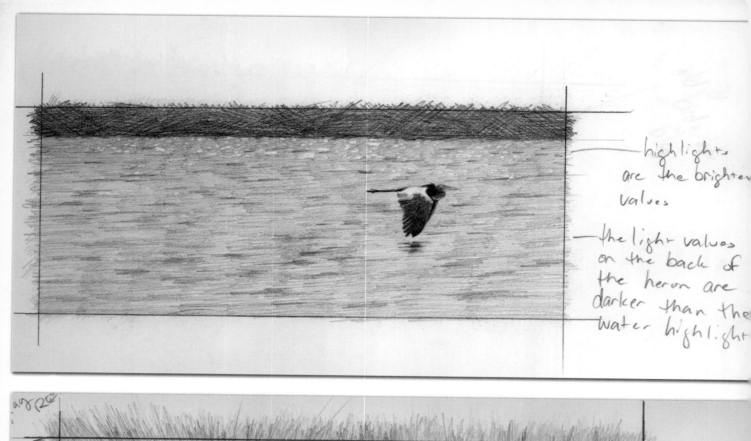

highlights
are the brighter
values

the light values
on the back of
the heron are
darker than the
water highlight

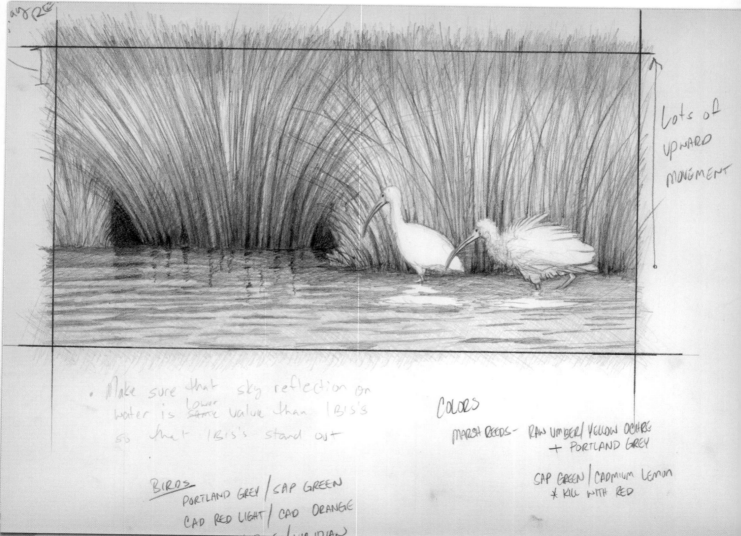

Lots of
UPWARD
MOVEMENT

• Make sure that sky reflection on
water is ~~same~~ lower value than IBIS's
so that IBIS's stand out

BIRDS
PORTLAND GREY / SAP GREEN
CAD RED LIGHT / CAD ORANGE

COLORS
MARSH REEDS— RAW UMBER / YELLOW OCHRE
+ PORTLAND GREY

SAP GREEN / CADMIUM LEMON
* KILL WITH RED

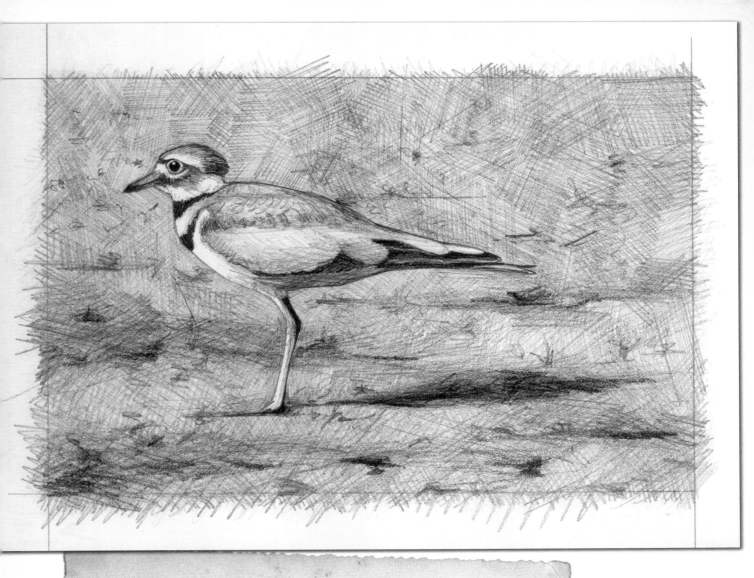

Robert Louis Caldwell

Robert Louis Caldwell is an award-winning artist nationally renowned for his wildlife and architectural oil paintings. His work has appeared in numerous national and international exhibitions, including the Society of Animal Artists' ART AND THE ANIMAL and the Leigh Yawkey Woodson Art Museum's BIRDS IN ART. A BFA graduate of Virginia Commonwealth University, Caldwell enjoys hiking and mountain biking when not in his Virginia studio. "These adventures outside are what usually inspire me to get back to the studio, pull out the sketchbook and capture an idea that I had while out having fun."

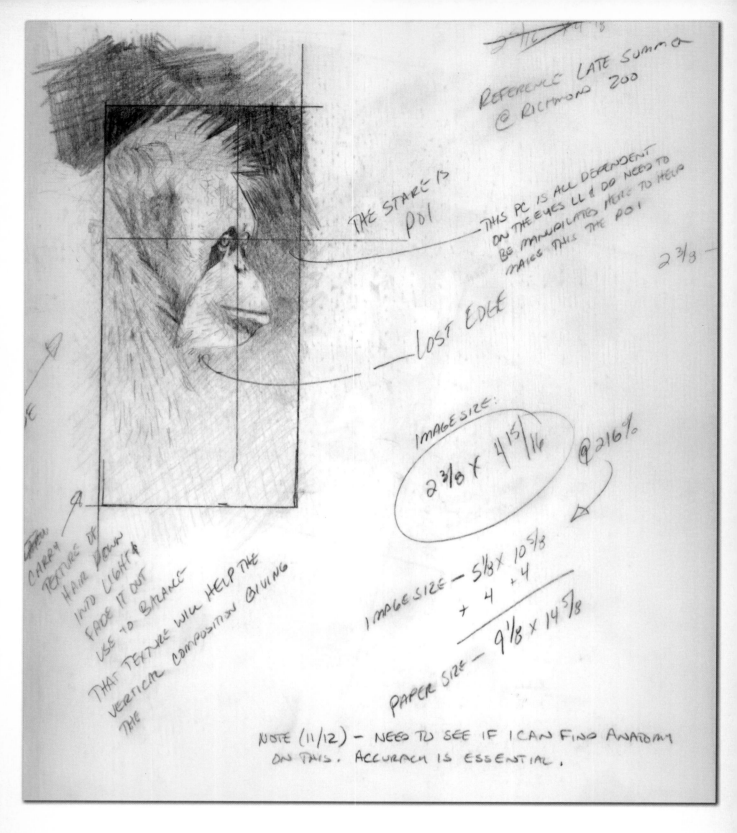

REFERENCE LATE SUMMER
@ RICHMOND ZOO

THE STARE IS
POI

THIS PC IS ALL DEPENDENT
ON THE EYES LL & DO NEED TO
BE MANIPULATED HERE TO HELP
MAKE THIS THE POI

2 3/8

— LOST EDGE

IMAGE SIZE:
2 3/8 X 4 15/16 @ 216%

IMAGE SIZE — 5 1/8 X 10 5/8
+ 4 + 4
PAPER SIZE — 9 1/8 X 14 5/8

CARRY
TEXTURE OF
HAIR DOWN
INTO LIGHT &
FADE IT OUT
USE TO BALANCE
THAT TEXTURE WILL HELP THE
VERTICAL COMPOSITION GIVING
THE

NOTE (11/12) — NEED TO SEE IF I CAN FIND ANATOMY
ON THIS. ACCURACY IS ESSENTIAL.

My sketches are the captured spark of a possibility.
They are ideas quickly drawn, rearranged, reworked,
sometimes forgotten and then rediscovered.

I mainly sketch when I am composing an idea for a new drawing or painting, although it may not always be on paper. I often get strange looks when I see a bird land on a perch outside of a window and I move my head to change my vantage point, recomposing the live image using the grids of the window to create a more pleasing arrangement of the forms.

My sketches are the captured spark of a possibility. They are ideas quickly drawn, rearranged, reworked, sometimes forgotten and then rediscovered. They are the working blueprint of my finished work.

I actually talk to myself in my head as I draw, saying things like, "What's the size of this space? What's the relation of this shape to that shape? How does this negative space affect that positive space?" This conversation goes on and on in my head until the object in front of me is rendered on paper.

I wish that I had more time to sketch for enjoyment. Although now that I am teaching some drawing and painting classes, I often find myself sitting down with the students and sketching alongside of them.

Sketching is where all of my creative license lives. Once my composition is transferred to drawing paper or canvas, I make no further changes to my work. For me, creative license means exploring "What are the possibilities?" for the next piece. I work all that out in the sketch. The possibilities are explored, a composition is found and an idea comes to life.

RL CALDWELL

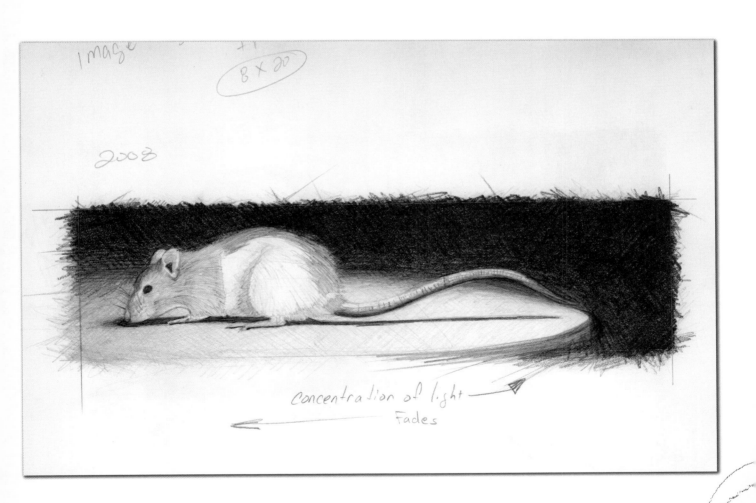

Lindsay Cibos

Lindsay Cibos is a comics artist and illustrator living in Florida. She created the graphic novel series PEACH FUZZ (Tokyopop)—a finalist for the FOREWORD MAGAZINE 2004 Book of the Year award—and has co-authored several art instruction books, including DRAW FURRIES and DIGITAL MANGA WORKSHOP. Cibos has also worked as a penciler on SABRINA, THE TEENAGE WITCH and several four-panel strip comics on SONIC THE HEDGEHOG (both by Archie Comics). Her newest project, an environmentally minded graphic novel called THE LAST OF THE POLAR BEARS, can be read online at lastpolarbears.com.

Last year, I wanted to increase my understanding of animal anatomy, so every day I sketched a new animal.

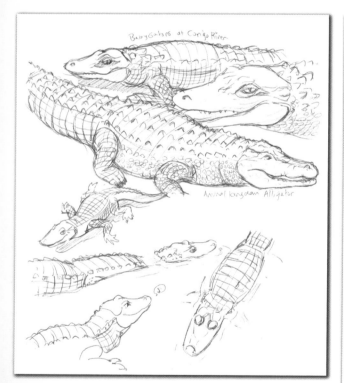

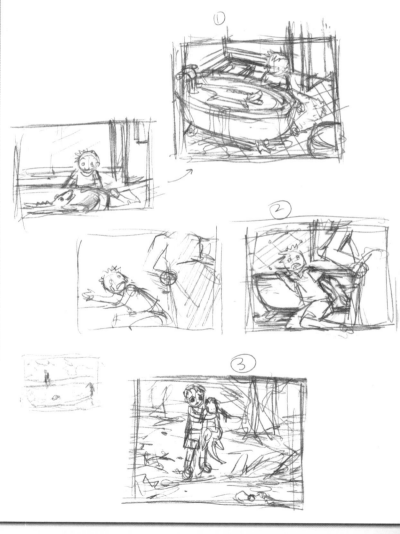

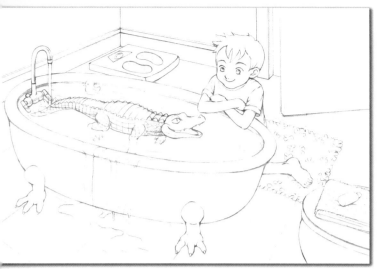

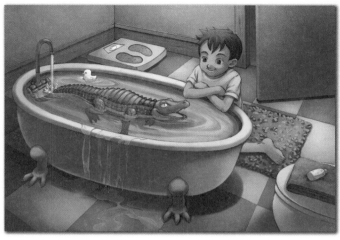

My sketchbook is a no-pressure environment for working out ideas, character designs, illustration compositions to develop into finished works, and for practicing new techniques and styles.

I generally set aside an hour every day for warm-up sketching. It isn't always possible when deadlines are tight, but I do it as often as I can. The subject matter varies. Last year, I wanted to increase my understanding of animal anatomy, so every day I sketched a new animal. The year before that, I was working on color sketches with a focus on speed and efficiency to improve my painting techniques. I've seen a noticeable improvement in both categories as a result of my practice sketching sessions.

From my years as an artist and doing observational sketching, I find that I don't just look at my surroundings, I appreciate the small details, qualities like light and shadow, texture and so on. If I'm doing observational sketching, I'll make note of the general shape and proportions of the subject. I also consider things like whether a line should be curved or straight, how to express a texture with pencil lines, etc.

Sometimes the sketches I do are only tangentially related to my finished work, like when I'm trying to improve an area of weakness, but I may come back to these sketches later and use them as a jumping-off point to a full-fledged illustration. Other times, my sketches are specifically intended to be rough drafts for finished

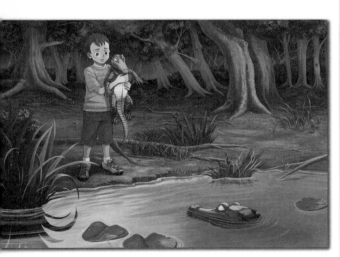

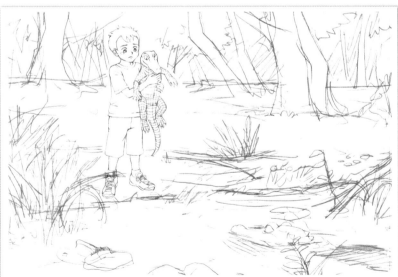

25

2:16 - 2:50

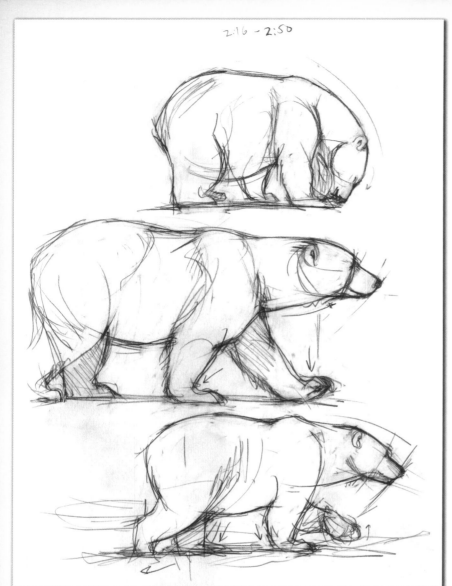

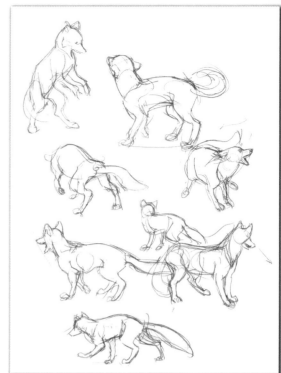

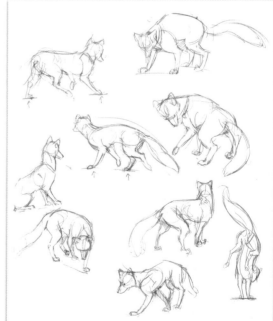

4 week old meerkats

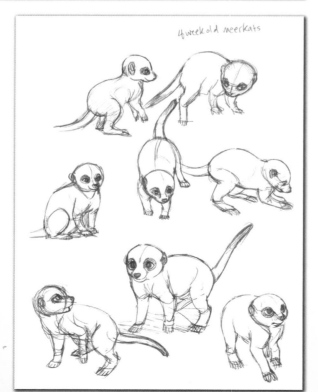

pieces. My sketches are typically confined to pages of my sketchbook, but when inspiration strikes unexpectedly, the nearest scrap of paper becomes my canvas.

Sketching is an opportunity to experiment. You can try out new techniques or draw in a different art style. You can't do that with an assignment—art directors don't like those sorts of surprises. Plus, since there's no obligation to finish them, if a sketch isn't going well, I can just abandon it and try something else.

Lindsey Custer

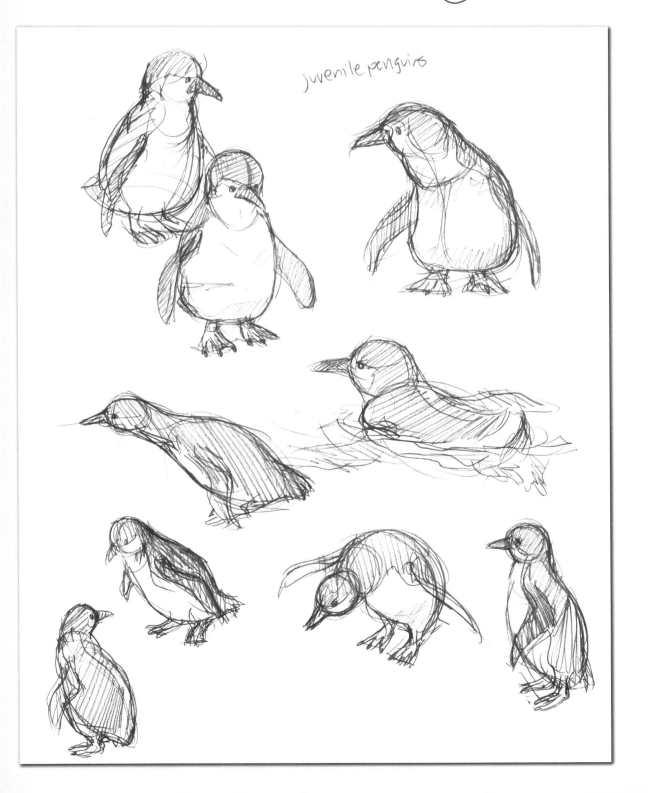

juvenile penguins

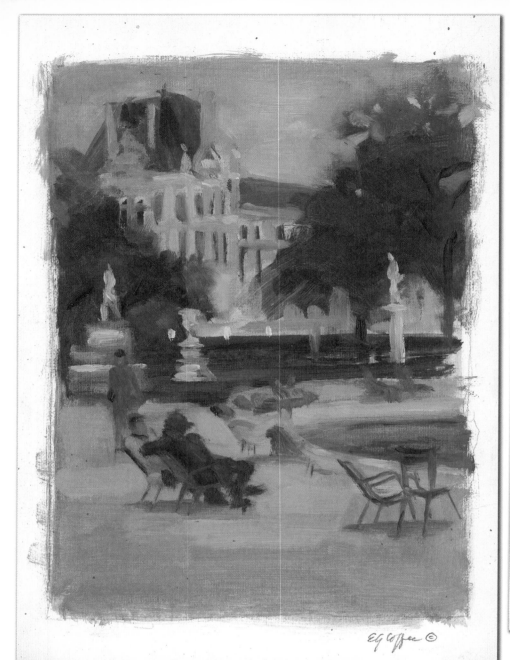

Elaine G. Coffee

Attending New York's School of Visual Arts, says artist Elaine Coffee, "gave me lots of options for sketching—especially riding subways," which led to a subway series of paintings. Now in Arizona, Coffee's artwork focuses on the figure. "Eventually, one figure was not enough and my work evolved to include more of the environment and more figures, a kind of contemporary genre painting," she says. "I like capturing gestures, the body language that reveals a person's state of mind." The artist's past studies include biochemistry and medical illustration, and she spent over a decade as an art director, writer and food editor for SCOTTSDALE MAGAZINE.

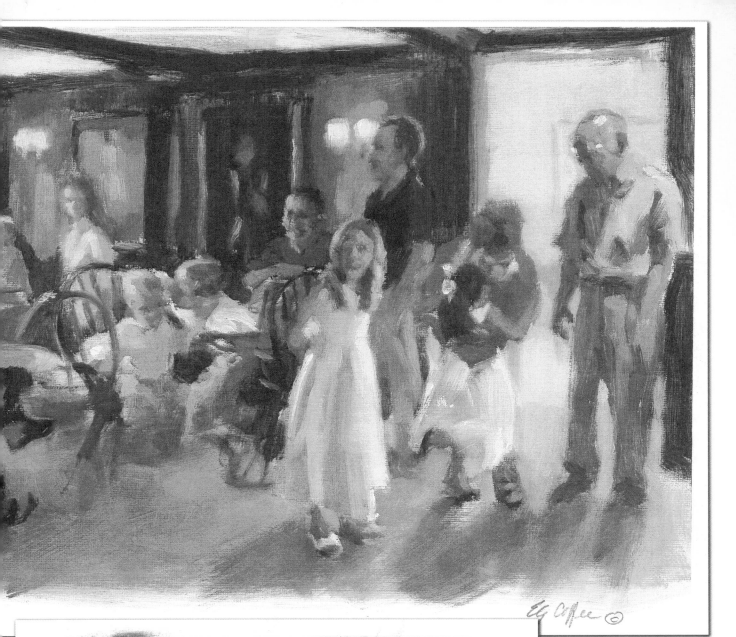

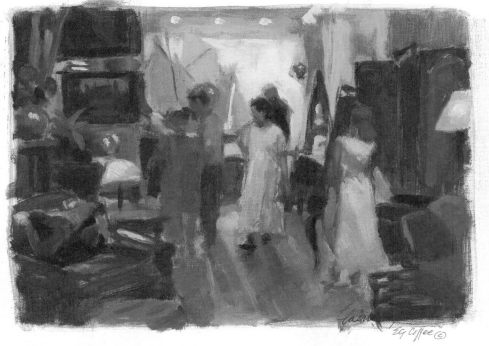

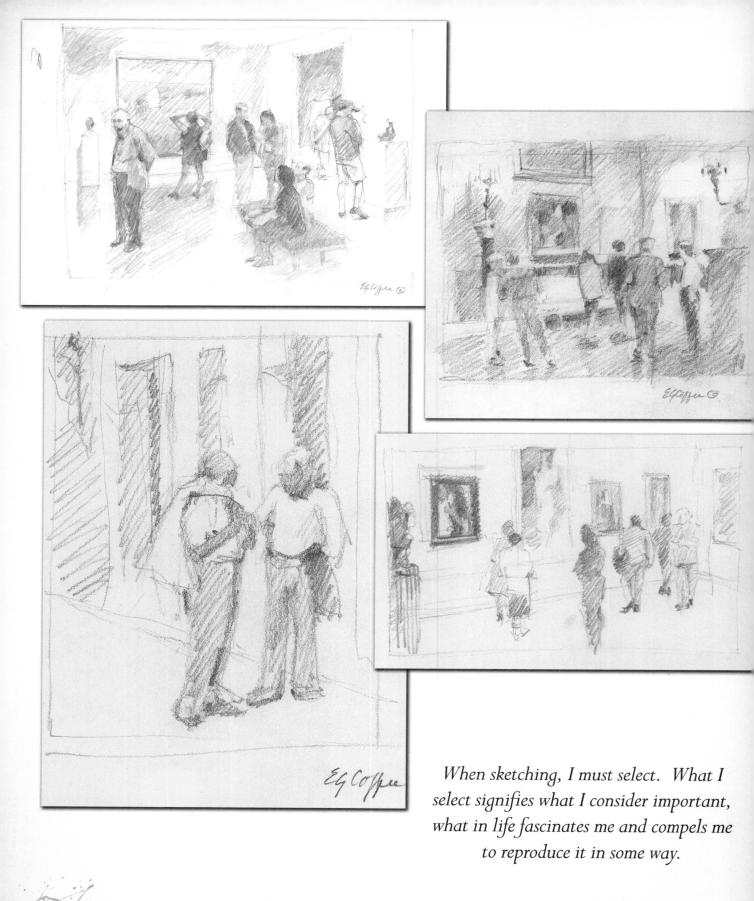

When sketching, I must select. What I select signifies what I consider important, what in life fascinates me and compels me to reproduce it in some way.

People inspire me to sketch. Interesting-looking people in interesting places.

Because my paintings are multi-figured and involved, sketches to establish values and composition are essential. They are the plans, the architectural drawings, the engineering for my finished work.

When I am sketching, I think about what I am sketching: body proportions, facial features and how to portray them. If there are multiple people, how do they relate to each other? How do I emphasize interesting characteristics?

When sketching, I must select. What I select signifies what I consider important, what in life fascinates me and compels me to reproduce it in some way.

Sketching teaches me to understand the marvels of the human body and personality and the incredible science of perspective, the translation of an endless three-dimensional space into a restricted two-dimensional area.

Sketching gives me the freedom to experiment. It's a beginning, an idea that may eventually be finished art, but it all starts with the sketch.

Elaine G Coffee

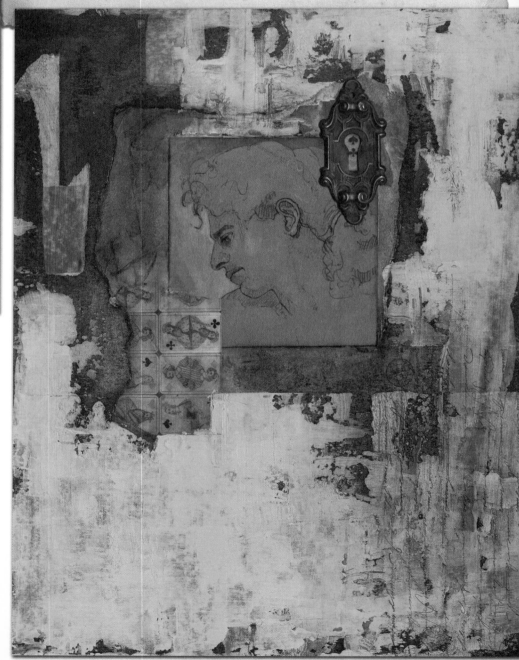

Lisa L. Cyr

The fantasy-inspired mixed-media creations of Lisa L. Cyr have been described as "not only multidimensional, but also multisensual." Cyr has penned seven books on art and design, including the best-selling ART REVOLUTION and EXPERIMENTAL PAINTING, and she is an artist member of the Society of Illustrators in New York City and the International Society of Experimental Artists. She has written for and appeared in a number of magazines and books, including the series SPECTRUM: THE BEST IN CONTEMPORARY FANTASTIC ART, and her artwork is included in the permanent collection of the Museum of American Illustration.

Working in a spontaneous, stream-of-consciousness way allows me to explore avenues that I may not have otherwise thought of.

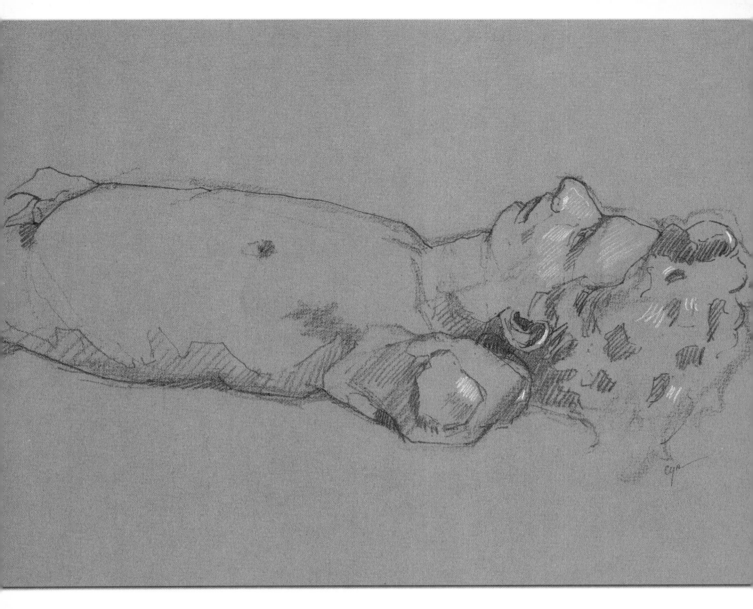

My journals and illustrated sketchbooks are where my ideation process begins. I write in my journals almost every day, collecting literary snapshots of what has transpired. I take these slice-of-life details and embellish them with an imaginative flair.

To ignite the process, I'll often conjure up past experiences or dreams, recall a poem that moved me, play instrumental music or listen to the sounds of nature with scented candles surrounding the studio. Expressive, meaningful mark-making triggered by a sensory-charged environment creates a pathway to the subconscious. Playful and carefree, the work seems to take on a life of its own. As I become completely engaged in the visceral process, I begin to see things in the abstract, pulling out the details and clarifying the picture.

Working in a spontaneous, stream-of-consciousness way allows me to explore avenues that I may not have otherwise thought of. I love to experiment, sketching my ideas in a mixed-media fashion. Instead of a pencil, I may grab an altered brush, custom roller, stick or sponge and make marks onto a scrap surface or directly into my sketchbook, developing imaginative, dream-like environments for my fantasy-based characters. I also enjoy working from life, drawing the figure in costume and nude.

When I am working in the sketchbook, there is never pressure to perform or to create work that is portfolio-quality in the end. For me, it's all about the journey and not the final destination. Mixed-media sketching is a license to play, free from preset expectations, limitations or boundaries. When uninhibited, the door opens for that spark of brilliance and magic to come through.

When sketching or journaling, I am capturing moments in time, later arranging them into a more refined composition or statement. Inspiration can be found almost everywhere, and it is up to the artist to be observant and open to what life has to offer. Using bits and pieces of my world as seen and interpreted through my artistic filter, I am able to build visually compelling, imaginative worlds where fantastical figures have a captivating story with a secret message just waiting to be revealed.

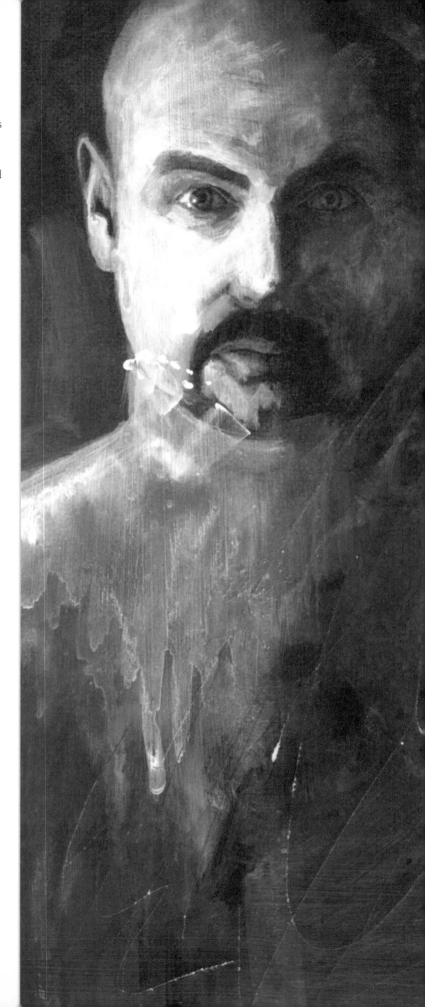

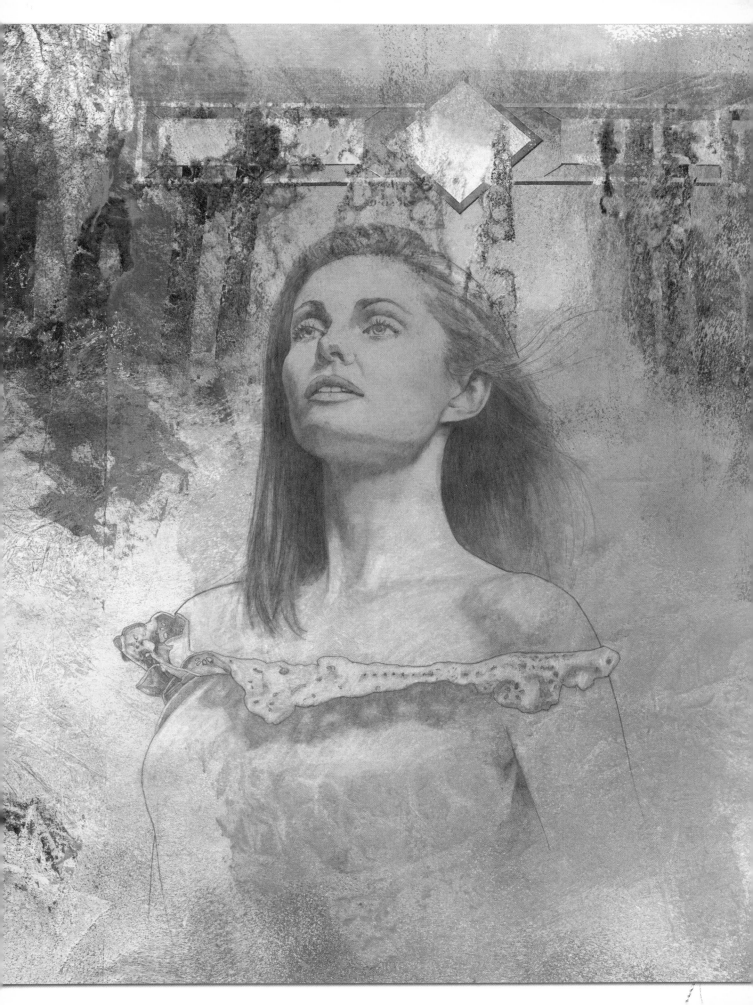

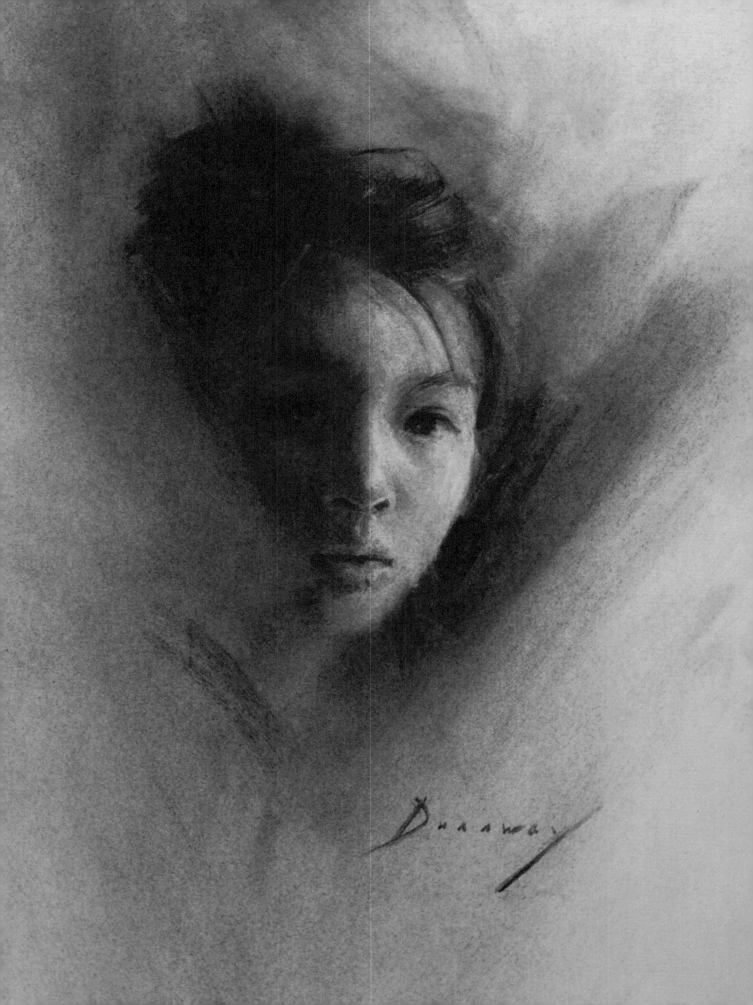

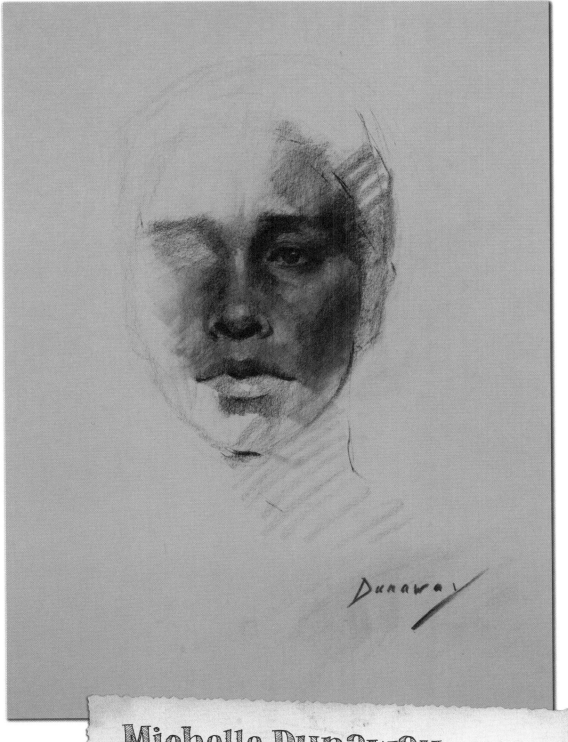

Dunaway

Michelle Dunaway

Once named by SOUTHWEST ART magazine as one of "21 Under 31" emerging American artists to watch, Michelle Dunaway credits her Alaskan upbringing for honing her awareness of the beauty in the everyday. Her portraits have landed her in many collections and publications, including North Light's STROKES OF GENIUS best-of-drawing series. In 2010, Dunaway was a top finalist in the Portrait Society of America's international portrait competition, where she won the Award of Exceptional Merit for her double portrait of actress Jane Seymour's daughters.

Chances are, if there's a paper lying around my studio, it has a sketch on it. Drawing is the foundation of painting, and I make it a point to draw and sketch from life as much as possible. It's so essential; it trains the eye to the nuances of light, rhythms, form and color temperature.

When sketching, I think about movement, light, emotion and accuracy of form. Creating a rhythm with values and edges to convey emotional content is most important to me.

What inspires me to sketch, write and paint is the idea of capturing the essence of a moment and remembering it visually. Sketching is so immediate. I tend to use vine charcoal, as I can put down a few gesture lines and tonal keys that will visually remind me of my initial inspiration. If I have time to do a longer sketch—say, at a museum, in nature or with a model—then I focus on problem solving and capturing a sense of light, form and accurate color from life.

Sketches, paintings and drawings are visual records of what you are paying attention to in life.

I love sketching, especially portrait studies and figurative gestures from life. It's a feeling of exhilaration and pure raw emotion. There's an intuitive element at play, especially when drawing another person from life. You're capturing a glimpse of the story of who they are and also your own emotions and inspirations. You're in a shared moment of creativity. Time seems to stop and you can feel suspended in that moment while expressing it artistically. To me, there's nothing quite like it.

Sketches, paintings and drawings are visual records of what you are paying attention to in life. Art makes me more aware of the subtle, beautiful moments in life and, in turn, noticing those moments inspires me to create. Then hopefully, someone else can also experience that moment through the drawing or painting, and it might cause them to be more aware of the beauty of their life and express it in their own way. It's a ripple effect.

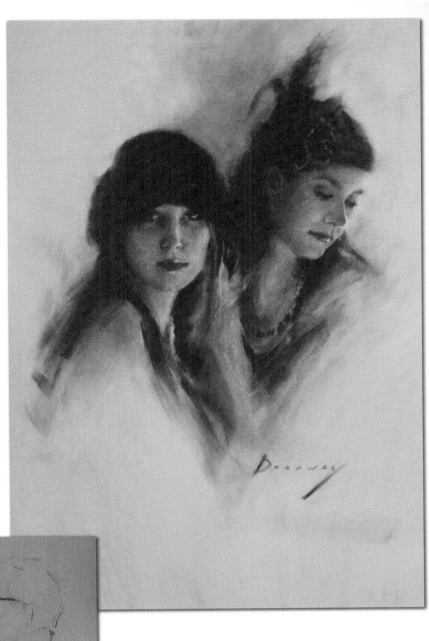

Sterling Edwards

The watercolors of Sterling Edwards strike a balance between photorealism and abstraction, with stylized shapes, bold design elements, and strong contrasts of light and dark accentuated with rich colors. Edwards continually draws inspiration from the Smoky Mountains that surround where he lives, in western North Carolina. He is the author of CREATING LUMINOUS WATERCOLOR LANDSCAPES and a sought-after workshop instructor.

I guess that you could say my sketches are inspired by my ability to create a scenario as I want it rather than accepting it the way that it exists.

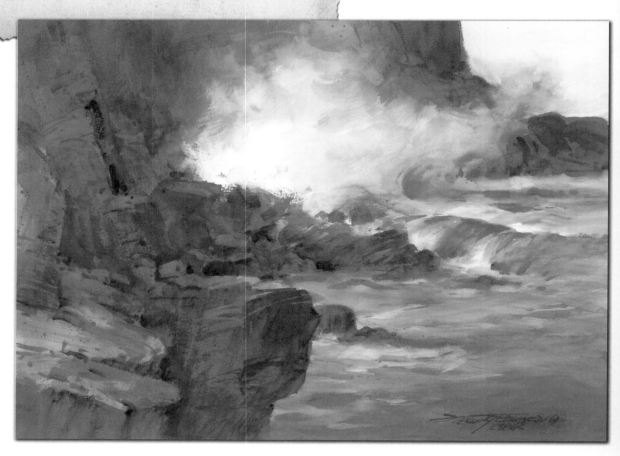

I am primarily a studio painter and work from photographs. The photographs that I take usually contain much more information than is necessary to produce a good painting. I love to exercise my artistic license and do several sketches of a subject with different light sources, moving objects around and planning where I would place the darkest values to create some drama in my painting. I guess that you could say my sketches are inspired by my ability to create a scenario as I want it rather than accepting it the way that it exists.

I don't sketch daily, but I do sketch often. I even keep a small sketch pad in my van for those times when I am on the road and see a potential subject for a painting. I probably do about ten to twenty small thumbnail sketches a week. They only take a few minutes and are full of useful information.

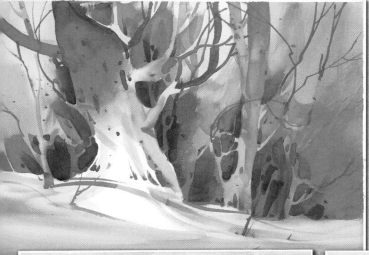
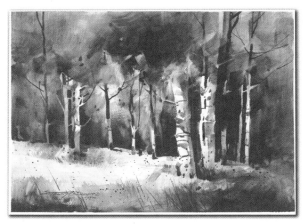
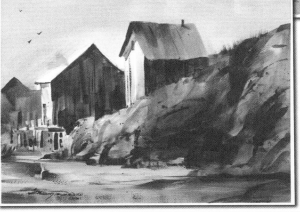
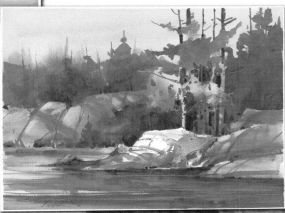
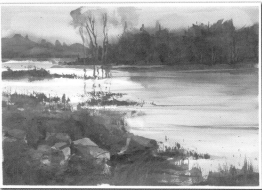
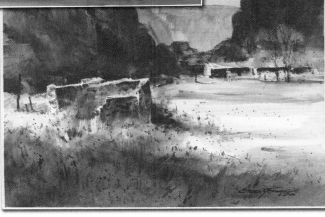

I like to look through my photographs and then do several three to five minute sketches of a subject with minor changes in each. Then I will put a checkmark beside the one that I like the best. In the studio, I always do a quick sketch before attempting a painting. A little planning goes a long way, especially with watercolors.

I get a lot of pleasure out of sketching. Since I rarely paint everything in a photograph, I get to have fun making my own world by taking the elements of the subject and adding, deleting, or moving things around. Sometimes I will exaggerate the shapes and give them a slight abstract design. Other times I will use just the larger shapes in the photograph and totally abstract the design. The possibilities are endless. Each sketch that I do usually gives me an idea for another sketch.

I am always planning a painting. Even my scribbled doodles are an attempt to find a design that might have the potential for a good painting. Rarely can I look at anything these days and not subconsciously break it down into a series of shapes and values. I am always drawing or painting, even if it's just in my thoughts.

Sterling Edwards

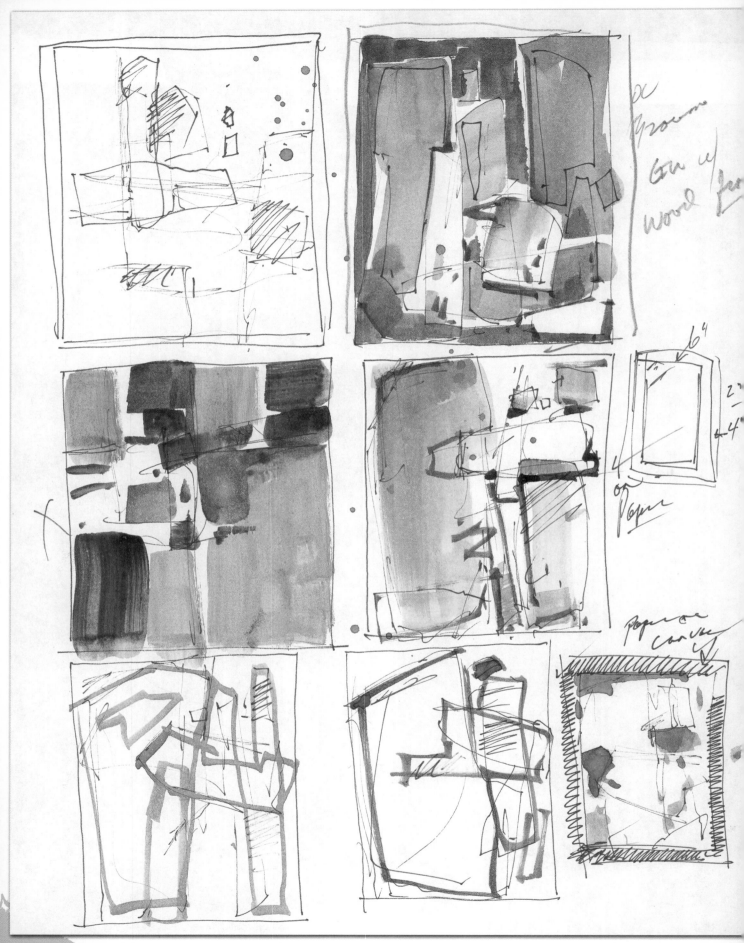

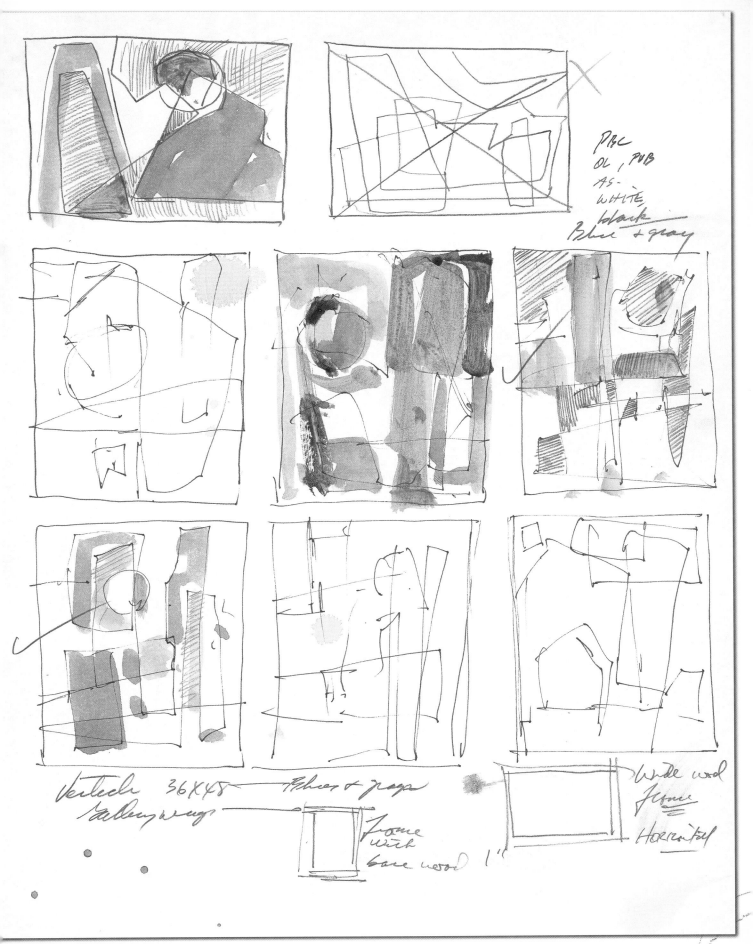

PBC
OL, PUB
AS-
WHITE
black
Blue & gray

Vertical 36 X 48
gallery wraps

Thicker & props

frame
with
bare wood 1"

Wide wood
frame
Horizontal

My feelings while sketching run the gamut from lazy and relaxed to I'm-so-frustrated-I-give-up-on-drawing-forever-someone-hold-me.

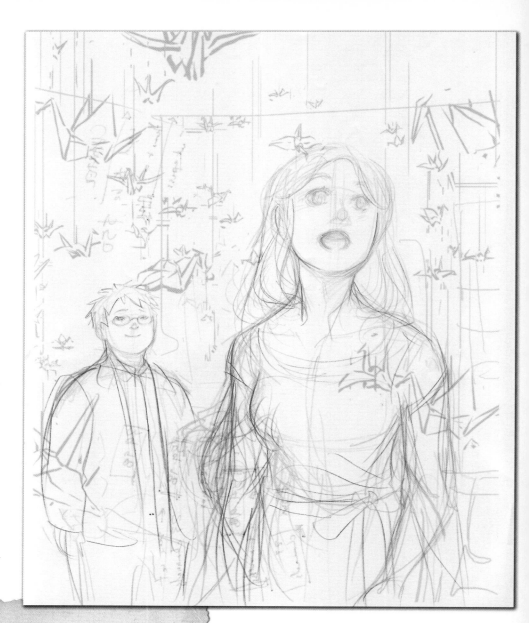

Irene Flores

Born and raised in the Philippines, illustrator and artist Irene Flores says she was heavily influenced by Japanese animation and American comics. She began her career in 2004, co-creating and illustrating MARK OF THE SUCCUBUS for Tokyopop. Now residing in San Luis Obispo, California, Flores is the author of SHOJO FASHION MANGA ART SCHOOL and co-author of SHOJO FASHION MANGA ART SCHOOL: YEAR 2, and has done illustration work for Marvel, DC and WildStorm Productions.

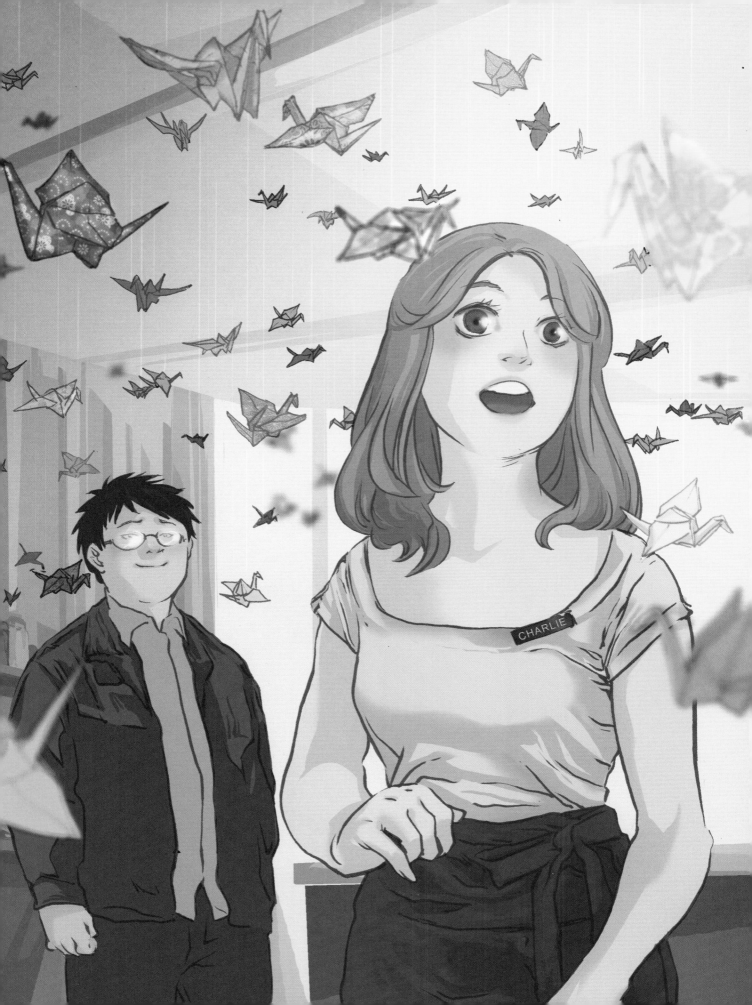

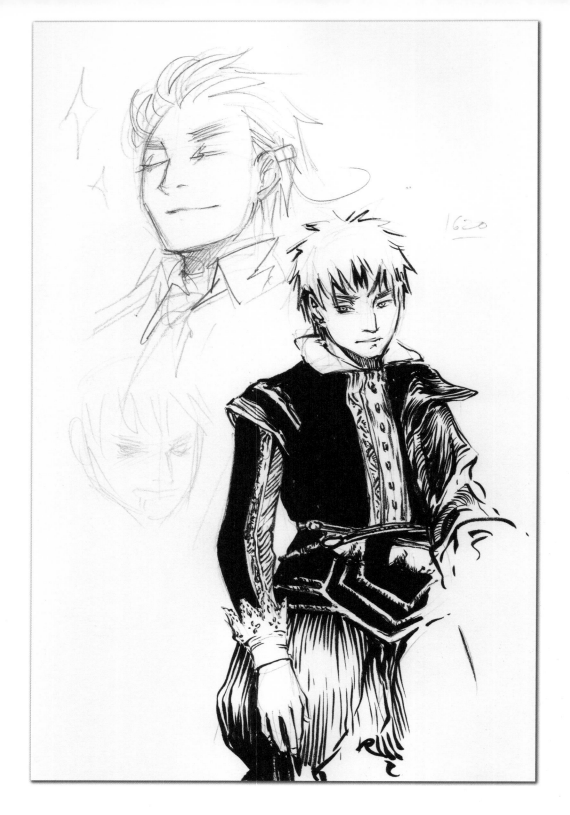

What inspires my sketching? Graphic novels. Artbooks. Late-night caffeine binges. The sublime nature of bodies in motion. Friends and the Internet, specifically my Tumblr dashboard. I follow some wacky, talented, hilarious, insightful, perverted, and well-spoken artists/ writers/people. Their ideas, words and art inspire me to sketch everything from adorable children to wendigos to space cowboys.

I start sketching after I go through my "wake-up" (not necessarily morning) routine. It goes something like

Internet, food, coffee, Internet, SKETCH. Actually, I go through this cycle three or four times during the day.

Most times, I need to draw an idea I don't want to forget. Sometimes, it's less specific, something along the lines of, "Hey, I want to draw Steampunk things right now," and random characters/objects will come out of that. Or, I don't think at all. It's all just random squiggles.

My feelings while sketching run the gamut from lazy and relaxed to I'm-so-frustrated-I-give-up-on-drawing-forever-someone-hold-me. I feel like the latter a lot. This usually stems from the fact that my sketches don't look as awesome as they did in my head. Also, I just want to be held.

The creative license of sketches is that ... they're so sketchy. There's no pressure to get each line and curve perfect. If I'm drawing a character running, I can play with the pose and the position of appendages. I often end up with some sort of multi-limbed, mutated, Vitruvian man knock-off, but it's very telling of my creative process. You can see me thinking through the pose changes and get an idea of how hard I like to press down on the paper, how long or short my line strokes are, through the jumbled and scribbly mess of the whole sketch. Finished pieces can end up looking great, all clean and polished, but the energy changes. There's less in-the-moment creativity.

My sketches are a record of my life and my art. I look through my sketchbooks over the years, and I remember the stories/series I was following from the volume of fan art I drew, the styles I started to adopt from various artists who influenced me, and the changes and improvement in style, anatomy, lines, color and so on.

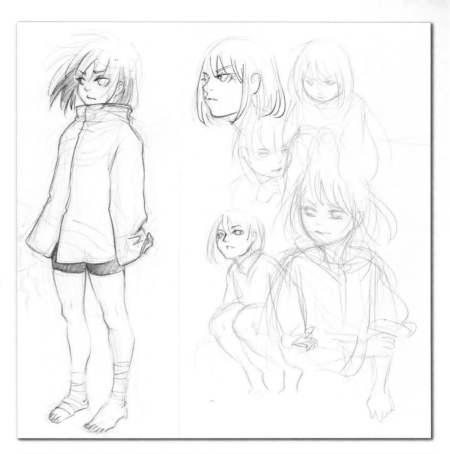

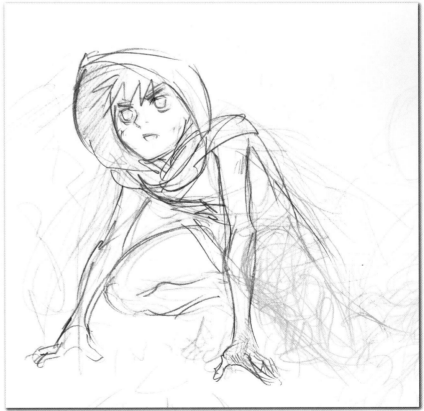

Grant Fuller

After building an impressive portfolio in commercial art (including for Sears Fashion) and broadcast production (more than three hundred TV commercials and a thousand radio spots), Grant Fuller embarked on a new successful career: watercolor painting and teaching. For the past twenty-five years, he has taught workshops and courses from coast to coast, as well as in the United Kingdom. He is the author of WATERCOLOR A TO Z and START SKETCHING AND DRAWING NOW.

My main source of inspiration comes from outdoor subjects, especially during the summer. Sketching is an integral part of my work, so I don't have a rigid schedule for it. I sketch whenever I need it. In the winter, some friends and I rent an art room in a local high school once a week and take turns bringing still life setups. I always prepare a drawing before adding paint, but often I will do several sketches instead of painting.

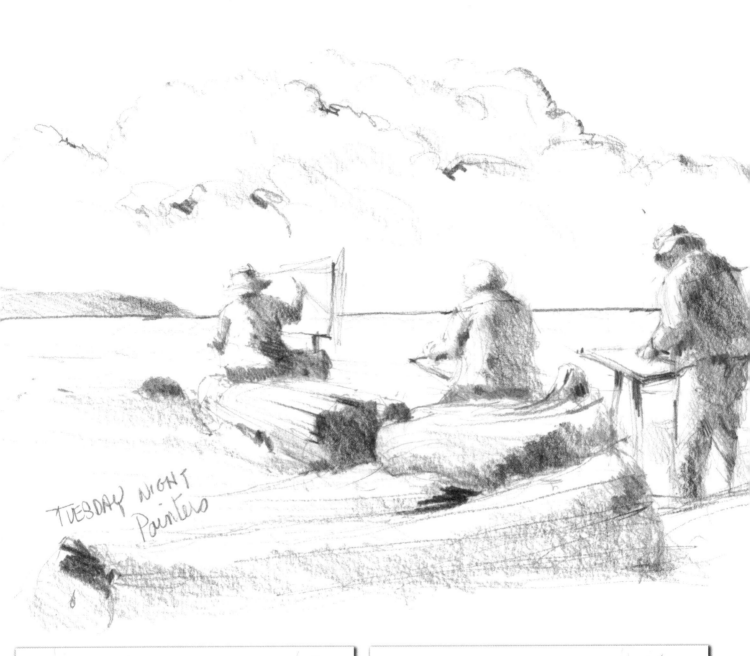

TUESDAY NIGHT
Painters

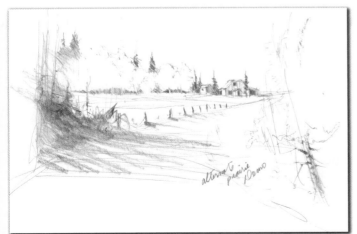

alternate
prairie Demo

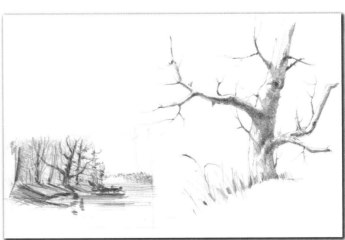

49

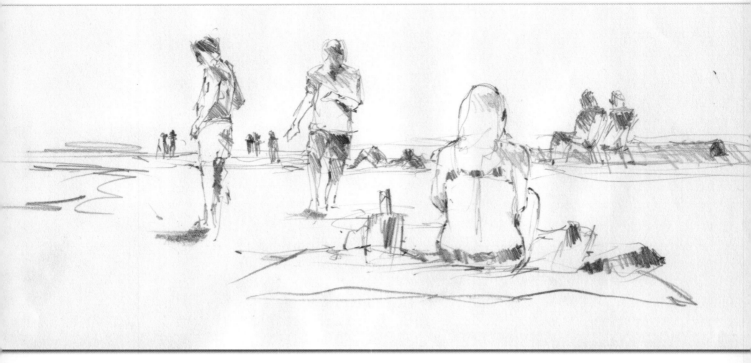

For me, drawing is the first step in painting, so I am forever working with a pencil. If I have any uncertainty about my subject, I will do a sketch. The sketch is accomplishing two main objectives. It is exploring where I am going to place the light and dark areas in the painting (a value study), and I am confirming that I can actually draw the objects that I want in the painting.

This process is so absorbing that I often feel like I have entered a different world. Even drawing a tree, which I have done countless times, is still an all-consuming exercise. I need to focus on what I am seeing and fight to keep my memory from interfering with the path from eye to brain to hand.

By sketching as though you are seeing everything for the first time, you will always discover something new. This inevitably changes how you perceive the world. I can go to the same location time and time again, and it never looks the same. Sketching heightens my awareness, because it forces me to study my surroundings.

Sketching can be used like a diary or a record of personal experience, but my purpose is primarily to gather information. I also need to keep my ability to see and visualize in constant motion in order to add new excitement to my artwork.

Another important objective in sketching is the sorting process. I can eliminate and alter the subject to include only the parts we like most. I can make arbitrary changes and explore ways of simplifying the composition. There is no need to be exact in a sketch, so I can be free and courageous with the drawing. This often leads to ideas that can be included in the final work. Sketching has become a normal part of the painting process where the ideas take shape. Without this preparation, paintings will become dull and repetitious. Paintings should be exciting, and this only comes from a good plan. Sketching is the time to experiment.

Grant Fuller

By sketching as though you are seeing everything for the first time, you will always discover something new.

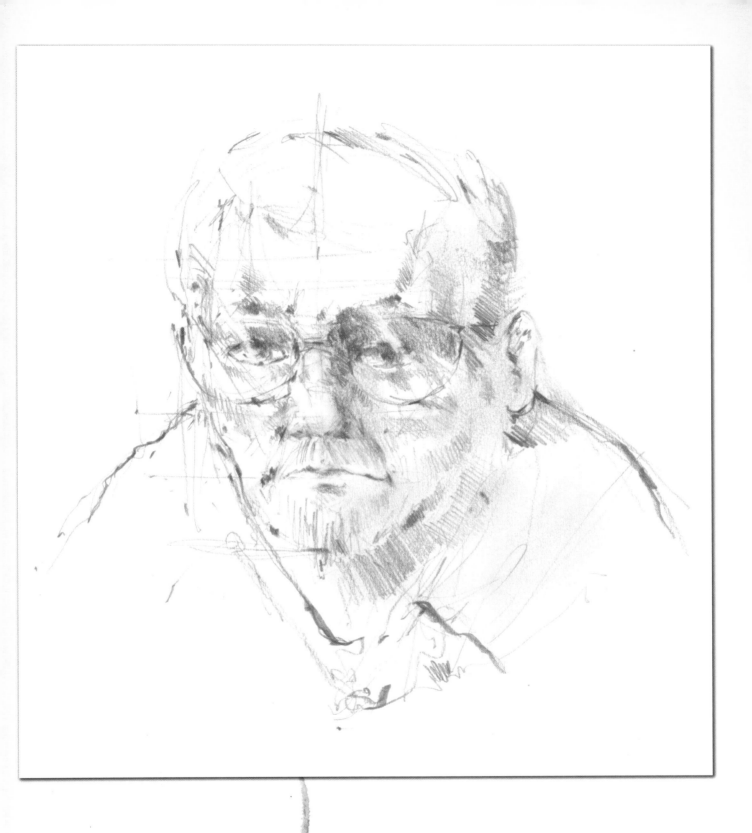

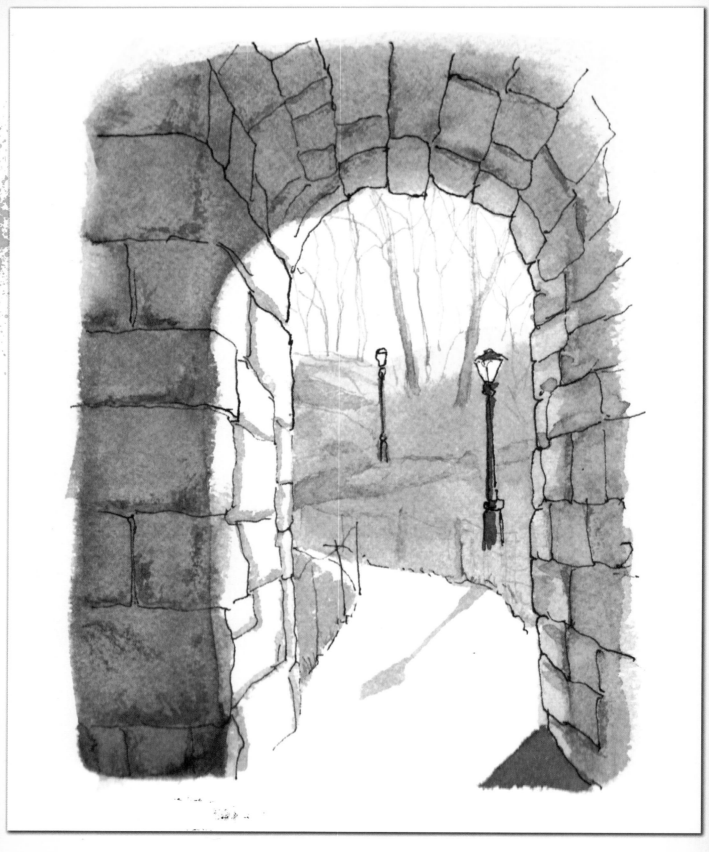

While sketching I often do not complete things, leaving lines unconnected, areas of color unpainted—and in doing so, I feel as if I am leaving the subject open to my continued interpretation.

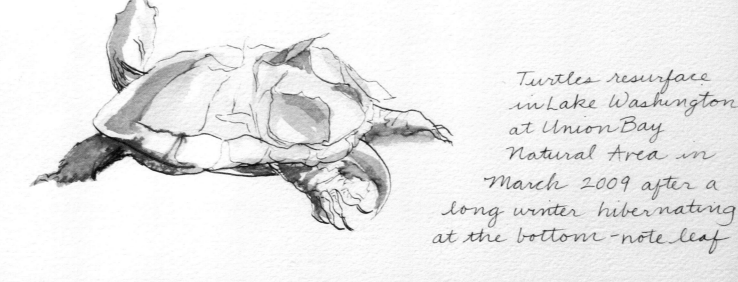

Turtles resurface in Lake Washington at Union Bay Natural Area in March 2009 after a long winter hibernating at the bottom — note leaf

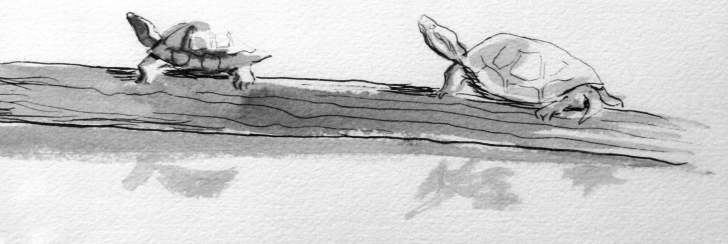

Molly Hashimoto

Seattle artist Molly Hashimoto considers teaching integral to her artistic journey, her mission being to connect students of all ages "to nature and cultural history through hands-on art experiences," with the hope of fostering a community that works to protect its treasured parks and wilderness areas. Her paintings and illustrations have been exhibited at the Shoreline Arts Festival—where in 2004 her painting LEWIS AND CLARK TRAIL: MISSOURI RIVER won first prize—among other invitational and solo shows. Her artwork has also appeared in cards, gift books and a calendar by Pomegranate Communications. Hashimoto studied illustration at the School of Visual Concepts in Seattle.

I sketch several times a week, either in my journals, or when I am developing ideas for paintings and illustrations. I get inspired by going outdoors to my garden, or to nature preserves, parks and wilderness areas, and by my travels.

I sketch when something really moves me—a new plant, flower, landscape, or special light in a season or time of day.

When sketching, I usually feel a very strong rapport with whatever I'm looking at, so it's a feeling of connectedness to the world. Plus, I often become very relaxed in the process—there's no stress in it at all, no sense that I have to get it right.

My mind really empties itself when I am just drawing. I suspend most routine thoughts while I am sketching and simply concentrate on what I am sketching. It's very restorative—so often in my art making, I'm thinking about deadlines, accomplishing things, or scheduling things, and sketching allows me to forget about all of that. It seems like a form of meditation—I really don't think about anything at all! When I add watercolor, there is more thought as I plan the palette and the stages of painting.

My plein air watercolor sketches often give me the information I need to create studio paintings together with photographs that I take on location. Sometimes a plein air sketch captures color and light direction or even exaggerates it, which all adds up to emotional content that can't be found in a photo. Most of my studio work is landscape painting; plein air sketches are invaluable for inspiration and information.

By really focusing, I learn new things about the world when sketching. I love a quote by Marcel Proust: "The real voyage of discovery consists not in seeking new landscapes, but in seeing with new eyes."

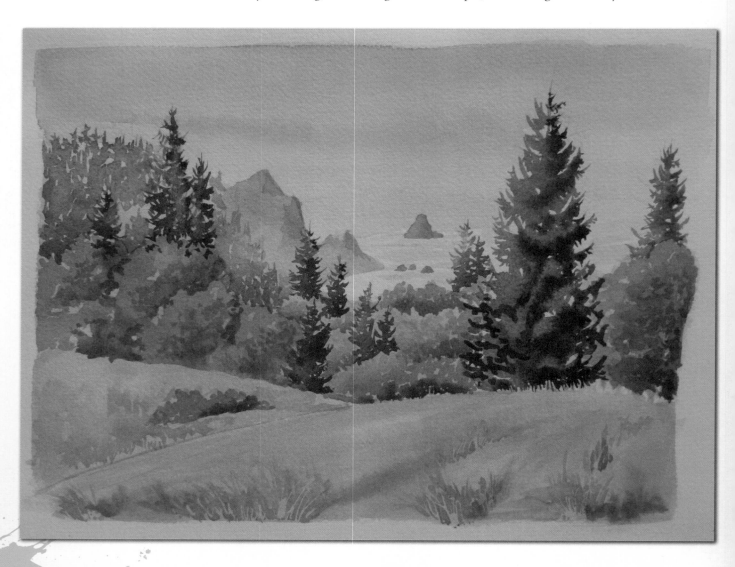

I normally sketch what I value, and I almost always see something new in it that makes me value it even more. Often when I am teaching, I sketch subjects to benefit my class that I might not be deeply interested in myself. I find when I look at something new that I might not have valued before, I see the beauty in it and begin to value it more.

While sketching I often do not complete things, leaving lines unconnected, areas of color unpainted—and in doing so, I feel as if I am leaving the subject open to my continued interpretation.

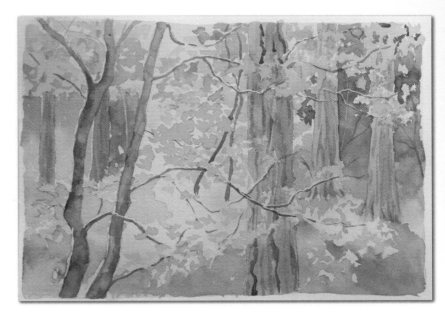

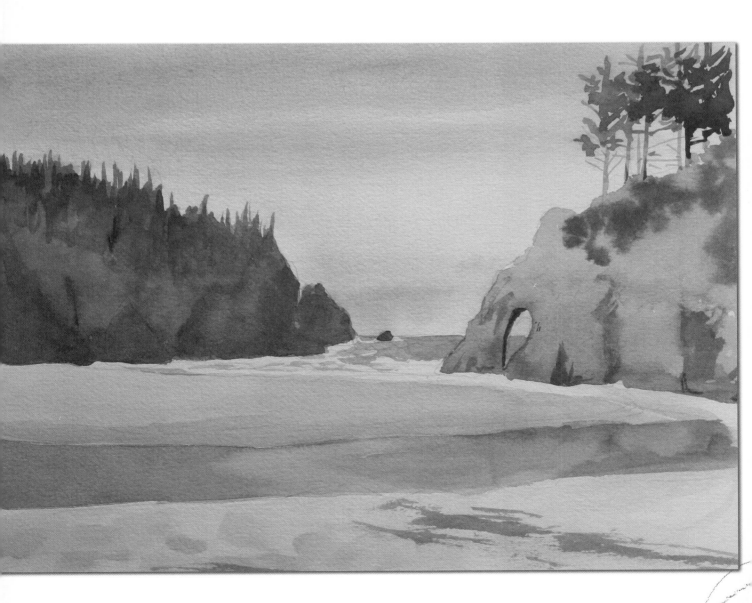

Carlynne Hershberger

Florida-based artist Carlynne Hershberger, a charter and signature member of the Colored Pencil Society of America, doesn't limit herself to only pencil, as she demonstrates in her book CREATIVE COLORED PENCIL WORKSHOP. Acrylics, oil pastels and collage elements regularly find their way into Hershberger's landscapes and abstracts, and she also creates portraits. In Ocala, she teaches weekly classes and workshops with fellow artist, co-author and studio partner Kelli Huff.

I think sketching is kind of like meditating: It helps me focus and get into the zone. It's also cumulative in that the more you do it, the quicker the ideas come.

I get excited about getting the sketchbook out when I have an idea for a series or a new concept that I want to explore. If I have a theme in mind, I like to start by working out my thoughts in lists. I make lists of words that relate to my concept. That's my start, and it helps to organize the concept. I can then break the list down into possible painting ideas. From those words, images start to form in my mind, and I can build the paintings from there.

I sketch the most at the beginning of a new series. Then, as I'm actually working on the paintings, I'll go back and refer to my sketches and word lists to keep the ideas fresh or to get a new idea for an element if I'm stuck on something. Usually what happens is I'll be six or eight paintings into the series and then feel like I have to start over with new lists and images. Sometimes, it's a matter of having exhausted everything I could take from the sketches and I want to explore a new angle. Other times, it's a case of a word on one of the pages that sparked a

new direction for me to go in. When I'm really in sketch mode, I'll carry the book with me so it's handy if a thought hits me while I'm out of the studio.

The sketches are usually a starting point. I begin there, jump into the canvas (or paper) and then refine the sketch idea into what I hope will be a successful finished painting. Since I do also work in mixed media though, I have on occasion taken my sketches and actually incorporated pieces of them into the painting in a collage form. That's a lot of fun. I like to take elements from the whole process and make them part of the finished product.

I probably should sketch daily but it just doesn't happen. I do occasional thumbnails to work out a composition, but I'm too impatient to really go much beyond that. I know some artists who do a series of value drawings, color studies, etc. I used to do that and I just can't bring myself to do it anymore. By the time I do all that and

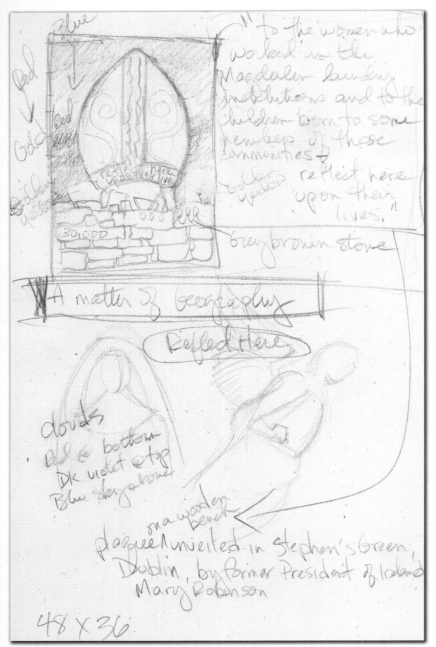

I finally get to the canvas, the excitement of the piece is gone. I love working out the challenges right on the canvas.

Aside from the obvious benefit of keeping my drawing skills honed, sketching helps me organize my thoughts, work out my plan of action, work out my compositions and generate new ideas. I think sketching is kind of like meditating: It helps me focus and get into the zone. It's also cumulative in that the more you do it, the quicker the ideas come. One sketch will lead to another and another, and it just builds on itself.

I used to be focused solely on images from nature—how I viewed the earth. As I've gotten older, I've wanted to do more with ideas about society and life experience on a more personal level. In order to do that, it takes more introspection on my part. I have to spend more time thinking, not only about the concept but about the art and how to present it. Sketching is like my road map to getting there, and through the sketching and list making, I'm finding myself more open to trying different things. I think working the road map now allows me to change it and find new paths to take.

white

Org
Red

59

WRAPPED

Jared Hodges

Born in Rochester, New York, Jared Hodges is a graphic novelist and illustrator. His work includes the graphic novel series PEACH FUZZ (Tokyopop), and instructional books such as DIGITAL MANGA WORKSHOP and DRAW FURRIES. He's also in MANGAKA AMERICA: MANGA BY AMERICA'S HOTTEST MANGA ARTISTS (Collins Design), featured as one of the twelve most influential artists in North American manga. Hodges currently resides in Altamonte Springs, Florida.

Sometimes life or projects get in the way, but otherwise, I try to sketch daily. I find that drawing is one of those skills that requires constant practice, reflection and refinement. During times when I'm working on aspects of an illustration that don't involve drawing (like painting or inking), sketching becomes a necessity to retain artistic competency. On a day-to-day basis, I treat sketching as a series of practice laps before the big race. It lets me work out the kinks and mentally prepare myself for the day's upcoming artistic challenges.

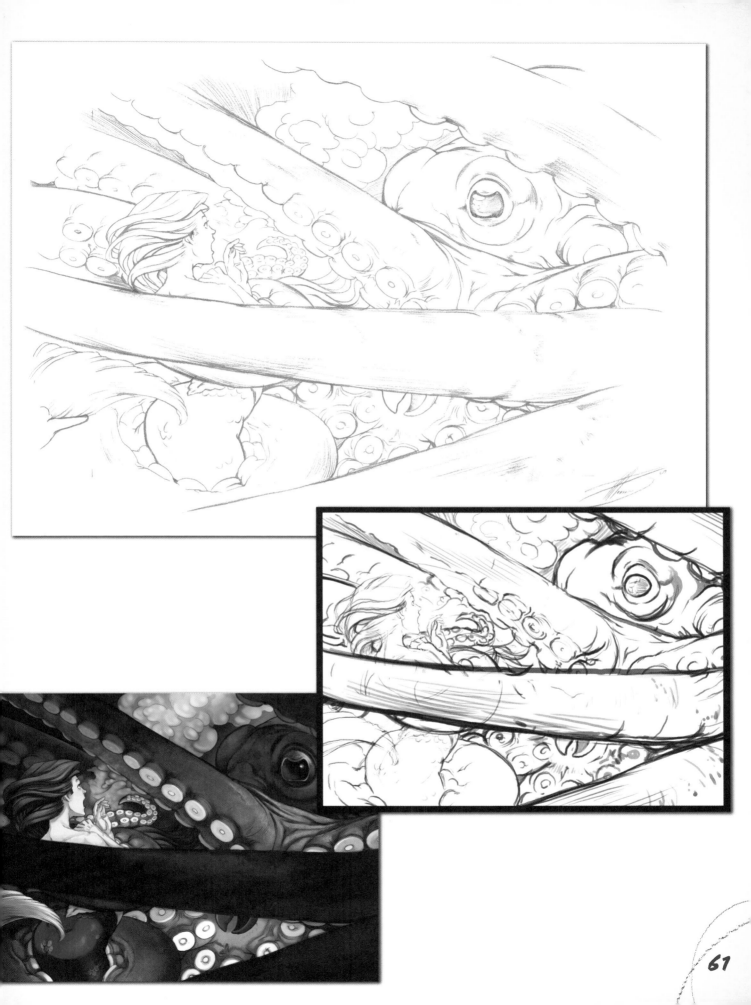

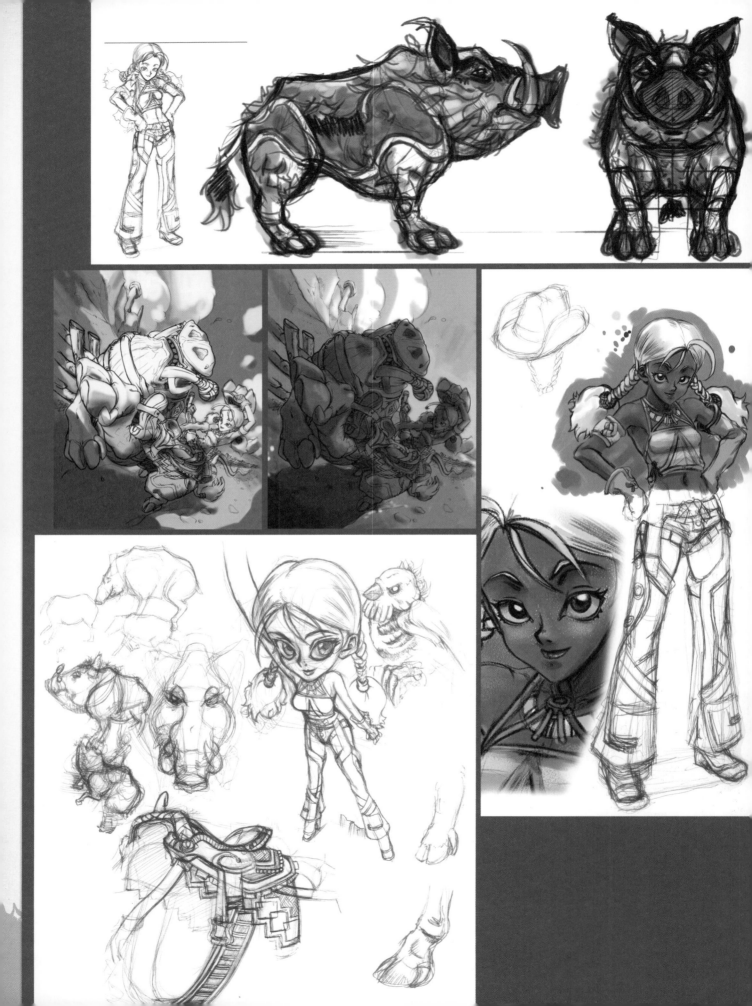

I almost always sketch in the morning, before I'm entangled in any projects. But I also sketch throughout the day, whenever time allows. Morning drawings are more about skill building and rehearsal, whereas afternoon sketches are generally observations or ideas that come throughout the day. I'll also sketch for half a day or more if I'm trying to develop an idea for a project.

What's going through my mind while sketching depends on my goal for the session. For instance, if my goal is to capture a body in motion, I might think about what a particular pose is saying, and then try to portray that through the fundamentals of gesture—overlap, line of action, expression, etc. However, if I'm trying to work out a complex idea, I might start with the theme and explore symbols or representative objects. Then I move into composition before drilling down to character placement and gesture. Other times, when I'm less goal-oriented, I'll practice drawing figures and faces from different angles.

There are quite a few reasons why I sketch. For one, it's a process of scrutinizing a subject. It's useful in systematically breaking something down and figuring out how to reproduce it. Sketching is also interpretive. So, in the way a writer uses the written word to capture an idea or crystallize a connection, I'm doing the same thing when I sketch, albeit visually. I'm testing ideas on paper, and as a bonus, these tests are simultaneously cataloged. It's easier to flip through ideas rendered in a sketchbook than to recall a faded memory. In that way, sketching becomes a visual to-do list and a how-to list of instructions for building complex imagery. It's practice, and then some.

From the moment we open our eyes, we're bombarded with visual information, but we rarely think about what we're looking at. I find that even with familiar objects, it's hard to recall anything besides scant details, like color or general shape. Sketching from observation is a sort of visual, analytical process playing out on paper. I often notice things while sketching that went unnoticed during years of casual observation. Since it takes time to re-create an object, person or setting in detail, your eyes and brain have plenty of time to discover aspects that you'd never notice in a typical, cursory observation. That's the power of sketching—observation, scrutiny and interpreted representation that reveal a greater understanding of the world.

Sketching isn't about creating a polished product. Like notes or a rough draft, it's incomplete and open to revision and reinterpretation. I can take risks in a sketch that

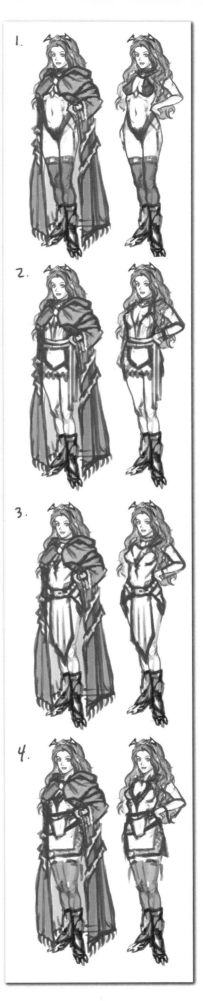

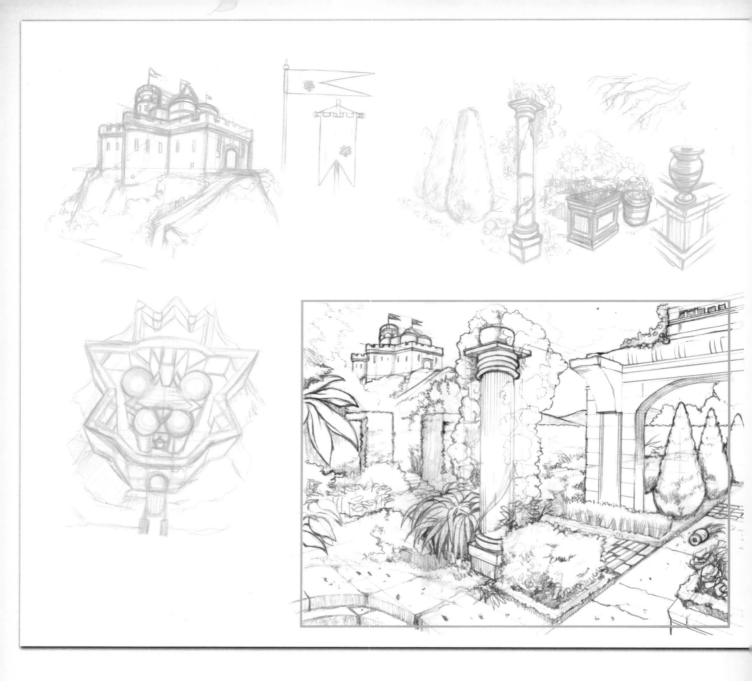

It's easier to flip through ideas rendered in a sketchbook than to recall a faded memory. In that way, sketching becomes a visual to-do list and a how-to list of instructions for building complex imagery.

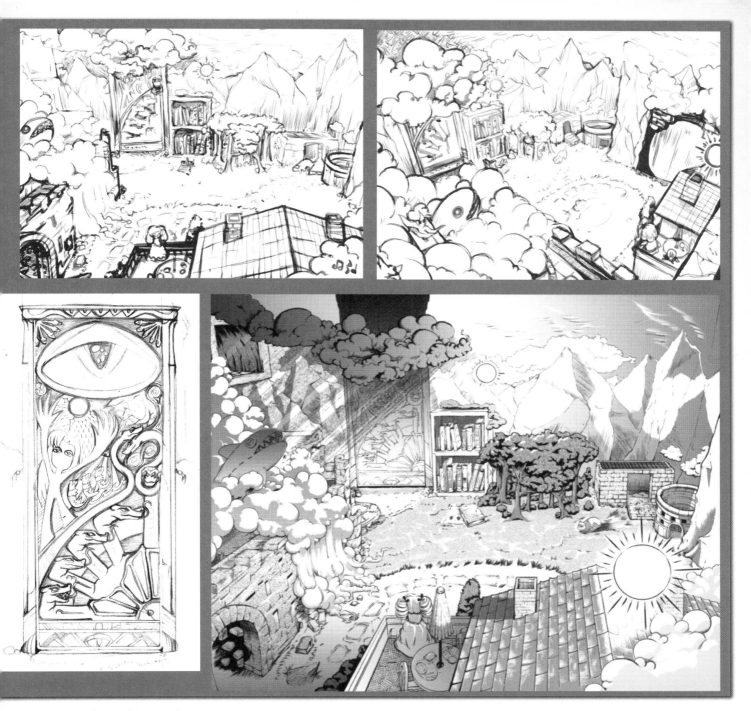

are hard to justify in a full-scale drawing or painting. Since sketching is practice and often private, it gives me license to try new things (like working in an unfamiliar style or reproducing a photo).

My sketches are the early draft, notes, and scaffolding for the finished work. They contain the germ that sprouts and grows and becomes the final art. Where I can see the potential in a rough sketch, it may take several passes before the image is refined enough to communicate its meaning to others. In that way, sketches are the raw essence of art.

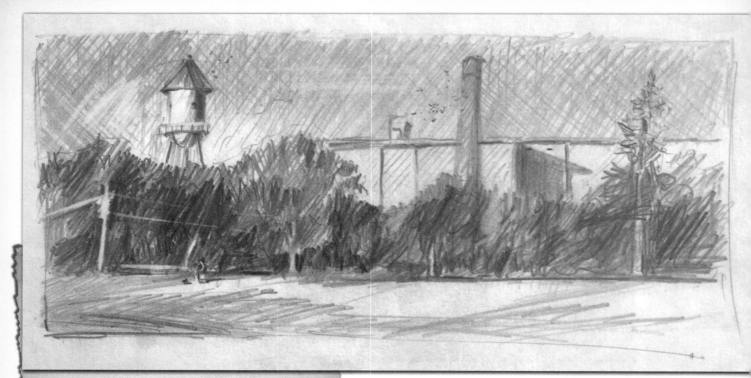

Russell Jewell

Russell Jewell has appeared in North Light Book's SPLASH best-of-watercolor series five times. He received his doctorate degree in art education from the University of Georgia and has taught high school and college students for nearly thirty years. Passionate about painting outdoors, Jewell has competed in many plein air competitions across the U.S., and he holds a patent for the Jewell Box Viewfinder, a compositional tool for plein air painters.

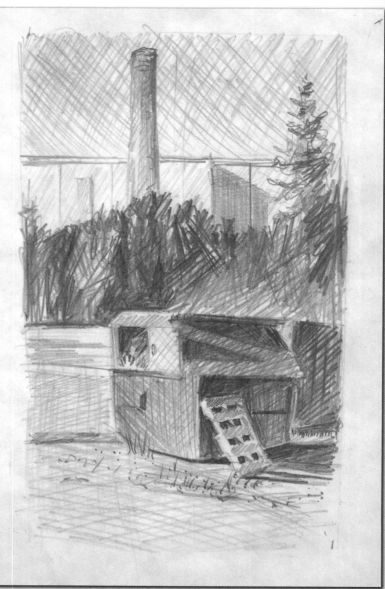

I do a lot of plein air painting, and one of my efforts in sketching is to discover what I would call the "fingerprint" of objects I paint most often. Therefore, I work at sketching objects in a composition, like people in motion, cars on a street, buildings in perspective, landscapes, atmosphere, and so on. Even though in plein air I am attempting to paint what is in front of me, I find it simpler if I have approached drawing the object at some time in the past.

I am not a habitual sketcher, but I envy those who are. I think a sketching habit is a lot like an exercise habit (at which I am also not good). I do find myself utilizing sketching as a warmup, especially to plein air painting. When I refer to sketching as a warmup, I am speaking of a simple yet full value sketch. If I am sketching in watercolor, I first tape the boundaries of the composition to create a hard-edge finished look. I prefer simple compositions to drawing single objects.

I like to sketch when riding in a car as someone is driving. This exercise requires me to respond to a glimpse of an object and then problem solve by placing the object in a simple composition. With these drawings, I am doing a value study out to the edge of a square or rectangle, which requires me to deal with negative space around the object as well.

I will also sketch from photos, but with a photo, I try to push a main emphasis and downplay everything else in the composition. The issue with photographs is the fact that everything in the photo is usually equally focused. When sketching from the photo, I try to "improve" the image as an art composition by creating a main emphasis through value contrast, size and texture, while diffusing the rest of the composition.

I am trying to create an atmosphere when sketching. Being a watercolorist is very much akin to drawing,

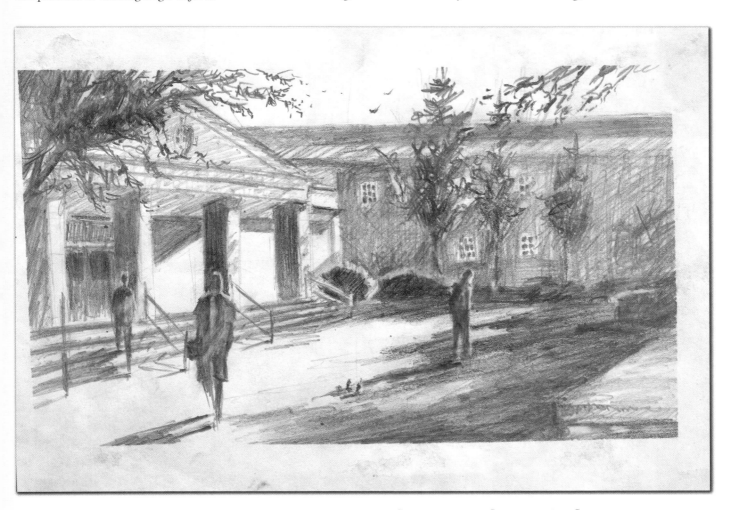

It is the sketchbook that houses most of the "work" for a work of art.

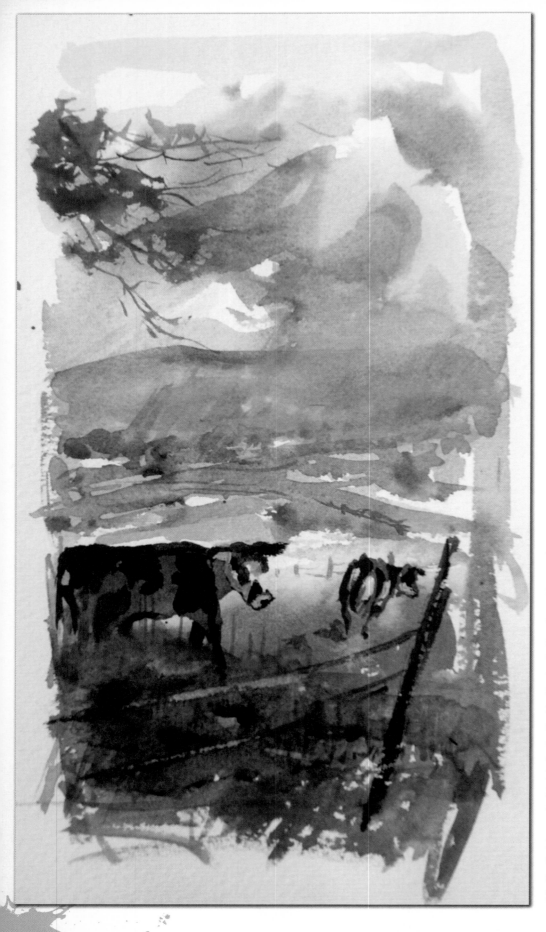

especially with a crosshatching technique. When I am drawing, I think of saving the white of the paper and then laying down a first hatching that is much like an initial wash in watercolor. As I progress through the drawing, each layer of crosshatching is like the next wash in a watercolor, until I am finally adding the darks at the end of the drawing. This sketching/watercolor relationship is what I find helpful as a warmup to plein air painting.

When sketching, I feel confidence coming from a better understanding of the object and the atmosphere that I am exploring. I remember a past student who drew horses like no one I knew. As I got to know her I discovered she loved horses. She rode horses. She fed horses. She cleaned horses. It was no wonder that she could draw horses because she knew horses. This is what I am trying to do when I am sketching. I am trying to get to know the object better. What is its form? What happens when light hits it from one side? What is its "visual fingerprint"? What fingerprint allows the viewer to recognize my sketch as the legitimate object?

The benefits I receive from sketching are numerous. First, I gain the confidence of understanding the object. Many times this benefit is gained from sketching from both real life and photographs. Secondly, if I am sketching from life, I am creating a record of a moment in time, much like a plein air painting. I would like to think a sketchbook becomes a legacy of someone's visual approach to life.

I suppose if you were to take a stranger's iPod and listen to their choice of music, then in some way, you would feel you "knew" that

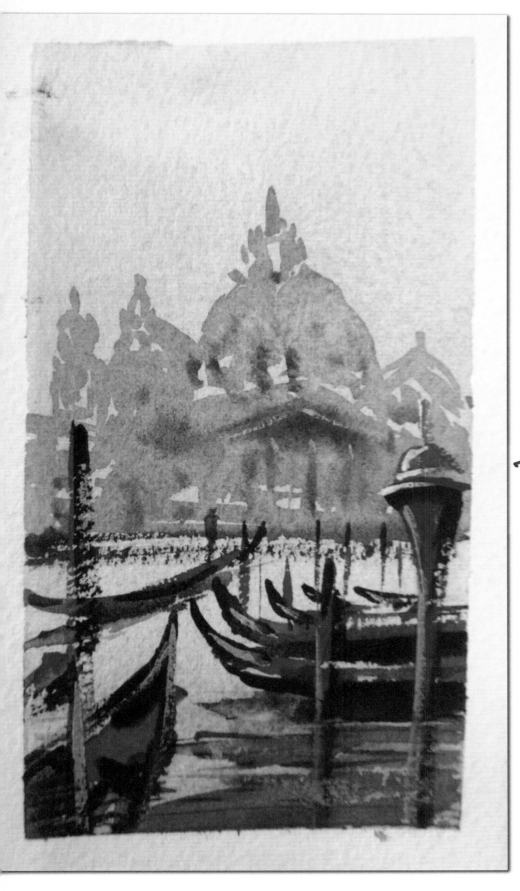

person. If you read the poetry of this same person, you would feel you had an even deeper understanding of them. Personal poetry seems to be akin to a sketchbook, which is essentially a personal visual record of someone's thoughts and interests. Sketching is a visual form of a personal exploration of the world in which we live. As the artist, we better understand our personal world. As a viewer of someone's sketchbook, we have a better understanding of this fellow human world traveler.

My sketches are the birth of ideas. The exploration of potential. The rough draft of a final product. The final product is not called a "work of art" for nothing. It is the sketchbook that houses most of the "work" for a work of art.

R Jewel

Dory Kanter

Chronicling "impressions with quick sketches and visual story-telling" is an everyday practice for Dory Kanter, whose best-selling book ART ESCAPES provides daily exercises and inspirations for artists, to help them build confidence and cultivate creativity. A resident of the Pacific Northwest, she leads painting and journaling workshops and is a passionate advocate of art in the schools. With grant funding, Kanter has developed innovative art and literacy curricula for high school students, and she has lectured at Yale University about the importance of creativity.

The greatest gift of sketching is how relaxing it is—relaxing and exhilarating at the same time. My internal art critic goes on vacation, and I am playful and don't worry about results.

Journaling is how I breathe as an artist—a way to celebrate a place, a moment, a conversation, a sensation. Journaling provides me with private moments that ground me, comfort me and inspire me. I find myself revived by the replenishing solitude of journaling.

When traveling, I sketch all the time, basically whenever I sit still long enough to get out a pencil or pen.

My habit, when at home, is to sketch as a way to reflect about each day. Most evenings, I create a whimsical journal page by making a 4" × 4" (10cm × 10cm) abstract drawing, quickly sketched with black Cray-Pas (oil pastels). I add watercolor accents and finish with a six-word summary of the day, handwritten underneath. This practice usually ends up making me feel grateful for something each day, even on a day with lots of challenges.

When sketching, I often ask myself, "Why am I drawn to this particular scene or subject? What exactly am I responding to?" I keep asking myself these questions and sketch to tease out the answers.

Creativity for me is "What if?" exploration. What if I use colored pencil on top of watercolor… and then scratch into the surface? What if I cut up two watercolors and weave them together? Let's find out!

Sketching is how I try out ideas, techniques, materials and compositions within the private space of my artistic journal. Quite often, these explorations find their way into my finished paintings. Or, they are the source of inspiration for a finished work of art.

The greatest gift of sketching is how relaxing it is—relaxing and exhilarating at the same time. My internal art critic goes on vacation, and I am playful and don't worry about results. It reminds me of when I was eight years old and discovered that mixing red and blue paint together magically created purple. It was an "aha" moment for me. This kind of magical moment continues to happen when I play around with materials, ideas and techniques in my sketchbooks. I try to bring that playfulness into my work, because I think it's the source of creativity, rather than skills or technical expertise.

I make value sketches to figure out how to interpret a three-dimensional landscape onto a two-dimensional canvas. I make color sketches to figure out the notes to the visual song I see before me. I make abstract sketches to crystallize impressions and feelings. Sketching is a

Couleurs

à Nice

à Cairanne

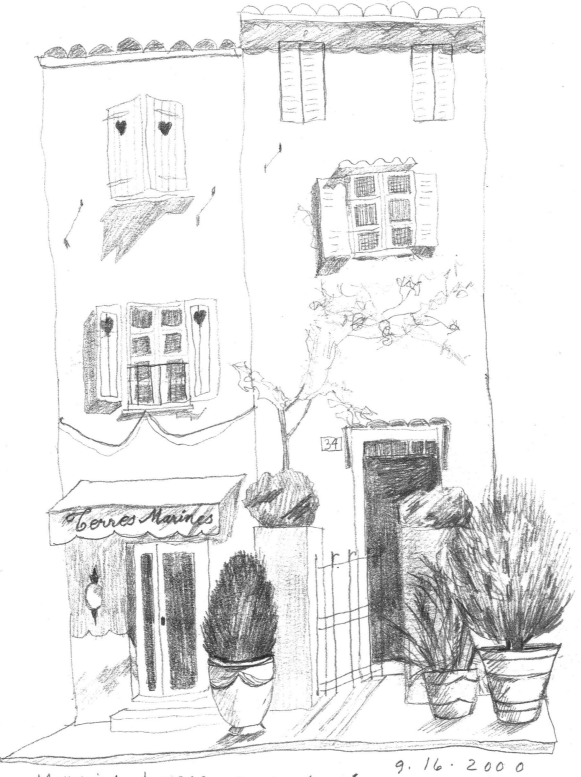

Mongins houses · · · · · 9. 16. 2000

language; I use this vocabulary to cultivate my curiosity for the everyday, awaken my senses and gather together scattered thoughts and impressions into a coherent whole.

I use my sketchbooks as a cache of remembrances. I mine the pages for images and ideas to develop into larger pieces. I always try to retain the fresh spirit of the original sketches in the larger works and refer to them as a touchstone.

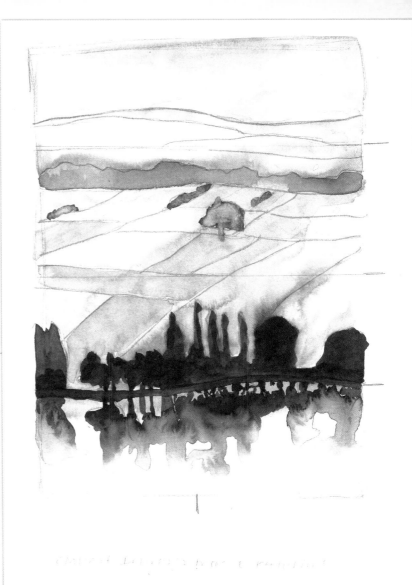

Maui Memories

Water Reflections

Leaf Patterns

Bougainvilla

Tropical Fish Detail

Hillside Up country

Kanaha Beach

David N. Kitler

Ever intrigued by nature's intricate details, artist, teacher and conservationist David N. Kitler has two objectives in his work: "to bring the 'wild' within reach of those who have not experienced it, and to provide a reminder to those who have." A member of the prestigious Society of Animal Artists, Artists for Conservation Foundation, and The Group of Twelve— comprised of some of the finest realist painters in Canada today—Kitler has received numerous best-of-show awards for his paintings, which reflect his extensive travels.

One of the biggest lessons I've learned is realizing that I can alter just about anything. I don't have to settle for the initial hand I might have been dealt, be it a photograph or a situation.

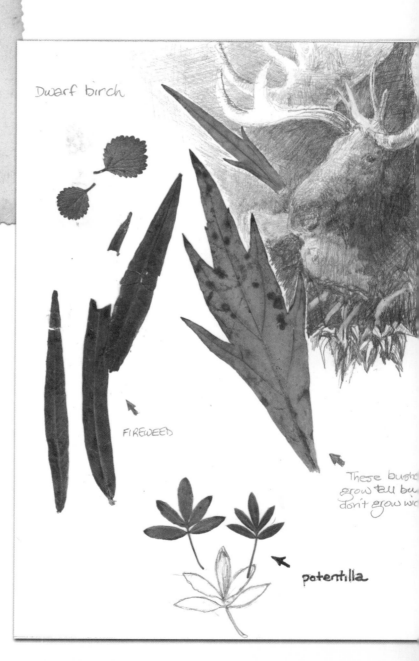

Dwarf birch

FIREWEED

These bush[es] grow tall bu[t] don't grow wi[de]

potentilla

When I was 17, my mother was killed (by my father), and I had to abandon my then-dream of attending veterinary school to work at a local factory. During the thirteen or so years I worked there, I spent EVERY free moment drawing. When others went out for a smoke during breaks, I sat down, pulled out a sketchbook and pencil, and lost myself for a few minutes working on a drawing.

Now, I don't necessarily sketch daily, although I find myself constantly doodling when I'm not painting. When I am traveling, however, that's a completely different story. I usually create a journal for each of my reference-gathering trips and will tend to use every spare moment to work on it and capture every experience.

For me, sketching and journaling are about the opportunity to look at a subject more closely. It's my way of getting "in tune" with the subject and its environment. If I am on location and am using sketches as a way to gather reference, it can be more about "dumping" as much of the visual input as possible onto paper. Then

Bison -
No reference
(doodle)

JUNE 24/97

White mountain avens?

Notice the changes of
colour on a single plant.

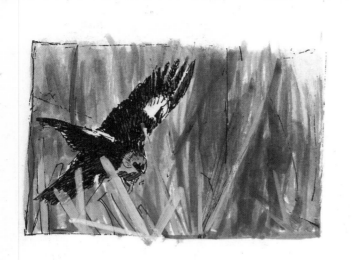

again, sometimes sketching is just a very enjoyable way to use some unexpected (and exceedingly rare) free time—for instance, when I'm at an airport waiting to board a flight.

I sketch when I am in the field, gathering reference. I also sketch prior to each painting, as part of its development, working on a potential image until I feel it is ready to become a painting. I also do a fair bit of sketching while demonstrating ideas to the students in my regular art classes.

Images can use up a lot of space in the brain (just look at how much space they take in a computer's hard drive). So it would be impossible for me to try to store and sort all the ideas that pop up using only my head. Sketching and journaling help me to move some of those images and ideas to paper, freeing my mind to notice new images and develop new ideas.

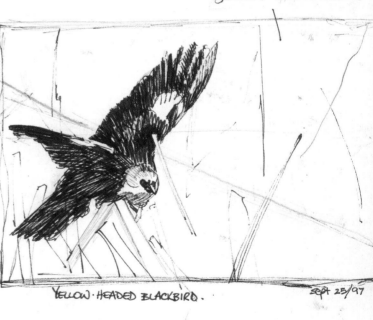

What colour background? gradation? – which direction?

YELLOW-HEADED BLACKBIRD. Sept 23/97

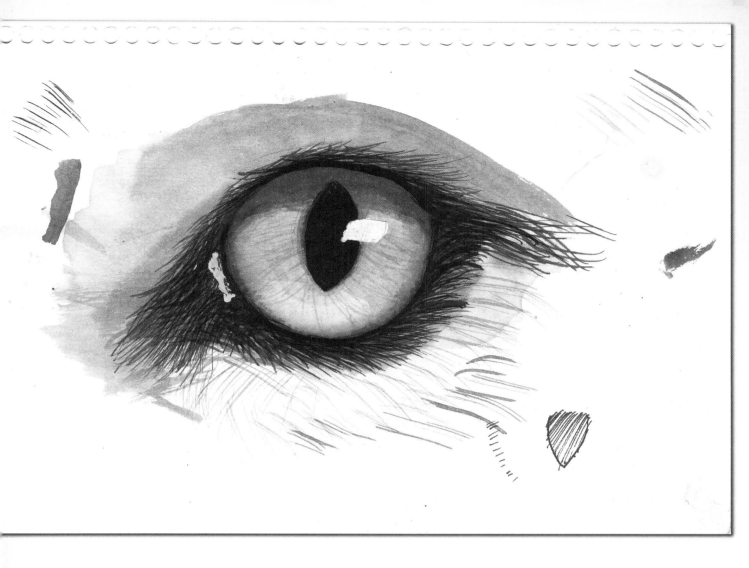

From an artistic perspective, sketching increases my familiarity with each subject. It creates a level of intimacy and a more personal connection. As there is nothing between the subject and me—no lens, no photographs, no barriers—I can develop a more direct association. Instead of just "imagining" something, I can visualize it by committing it to paper. From a physical perspective, sketching helps me relax and is a great stress-buster.

Sketching opens my eyes to things I might not have otherwise noticed. It also helps me to look at the world in its simplest form, its most basic elements.

When sketching, I might be thinking about capturing an initial impression. Or, I might be concentrating on a particular aspect of my subject or its environment (more like visual note-taking), be it colors, shapes, a mood, or a unique detail. I might also be thinking about design or compositional elements, or trying to work out how to take an illustrative or unique approach to that subject.

When sketching, I can explore and take more chances. I feel unrestricted and have more freedom to experiment. A sketch is art in its most pure and innocent form. When viewers look at a finished piece of artwork, they expect a certain level of quality and completion, but they don't place those same expectations on a sketch. They take sketches at face value. There is no "right" or "wrong" sketch, no judgment, so I feel less guarded.

One of the biggest lessons I've learned is realizing that I can alter just about anything. I don't have to settle for the initial hand I might have been dealt, be it a photograph or a situation. Also, sketching helps me to see that

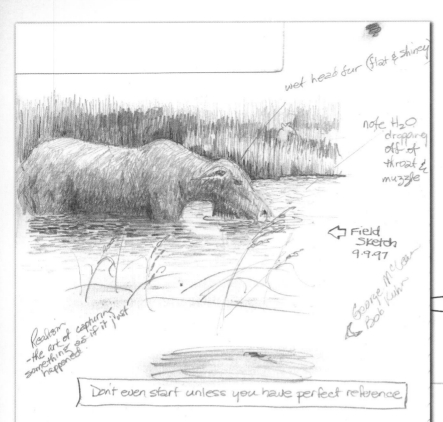

wet head fur (flat & shiney)

note H$_2$O dropping off of throat & muzzle

← Field Sketch 9.9.97

George McLean & Bob Kuhn

Realism - the art of capturing something as if it just happened.

Don't even start unless you have perfect reference

my first idea is not always the best one. When I was in art college, we were not allowed to start a project until we had done at least ten sketches. Good design involves planning. Through that process, we worked out a lot of the problems or faults with an idea before we committed to working on the final piece. I still believe that this is a sound approach to art and to life.

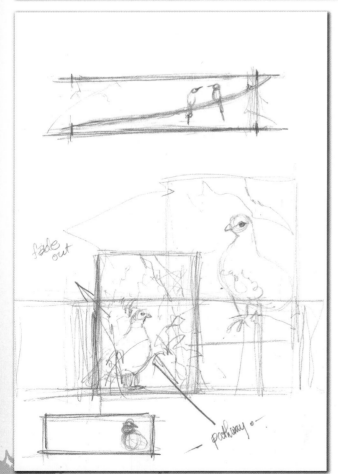

fade out

pathway

4. 5&9

Vultures (in pencil) ——— leading to vultures in colour?

fog in background

2/3

1/3

Get away from green!
reverse print.

work with water as important element

Get away from green!

work with water as important element

1/3

2/3

wate = key

Nita Leland

After graduating from Otterbein University, Nita Leland lived with her husband, Bob, in France for eighteen months. Returning to Dayton, Ohio, she started painting watercolors while raising four children. Leland's greatest joy is teaching. She has developed student-centered workshops and books on color, creativity and collage for the practicing artist and teacher, as well as the novice. She is in demand throughout the U.S. and Canada as an artist, teacher, lecturer and exhibition juror. Nita is the author of several best-selling art instruction books, including CONFIDENT COLOR and NEW CREATIVE COLLAGE TECHNIQUES.

I usually sketch when I'm developing ideas or gathering information for a painting. Sometimes I isolate details to help me better understand a subject, even though I may not use them in the painting. Now and then, I just doodle for fun.

At one time I sketched daily, but teaching and writing take up most of my time now, so I don't sketch as much as I used to. I tell my students they should sketch incessantly to improve their drawing skills, which I used to do myself. (I should take my own advice.) Now I use sketching more for information-gathering, but this is still very useful in my creative process. The more information I have, the more creative I can be when I do the work.

If I'm sketching ideas for a picture, I'm thinking ahead to color and design possibilities. I'm project-oriented

and focused. If I'm doodling, my mind is a blank. It's almost like meditating—very relaxing.

I really enjoy the process when I'm not thinking of the sketch as a finished product. Sometimes I drift into a playful mood that generates a more creative direction than my original intention.

I learned from a friend who is an avid sketcher that it's important to get the image down and never to erase or tear up a sketch. A sketch captures a moment that may never be repeated. Our memories don't hold the detail that can be captured in a quick sketch on site.

Sketching helps me to see things I might miss with a casual glance. When I look through old sketches from my files, the moment when I made the sketch comes

back to me. I guess you could say sketching helps me to appreciate my current situation and later to relive that moment in my past.

A sketch doesn't have to be perfect. You can do anything you like with a sketch, because you assume no one else will see it. The feeling of freedom is invaluable. Unfortunately, the spontaneity in the sketch is sometimes lost in the finished art.

How my sketches relate to my finished work depends on the sketches. Some initiate new ideas for paintings or collages, and others provide information to help make an artwork more convincing. I often go through my sketch file, using the sketches as prompts for future work. I have favorites that I return to again and again, such as my green pepper series.

Nita Leland

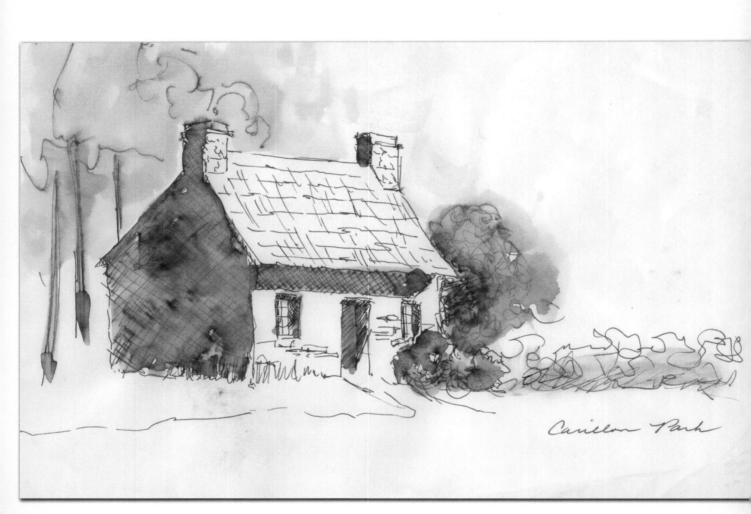

You can do anything you like with a sketch, because you assume no one else will see it.

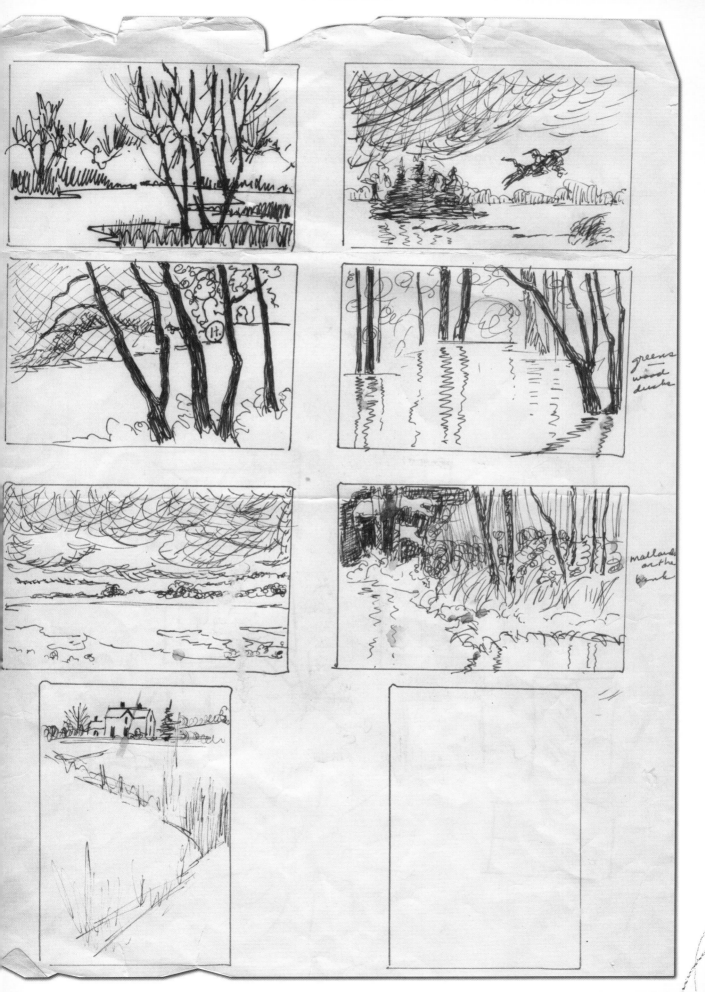

greens — wood ducks

mallards on the bank

85

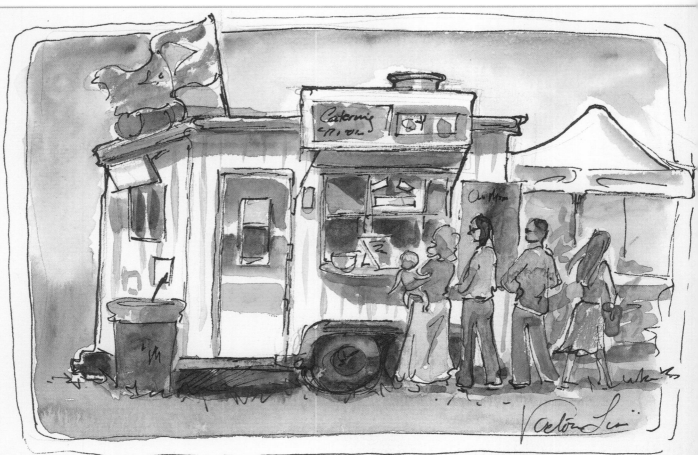

9-19-09 Sustainable Living Fair

Victoria Lisi

Victoria Lisi is the author of VIBRANT CHILDREN'S PORTRAITS: PAINTING BEAUTIFUL HAIR AND SKIN TONES with Oils, and has illustrated children's picture books and numerous book covers. She teaches watercolor, painting and drawing at Aims Community College in Loveland, Colorado, and she also taught illustration for six years at Western Connecticut State University. She sometimes collaborates with her husband, Julius, a portrait and landscape artist. Aside from creative projects, Lisi enjoys photography, hiking, reading and swimming.

Trying to draw or sketch something helps you appreciate the incredible complexity and subtle nuances of a subject.

The visual beauty of people, places and animals always inspires me to sketch. I also love to sketch from my imagination. It's particularly nice to sketch outside in Colorado on a pleasant day. It's hard to beat that.

I sketch several times a week. I go to a life model session that meets once a week, and I go plein air sketching or painting when weather permits. I sketch for my class demos. I frequently work out ideas from my imagination.

When sketching, I think about what I am drawing. I ask myself questions about the subject, such as how does

that line curve, or how dark is that? But often I go into a pleasant zone where I just draw without thinking. I find it very relaxing, and I'm grateful for the beauties of nature.

Sketching trains your eye and helps you be a better artist, but I also think it trains you to notice and appreciate the natural world. My students are always amazed at what they start to see once they draw something—the rough texture of tree bark, or how hair sometimes falls into curving shapes.

Jennie Thompson

9.28.01

Trying to draw or sketch something helps you appreciate the incredible complexity and subtle nuances of a subject. I think it helps you go beyond concepts and see what's really in front of you. I see in terms of drawing and painting, and appreciate everything more. There is an amazing divine artistry to the world of form.

Compared to working on finished art, making sketches is more flowing and fun. I prefer to do more finished sketches and let them stand alone, or very loose sketches that I will rework as a painting. I don't like redoing things because I lose the spontaneity. I've noticed that I lose my enthusiasm if I redo the same subject matter. I enjoy letting the sketching take over and seeing where it leads.

Victoria Lisi

Laurin McCracken

Once an architect and marketer for architectural and engineering firms, Laurin McCracken now makes a career of watercolor. He says his travels past and present have benefited his art. "While I came to watercolor painting late in life, as an architect I have always carried a sketchbook," says McCracken, from his Mississippi Delta studio. "One time I sketched the backs of the heads of thirty engineers in a meeting with a railway in southern Japan, another time I sketched the Sphinx and the pyramids outside Cairo, and on other trips, I did the sketches in this book."

The primary benefit of sketching is that you never remember a place as clearly as when you have drawn it.

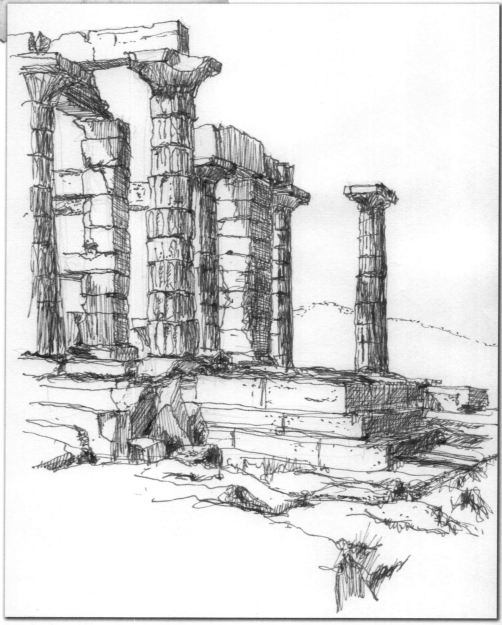

Temple of Poseidon, Sounion, Greece

Interior, Bath, England

Palisades, Nafplion, Greece

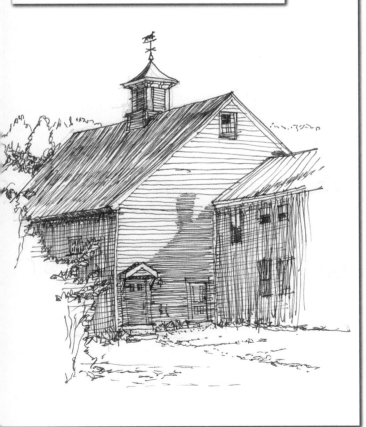

Barn, Hancock, New Hampshire

Town Center, Nafplion, Greece

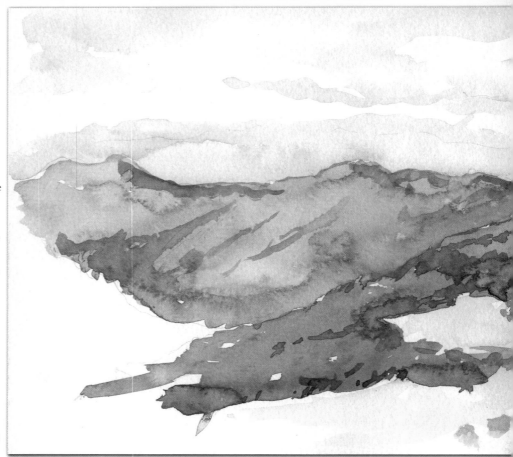

I try to draw often; sometimes it has been just the glasses and service ware on the table at a lunch meeting. *Interior, Bath, England* was drawn during a meeting in the town's conference center, which thankfully was a very rich interior space full of history and detail.

I usually sketch when I travel. I am a studio painter, and the sketches I make related to my complex paintings are very different than the ones I do on the road. *The Bay at Nafplion* and *Temple of Poseidon* are examples of making the time during travels to record a site and remember the experience.

One of the benefits of sketching is both being in the moment and being a part of the continuum at the same time. While the sketch of the barn in Hancock, New Hampshire, is about recording a historic structure, it is also about seeing how the sun falls across the wall of the barn and how the light shapes the cupola of the barn.

I come away from making a good sketch feeling rested and exhilarated. The times I prefer are the times with a glass of wine in a lovely piazza, surrounded by ancient buildings bathed in late afternoon sun, such as in the Town Center at Nafplion, Greece. While creating the view of Balquhidder, Scotland, the ancestral home of the McLaurin clan, I got so caught up in the moment that I did not notice it had started to rain until I realized that my sister was holding an umbrella over me.

I am quite the realist and work very hard to capture things as I see them. However, the sketching method I use most frequently does allow me to filter out the "noise" and concentrate on what makes that place special.

The primary benefit of sketching is that you never remember a place as clearly as when you have drawn it. What you have drawn becomes a part of you. While I can remember clearly a few photographic moments—when I took what I knew was going to be a terrific photo—I can remember almost every time I stopped and did a detailed drawing of a place.

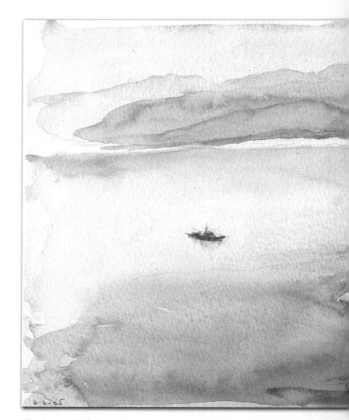

The Bay at Nafplion, Greece

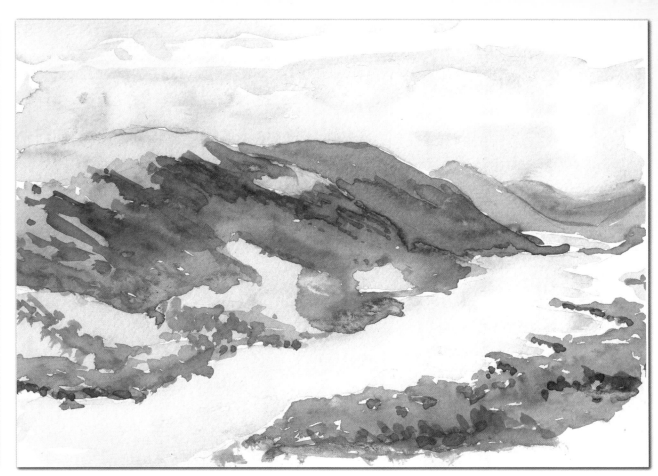

Balquhidder, Scotland

93

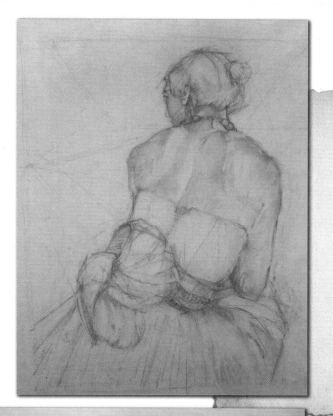

Sydney McGinley

Designated as a Master Pastelist by the Pastel Society of America, Sydney McGinley focuses on the human form and enjoys soft pastels for allowing her to draw and paint simultaneously. Her work has won many national and international awards, is collected in the U.S. and Europe, and has appeared in THE PASTEL JOURNAL and books including A PAINTER'S GUIDE TO DESIGN AND COMPOSITION, PURE COLOR: THE BEST OF PASTEL and STROKES OF GENIUS 3: THE BEST OF DRAWING.

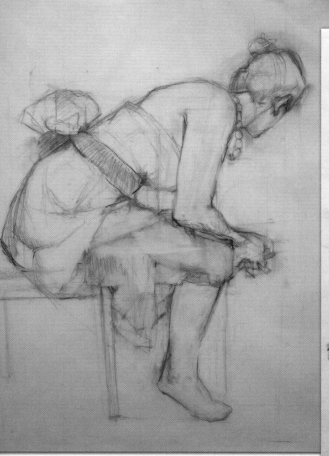

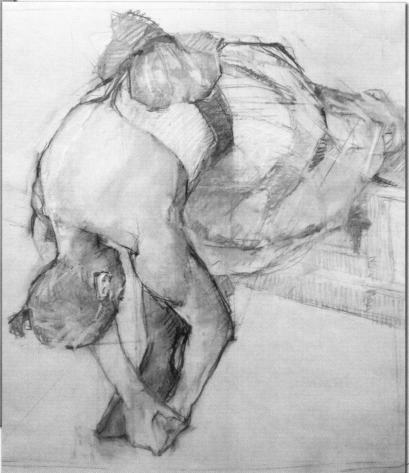

My work for several years has focused on the female figure. I work usually in a series; initially, one particular pose is chosen from a series of similar poses. I endeavor to develop that image by creating a large gesture drawing on paper or tracing paper, using charcoal, Conté pencil and erasers. I look for strong directional lines, arabesques and enclosures, applying lines of varying weight, and then, finally, I consider these resulting relationships. In an attempt to unify and simplify, I limit the marks to those important ones. My goal at this time is to achieve technical harmony in the drawing, as well as a harmony of intellect with individual expression. My emotional response is naturally mine alone, but it is paired with the respect and integrity the act of drawing deserves.

While developing a drawing, I am anticipating the heightened awareness that comes with discovery. It's an initial response to new material and a time of direct communication with the subject, a dialogue with known boundaries. I choose quiet solitude at this moment because of a need to achieve acute awareness of an ongoing rhythm that occurs with mark making. In addition to being mindful of the technical choices of marks, I'm looking for a truthfulness in the subject matter balanced with a vitality in expression. These drawing sessions are complete within two hours; any longer and they might be overworked.

Drawing provides me with an honest expression that may not appear in the finished work. I am equipped with tools from my education to make those marks that are mine alone. This exercise of searching through drawing allows me to forget that I am me. When I examine what I have done, it's as if another being was in my studio.

Some of these large drawings will be framed and shown with the corresponding pastel paintings. They are separate entities.

If I am satisfied that an image merits further development into a painting, I will continue with my next considerations, which are composition, value and color.

Thumbnail sketches in 7" × 5" (18cm × 13cm) format follow. These are designed first on tracing paper, then drawn on pastel paper for value and color choices.

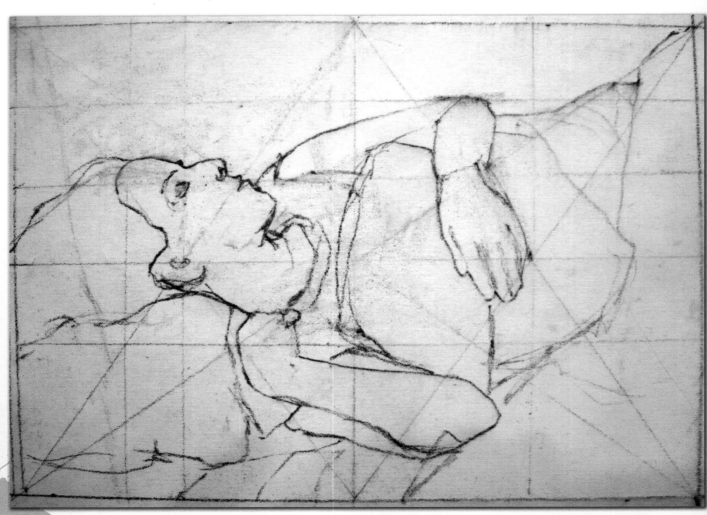

Usually a few thumbnails are developed. I try to keep the freshness in the finished piece that I found in the quicker thumbnail. Here I can work out some of the problems that may arise during the painting.

Excellent work completed by other artists inspires me to achieve my very best. We are attempting to solve the same problems, regardless of the decades or centuries separating us. I tend to be directed to the drawings made by other artists; they provide more information about the creator than a highly finished work. Drawings are a form of naked scaffolding that allows viewers access to the thinking process of the creator.

There are days and weeks that my studio easel stands in solitude, a witness to a life that is sometimes too full to allow time for the dialogue between pencil and paper, the essential form of expression for developing new ideas—ideas that spill one onto the next, and then inspire additional possibilities. However, when away from my tools, my mind is actively creating. This break from making actual marks allows for another separate and distinct form of inspiration, which often proves just as essential.

Sydney McGinley

Drawings are a form of naked scaffolding that allows viewers access to the thinking process of the creator.

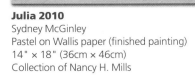

Julia 2010
Sydney McGinley
Pastel on Wallis paper (finished painting)
14" × 18" (36cm × 46cm)
Collection of Nancy H. Mills

Mark e. Mehaffey

Mark Mehaffey's vibrant, energetic watercolors have earned him the American Watercolor Society Medal of Honor and a spot in three Splash best-of-watercolor series books. A long-time public-school teacher, Mehaffey has dedicated much of his time to nurturing young people's love of art while demonstrating his own. The author of CREATIVE WATERCOLOR WORKSHOP, Mehaffey lectures and teaches workshops throughout the U.S. when not in his Michigan studio. In his spare time, the artist is inspired by, among many things, fishing and family.

Sketching has taught me that it's all about balance—between planning everything out and following that plan, but also allowing for hidden surprises and spontaneous happenings.

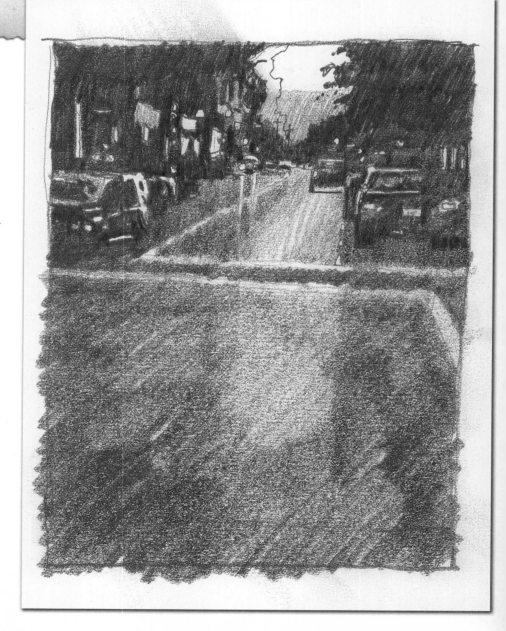

Art is about ideas and communication, and the sketch-book is where it all begins. My sketchbook is my place to check on ideas. I may be inspired by an unusual combination of shapes, the value contrast between light and shadow, figures in action, or any number of other interesting visual ideas, but my sketchbook is where it all begins.

Some of my work is more intuitive and begins with paint on paper or canvas and goes from there, but practically all of my representational work begins in my sketchbook. I do my best to decide what is my main idea (that determines the focal area), what are the shapes and how do they fit together (the design), and how light or dark is every shape (the values). Everything is simplified, assigned a value based on importance, then evaluated. If it looks good and can be easily read in my sketchbook, then I do the painting based on the sketch. If it is confusing or does not fit with my original idea, I redo the sketch until it works. This often means many drawings of the same idea.

When I sketch, I think about making a good design that fits with my idea. Most of the time I lean toward an interesting design, but I will sometimes have a bit of an awkward design if it captures the content I had in mind.

I see the world as a collection of shapes. As an artist I get to eliminate some, add some, rearrange some, decide on how light or dark they will be, and decide on their color … such power!

Years ago I would jump right into a painting as soon as I got an idea. This would occasionally result in a decent painting, but not as often as I would have liked. When I started planning first and working out where the shapes went, how they fit together, and how light or dark all the shapes were, then my success rate really went up. Sketching is absolutely worth the time. It is so much easier to see if an idea is going to actually work for a painting via a small sketch than to invest lots of time on a painting and then realize that it just doesn't work—and sketching is way more economical!

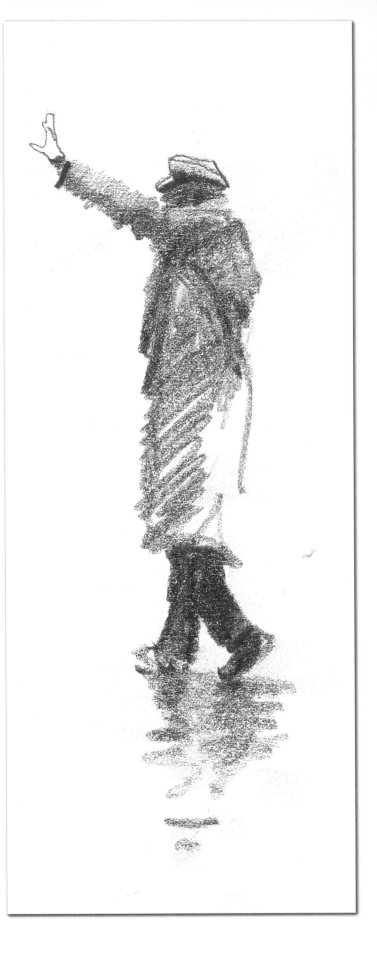

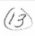

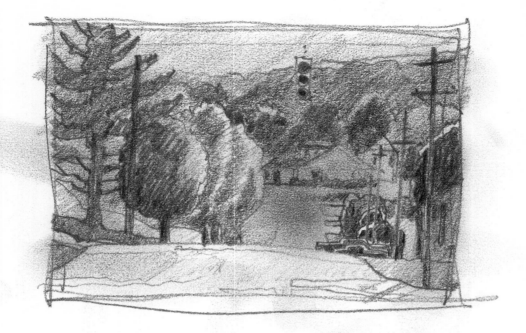

For me, my sketches are fairly close to what I envision for the finished painting. I want to SEE it first in my sketchbook; if it works for me, I paint it. The painting is usually a good match to the sketch—usually.

Sketching has taught me that it's all about balance—between planning everything out and following that plan, but also allowing for hidden surprises and spontaneous happenings. Life and painting are just like that (so is golf!).

Mark E. Mehaffey

AN ARTIST CREATES HIS OR HER OWN REALITY... THE WORLD IS THE WAY IT IS, WE MAKE IT THE WAY IT SHOULD BE.

"The tree on the right was straight from a student's photo reference," says Mehaffey. "The one on the left shows how I made it more interesting than reality."

Since our language is not written, my art serves mainly as a conduit for handing down old family designs from one generation to another.

Virgil Ortiz

Born into a family of renowned American Indian potters, Virgil Ortiz now exhibits his own sought-after clay works worldwide, including at the Cartier Foundation in Paris. "I didn't even know it was art that was being produced while I was growing up," says Ortiz, who remains with his tribe in Pueblo de Cochiti, New Mexico. The patterns and designs in his works, which extend to home décor and fashion—he recently collaborated with designer Donna Karan—combine tradition with a contemporary edge, revealing the influence of his culture and his desire to preserve it.

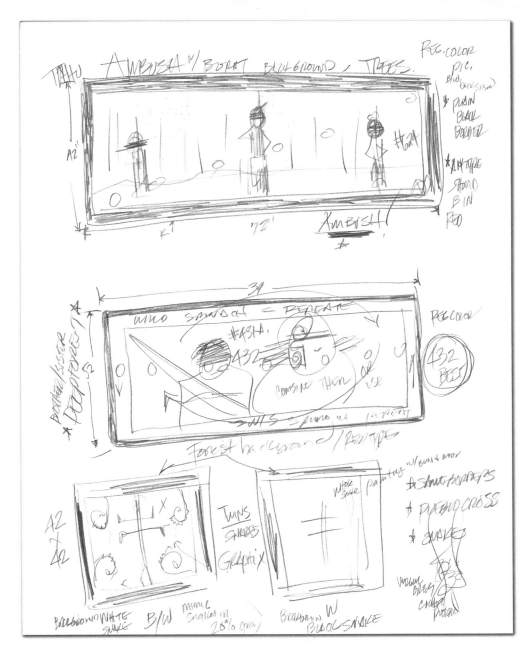

When I sketch, my mind is racing at such a velocity—I try and jot down as much and as quickly as I can before I move on to the next thought.

Sketching actually allows me to troubleshoot designs, patterns or framing a photo shoot before I attempt creating anything. I usually sketch in the midnight hours, when the Pueblo is quiet and resting. If not then, it's usually sitting on a plane with headphones cranking.

In Pueblo de Cochiti, our ceremonial regalia and pottery designs are a huge part of my inspiration. Since our language is not written, my art serves mainly as a conduit for handing down old family designs from one generation to another.

If it's clay works I am sketching, I try and envision the historic pottery designs and revive, rearrange and bring my own style to them. If it's fashion, photography or jewelry, I usually let all the mediums I work in influence one another.

My sketches are a blueprint for my nieces and nephews on how I create a pottery figure's stance, and hopefully these sketches will stay with Pueblo de Cochiti's generations to come.

VIRGIL
ORTIZ
COCHITI
PUEBLO

RUNNER TRYPTICH ALL RED!!

SIDE VIEW #32

#49
S-

DANIEL PROFILE #.

32.(F)
49.(S)
11.(SL)

#11

LEFT VIEW

OUTLINE OF
PARTIAL FACE.
PS ON TOP.

WITH NO BORDERS + COPY
—'BLACK BAND',
BLEED INTO EDGE
① CLIP CORNERS

ALL 4½"X4½"

SCRIPT ON EITHER
SIDES

USE PHOTO "BACKGROUND OF SWEEPS"

VORTA

COCKPIT
PLANE

LAST SHOOT — FINALS. RUNNER RIGHT 32
49
11

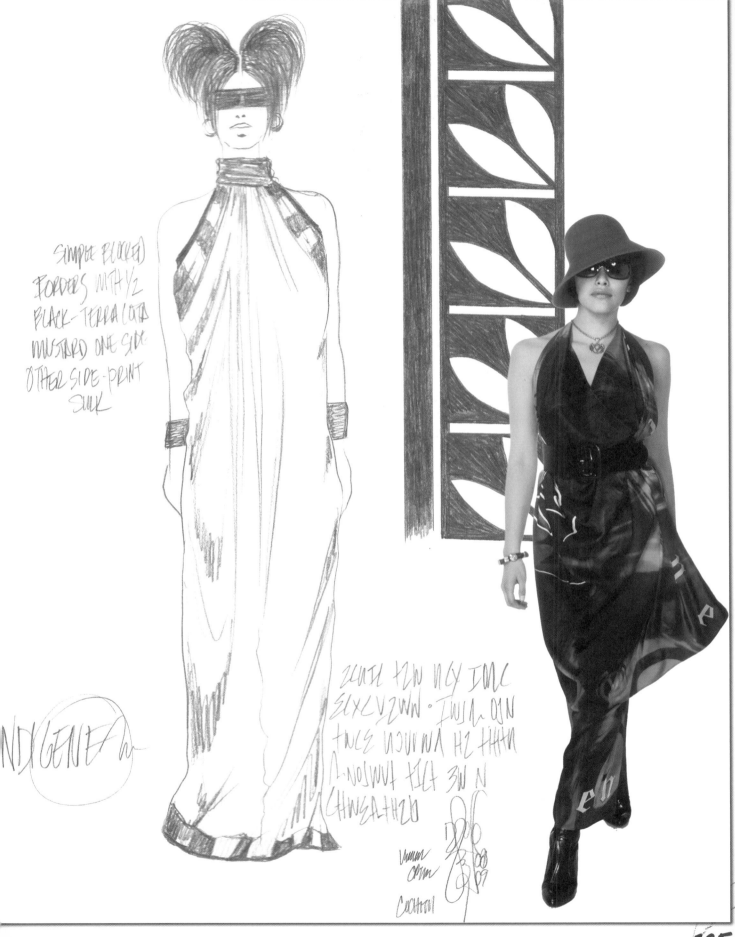

SIMPLE BLOCKED
BORDERS WITH 1/2
BLACK-TERRA COTTA
MUSTARD ONE SIDE
OTHER SIDE - PRINT
SILK

NDIGENE

105

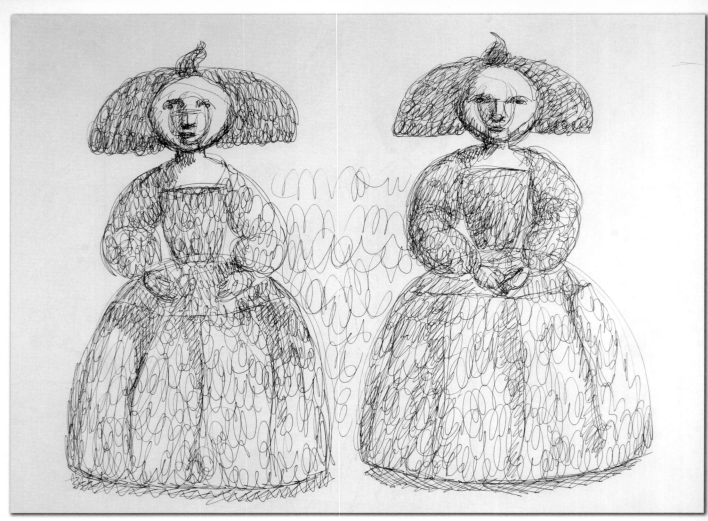

(All Pérez photography by Barry McCormick)

Santiago Pérez

A whimsical world of fantasy awaits in the paintings of Santiago Pérez, whose boundless imagination comes to life in his New Mexico studio. The Texas-born artist served in the Air Force for twenty-four years before retiring to Albuquerque, where his works can be found in the National Hispanic Cultural Center and the Albuquerque Museum of Art and History. Characters and creatures of all kinds interact in his paintings, which are mainly in oils, though Pérez works some in acrylic and various drawing mediums. His artwork has been published in three major books on Hispanic artists by the Hispanic Research Center at Arizona State University.

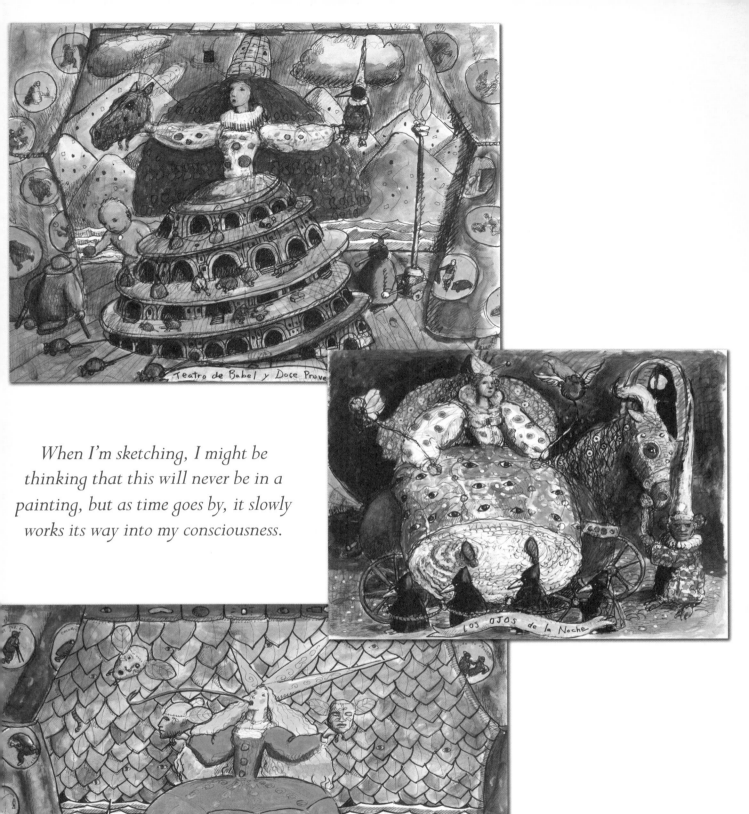

When I'm sketching, I might be thinking that this will never be in a painting, but as time goes by, it slowly works its way into my consciousness.

Teatro de Babel y Doce Prove

Los Ojos de la Noche

La Princessa delas Ranas PescaMoscas

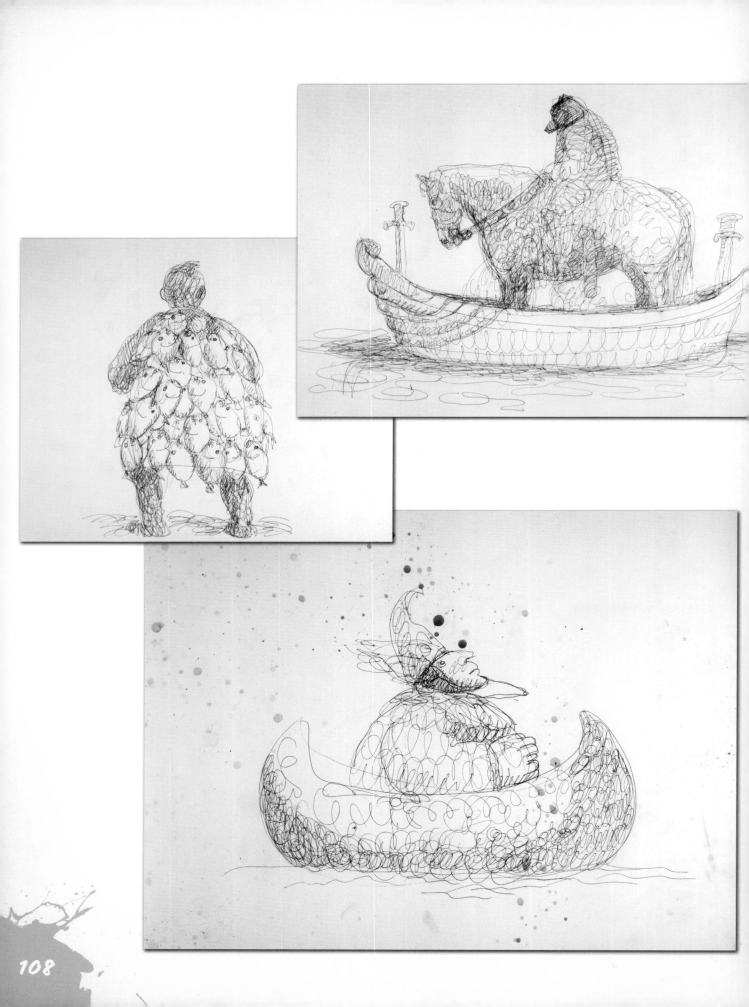

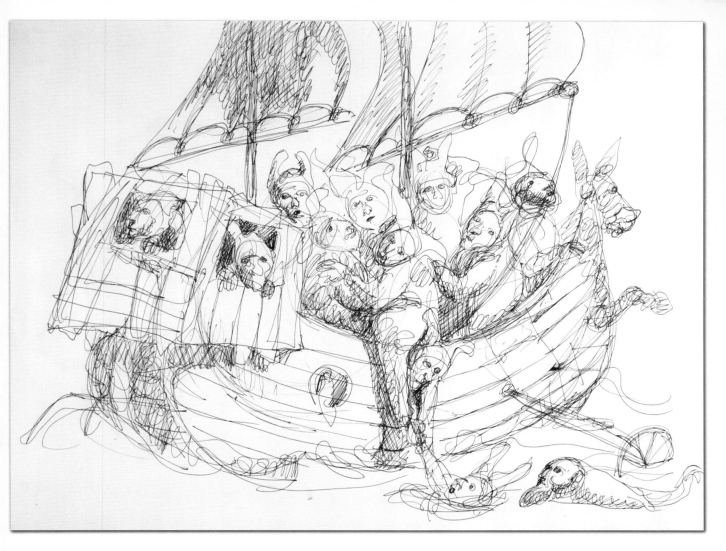

When I was a child, all I did was draw. It was a fantastic world to get into. After all these years, I can turn on that fantastic world just by drawing, on the canvas or paper.

Sketching or drawing is part of my painting process now. I draw on the canvas—to start and work out a painting—more often than on paper, but I still do some paper drawing just to see how something outlandish will appear. My subjects are fantastic creations from an imaginary world, so I am always inventing new ones or improving old ones.

I don't sketch as a daily habit, but I may sit down and go through half a tablet of drawing paper all at once. I doodle more often on scraps of paper and come up with crazy critters or patterns. Sometimes I copy an animal's anatomy to get it right, or obsess over a detail, like an eye or nose. My eye is always tracing outlines of boulders and trees, stumps, and animals and people—practically every object—when I walk in the woods or out in the city streets. A fire hydrant or sidewalk crack is interesting.

I usually sketch when I find a tablet hanging around the studio. There are a lot of things to do in my studio, so sometimes I draw as a distraction to lessen the anticipatory stress or tension.

When I'm sketching, I might be thinking that this will never be in a painting, but as time goes by, it slowly works its way into my consciousness. I try not to think too much, but let my hand loop and scribble and create lines with no intentions.

Sketching is an unfinished work most of the time, although I may go all out and create a finished drawing. What it may provide is a non-judgmental activity. It may provide the central core of a painting. I draw on the canvas with a brush, and I work out the finished piece on the canvas more often.

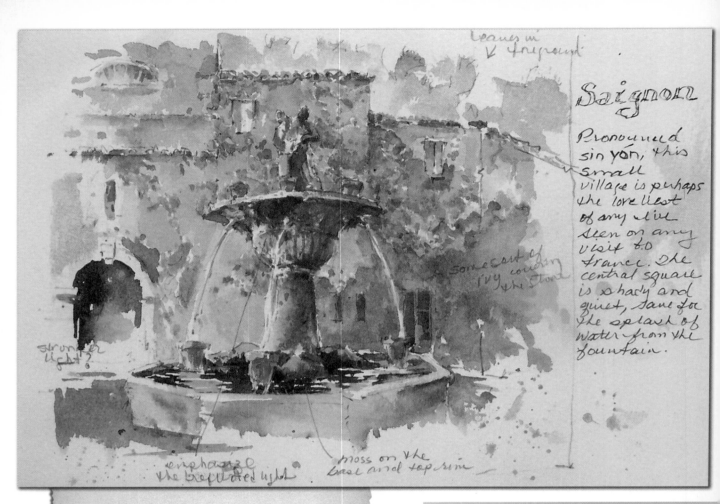

leaves in
k foreground

Saignon

Pronounced
sin yōn, this
small
village is perhaps
the loveliest
of any I've
seen on any
visit to
France. The
central square
is shady and
quiet, save for
the splash of
water from the
fountain.

Some sort of
ivy covering
the stone

stronger
light?

emphasize
the reflected light

moss on the
base and top rim

Robin Poteet

Watercolorist Robin Poteet was a freelance
advertising designer for the home furnish-
ings industry before turning her focus to
full-time painting and art instruction. She
ultimately returned to where she grew up
in Southwest Virginia and renovated the
historic log home belonging to her grandpar-
ents, a five-acre property that has become
her haven and studio. She teaches water-
color classes in Roanoke, as well as work-
shops and annual trips abroad. Poteet was
one of ten artists chosen as "Ones to Watch"
by WATERCOLOR ARTIST in their December
2010 issue.

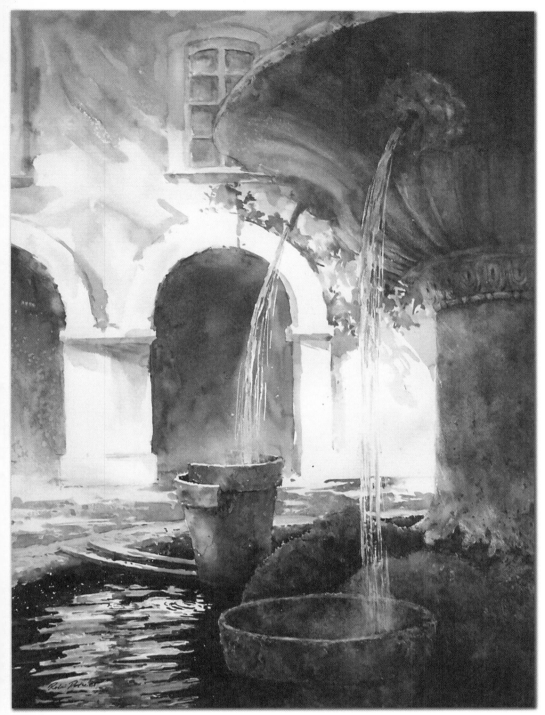

In the Shade; Saignon Fountain, France
Robin Poteet
Watercolor on 140-lb (300gsm) cold-press Arches
paper (finished painting)
27" × 20" (69cm × 51cm)
Private Collection

*I can open any page from my travel books and instantly
recall the mood, temperature and flavor of the scene—
something I'm just not able to do with photos.*

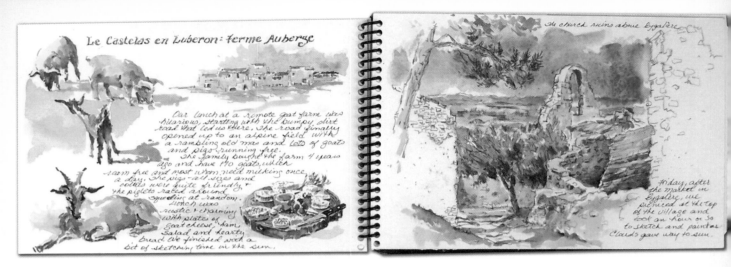

Le Castelas en Luberon: Ferme Auberge

Our lunch at a remote goat farm was hilarious, starting with the bumpy dirt road that led us there. The road finally opened up to an alpine field with a rambling old mas and lots of goats and pigs running free. The family bought the farm 4 years ago and have 170 goats, which roam free and most when need milking once a day. The pigs—all sizes and colors were quite friendly & the piglets raced around squealing at random. Lunch was rustic & charming with plates of goat cheese, ham, salad and hearty bread. We finished with a bit of sketching time in the sun.

The church ruins above Eygalières

Friday, after the market in Eygalières, we picniced at the top of the village and took an hour or so to sketch and paint as clouds gave way to sun.

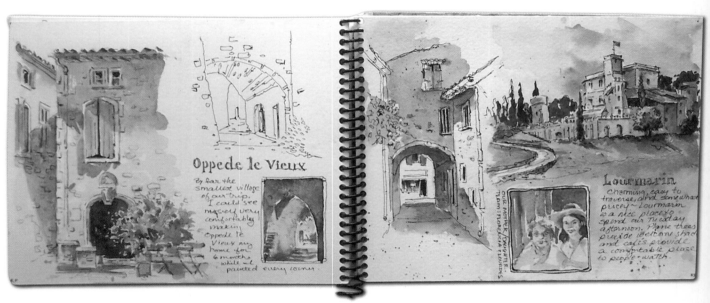

Oppede le Vieux

By far the smallest village of our trip, I could see myself very comfortably making Oppede le Vieux my home for 6 months while I painted every corner.

Lourmarin

Charming, easy to traverse, and somewhat pricey~ Lourmarin is a nice place to spend our Tuesday afternoon. Plane trees provide welcome shade and cafés provide a comfortable place to people-watch.

Drawing/sketching has always been a natural and constant part of my life—probably because I enjoy it so. My dad was an architect and often worked at home, so I learned to appreciate the beauty of pencil marks early on. I think just being able to observe others create, particularly as we are growing up, makes a lifelong impression.

I'm drawn to anything that involves nature, but it's travel, with all of its new sights, sounds and smells, that's an automatic source of inspiration for me. It heightens my senses and my imagination. I've started constructing my own sketchbooks for travel and that has definitely made the sketching process more personal and fun. I cut down full sheets of watercolor paper to a size that feels comfortable (usually 7" × 10" [18cm × 25cm] or so) and don't aim for more than twelve inside pages per book. That gives me twenty-four painting surfaces, which is plenty for

most of my trips. I intersperse 140-lb. (300gsm) and 300-lb. (640gsm) watercolor paper and a few sketch-weight sheets, then cut mat board for the front and back covers. The local office-supply retailer spiral binds my blank books for a nominal fee and I'm ready to go. The actual making of the book starts my creative wheels turning so once I've reached my destination, I'm anxious to begin sketching. I fill the interior pages on location and work on the covers once I'm home.

I pick up a pen or pencil whenever the mood strikes, but I'm definitely a morning person, and that's my best time to work on value studies and preliminary drawings for paintings—things that require analysis and concentration. In the evening, I sometimes sketch as a way to unwind. It's a wonderful feeling to draw for the pure fun of it, whether I'm working from my imagination or drawing the chair across the room. Other than my travel

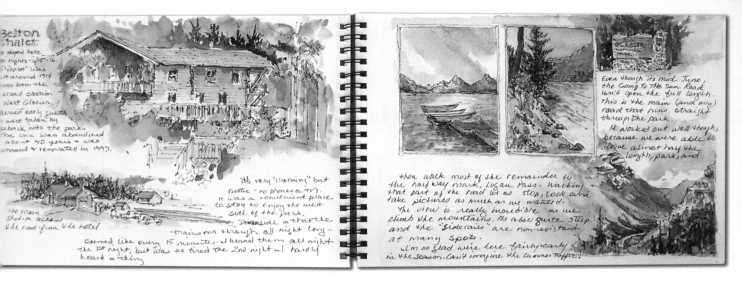

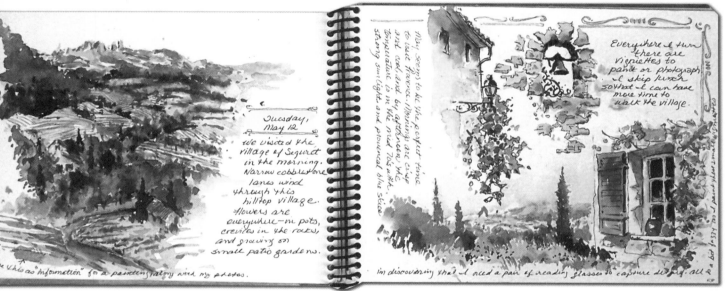

books, I don't maintain "formal" sketchbooks, so often my drawings are on snippets and scraps of watercolor paper.

Sometimes my thoughts, as well as my marks, are fast and deliberate, such as when I'm working on a value study for a studio painting. I'm analyzing, making decisions, and trying to visualize an end result. When I'm sketching en plein air, I'm much more "in the moment." Thoughts and decisions run through my mind, but in a subtle way. It's as though I become an observer of myself and my process. I really enjoy that mental silence and think of it as a form of meditation.

Much of the time, I suppose I shuffle between left and right brain, trying to make the best of both.

My career has been in graphic design, and though I wouldn't trade that experience, I know how creativity can become a commodity, with a deadline, purpose and sales pitch attached. Now that I'm transitioning to painting, it's much more about the process and the freedom. I can create without it having to be a certain, final *thing*. That's a huge relief! I'm definitely working hard as a painter and instructor, because I still have to make ends meet, but now it's MY choice of subject and method. Being able to spend time sketching for pure enjoyment is the icing on my cake.

Sketching probably helps lower my blood pressure. I relate it to watching my cat take a good long stretch. It's the most relaxing and natural part of my entire art process because I know nothing is final, and when finished, it gets tucked away somewhere. Aside from that, sketching lets me practice the art of seeing and observing. It helps my eye and hand work in tandem, and it helps me stay connected to my subject. I don't

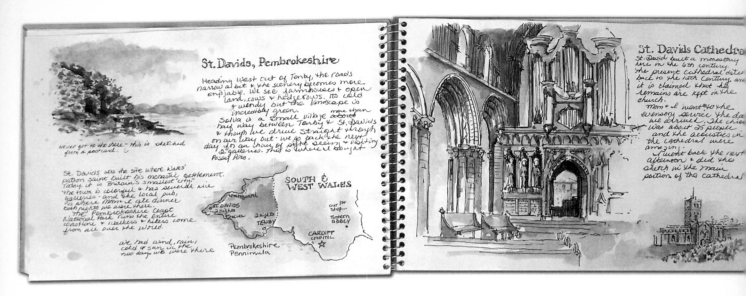

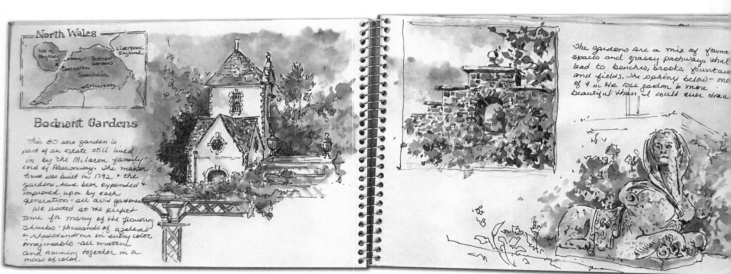

necessarily make detailed drawings in my final paintings, but I do want my perspective and proportions to be accurate, and the practice of sketching makes that easier.

Cameras are wonderful, but they remove us a step from what's around us. With a film camera, I was at least pausing, thinking and composing my shots. When I switched to digital I began clicking away, then at one point realized I was missing out on the actual experience of the scene. Sketching on location gives me that reality check. I can open any page from my travel books and instantly recall the mood, temperature and flavor of the scene—something I'm just not able to do with photos. That's not to say I don't still overload the memory card, but I do recognize there's no substitute for what sketching brings to my overall work.

There's nothing glossy about what I sketch and paint. The most interesting people have sags and bags and are just going about their daily lives. The buildings I'm drawn to also sag a bit, and show some rust and wear and tear. I prefer things that are overgrown and a bit chaotic. I like to think we artists are less judgmental than most people and simply appreciate things just as they are.

I think of sketching as an "anything goes" process. It's sometimes my way of expressing a thought in a visual way. Other times it's just letting the pencil guide my hand. There's no finished product to fret over, and that provides a lot of freedom. Up until now, these sketches have mostly been tucked inside drawers or sitting in sketchbooks on my bookcase. They're just a part of what I do to create art.

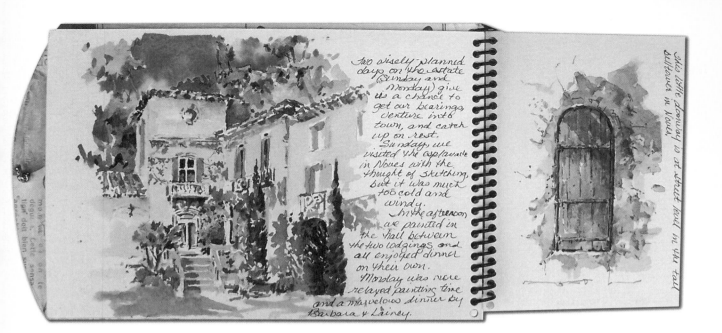

Two wisely-planned days on the estate (Sunday and Monday) give us a chance to get our bearings, venture into town, and catch up on rest. Sunday, we visited the esplanade in Nans with the thought of sketching, but it was much too cold and windy. In the afternoon we painted in the hall between the two lodgings and all enjoyed dinner on their own. Monday was more relaxed painting time and a marvelous dinner by Barbara & Lainey.

This little doorway is at street level in the tall buildings in Nans.

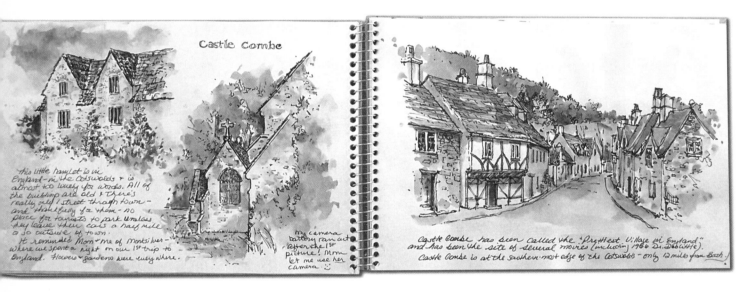

Castle Combe

This little hamlet is in England - in the Cotswolds + is almost too lovely for words. All of the buildings are old + there's really only 1 street through town - and I made 3 of them - no place for tourists to park unless they leave their cars a half mile or so outside of town.
It reminded Mom + me of Montsi... where we spent a night on our 1st trip to England. Flowers + gardens were everywhere.

My camera battery ran out after the 1st picture! Mom let me use her camera.

Castle Combe has been called the "Prettiest Village in England" and has been the site of several movies (including 1966 Dr. Doolittle). Castle Combe is at the southern-most edge of the Cotswolds - only 12 miles from Bath.

I can turn to any page in my travel sketchbooks and mentally recall details from that day, which is a huge help when I'm working in the studio, and a joy when I'm just reminiscing. For me, painting is all about expressing emotion and atmosphere, and since I often write on my sketches, I have words to guide me as I paint. The finished piece may have no resemblance to my preliminary sketch, but under the surface, there's definitely an influence from those first pencil marks.

Robin Poteet

SATYR HEAD

CLEAR PLASTIC MODEL OR TIN MAN w/ HEART

8mm FILM PROJECTOR

GASOLINE CAN

BRASS FLY ASHTRAY

HEART MODEL

CLOCK CLOWNS ON SEE-SAW BALANCING

50's LAMB TOY

STANDING ON STACK OF BOOKS POSSIBLY TO RAISE UP TO SATYR EYE LEVEL

TOOLS
OPTIONS
DELETE FILES
✓ , , ALL OF PRIMATIVES

- JESUS WILL POINT OUT HYPOCRACY BUT NOT TO CONDEMNATION HE WANTED THEM TO REPENT
- TO AVOID BEING PUFFED UP WITH PRIDE CHOOSE A LOWER POSITION AND IF GOD LIFTS YOU UP, HE WILL BE PRAISED
 1COR 10:13 JAMES 4:7

MATTHEW 13
- SIN BUILDING UP IN THE CHURCH BIRDS AND LEAVEN REPRESENT SIN
LUKE 13:24
- THE ONLY TIME JESUS SAID TO "STRIVE" WAS TO ENTER THE NARROW DOOR
- BEING RELIGIOUS ISN'T SUFFICIENT

ON TOP OF THE WORLD

*I appreciate how sketching
brings me back to the basics:
line, value and form.*

Jonathan Queen

*Realistic narrative still life has been the center of Jonathan Queen's paintings
for almost ten years. His work hangs in private collections from San Francisco
to New York, and also in the collections of the Cincinnati Art Museum and
Frisch's Restaurants, Inc. "The decision to paint a Big Boy bank started me
on the path to making toy narrative still life my focus," says Queen, a father
of four who experiments by swapping heads, sculpting new features and
assembling unique props to create one-of-a-kind characters. "Toys in the
right setting become complex characters with a deeper story to tell."*

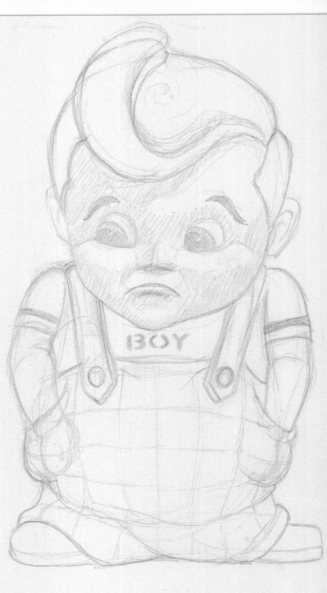

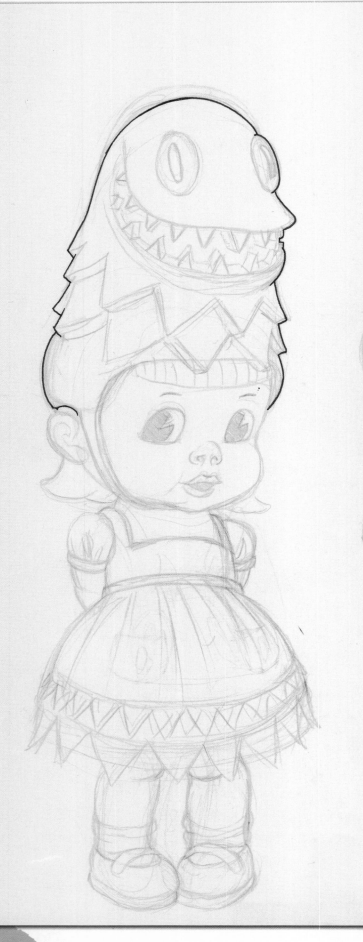

TIM BISKUP RANGEAS

My sketchbooks document thoughts, ideas, dreams and memories that can't currently be executed in paint. I am inspired to sketch when I'm out of the studio and my time seems limited. Sometimes I sketch an object that won't fit into a still life practically. When I have an idea that doesn't relate to objects I own, the sketch works as a materials list. Then I'll gather parts and sculpt/build the other necessary components.

I go through phases of sketching. I always try to have a sketchbook with me, but I don't schedule time to sketch. Sketching is frequently a response to what inspires me or merely pictorial note taking.

I usually sketch on the bus, in church, in the park—basically, whenever I am sitting in the same place for a while. I find it easy to draw from observation while talking or listening. Those functions can work simultaneously. However, when I am composing or inventing a character, I work in a way that needs more isolation and concentration.

When sketching out ideas for paintings, I work small and simple. The concept drives the action. When I draw from observation, I'm focusing on the subject and the goal is to render accurately.

Most of my drawings are from observation, and there is an energizing feeling that accompanies this process because I feel like I'm racing against time. I don't try to "finish" drawings. I try to render them with a hierarchy of importance.

Sketches are reminders of previous excitement. I sketch an idea from my head when inspiration strikes. I sketch from observation when I want to learn about or familiarize myself with a subject. This could directly influence a new painting, but I might need time to ponder my direction. Later, while flipping through a sketchbook, I am reminded of previous ideas. The span of time filters the idea and I can more objectively consider the development of the concept.

I appreciate how sketching brings me back to the basics: line, value and form. While it is easy to be wooed by color, sketching helps me to see the framework of life. Since 90 percent of the information our eyes receive is based on light and shadow, it is vital to practice rendering for anyone who wants to paint three-dimensional space on a two-dimensional plane.

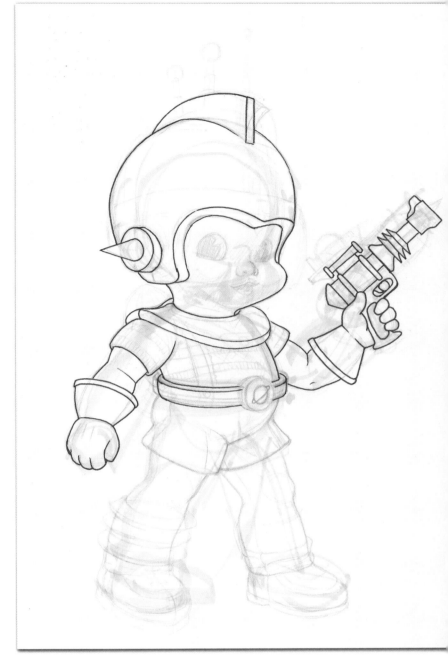

With sketching, I enjoy the freedom of selective focus that I can't use in my paintings. The white of the paper is a dense fog and the pencil extracts information from that cloud. Sketches feel like memories or dreams because of their incompleteness. My sketches are exploration, while my paintings are refined solutions.

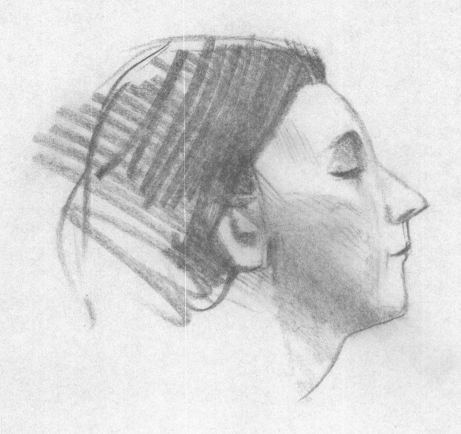

Ian Roberts

Accompanying his artist father on plein air painting trips from the time he was eleven undoubtedly influenced Ian Roberts, who for the past fifteen years has taught landscape painting in Provence, France. He attended Parsons and the Ontario College of Art and Design before opening Atelier Saint-Luc, his art school named for the patron saint of painters. He is the author of two instruction books, CREATIVE AUTHENTICITY: 16 PRINCIPLES TO CLARIFY AND DEEPEN YOUR ARTISTIC VISION and MASTERING COMPOSITION: TECHNIQUES AND PRINCIPLES TO DRAMATICALLY IMPROVE YOUR PAINTING.

*Right there is the value
I see in sketching:
melting the difference
between "official" work
and personal work.*

I want to make a distinction between drawing and sketching. A drawing, like a painting, has a goal, a finish. So I have a certain investment in it. I feel responsible for the result.

Sketching frees me from that. I wish I could release that sense of responsibility I have for making "good" drawings and paintings. I think it is a constipating influence. When I sketch, I'm free. There's no pressure. It's all process; no product.

The main function of my sketching is to catch the fleeting images and ideas that pop into my mind. A sketch is shorthand to hold those images. Because if I don't, they'll be gone. Those little visions and insights are gifts, and I feel I need to honor them and record them, even if only one in a thousand becomes anything significant.

I sketch to record those moments. Sometimes they come fast and furious. Dozens in a day. Other times hardly at all.

I do draw the figure weekly to keep my chops up, so when ideas come I have a facility to record them. A lot of what I paint is landscape, so my sketchbooks are filled with compositional studies—the arrangement of the major shapes and the skeleton or armature of those masses. I use it like a road map in advance of starting.

I also sketch to record an idea for a painting when I take a photo of something. I often find it surprising to look at the photo later and wonder what it was I found so interesting. The sketch can remind me of the "core" idea. That often makes me realize how fluid my sense of what I am seeing is. The sketch records that, whereas the literal photo doesn't record that and seems lifeless without the vision.

I suppose sometimes the sketch wouldn't look different than a more finished drawing. Yet the mindset at the time was different.

Sketching is exploratory and I am nonjudgmental while doing it. In a sense, it's cheap. There's nothing to lose in trying out a new idea.

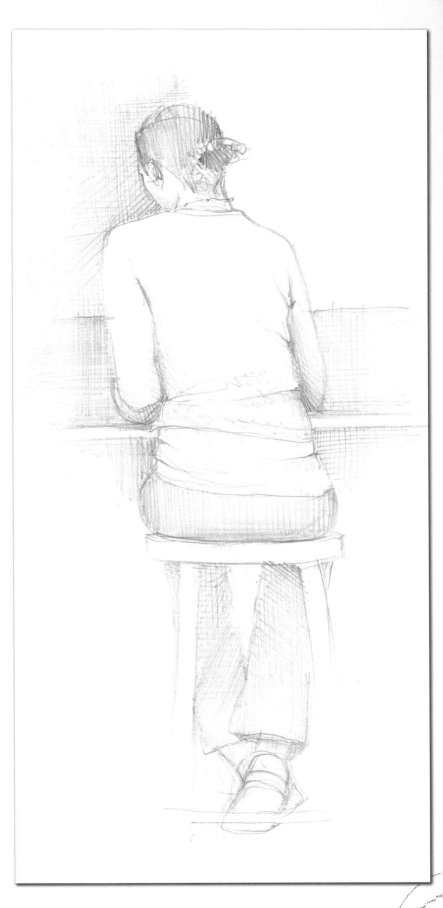

In that way, sketching feels directly connected to awareness or consciousness. Since art is ultimately about consciousness, sketching often gives ideas their most immediate and lively form. Largely unfiltered, it's all vision, all potentiality. Refreshing, free and simple.

Some things need more finish, of course. Everyone knows the problem of holding on to the liveliness of a sketch in a finished painting. This piece needs adjusting. That should be cleaned up until everything is perfect. And dead.

The daring and varied sketch undergoes through some strange "artistic corrections," and the finished work becomes a pale reflection of the fire that passed through my imagination.

Right there is the value I see in sketching: melting the difference between official work and personal work. How and why does such a distinction exist?

Sketching can reveal that distinction more clearly, breach that barrier. Life's too short to be safe, responsible and boring.

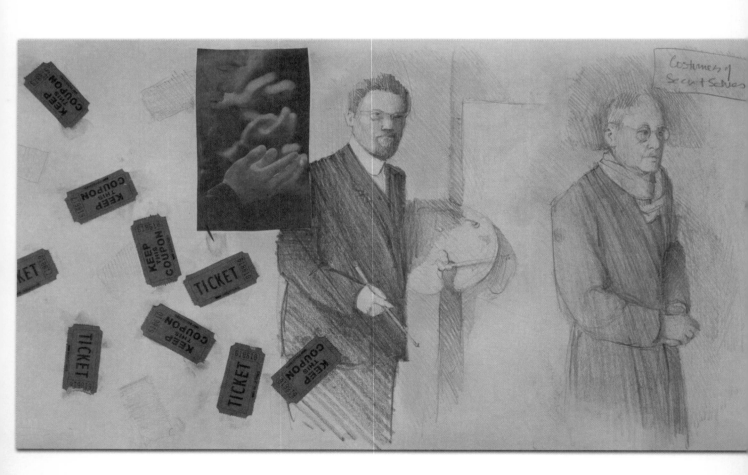

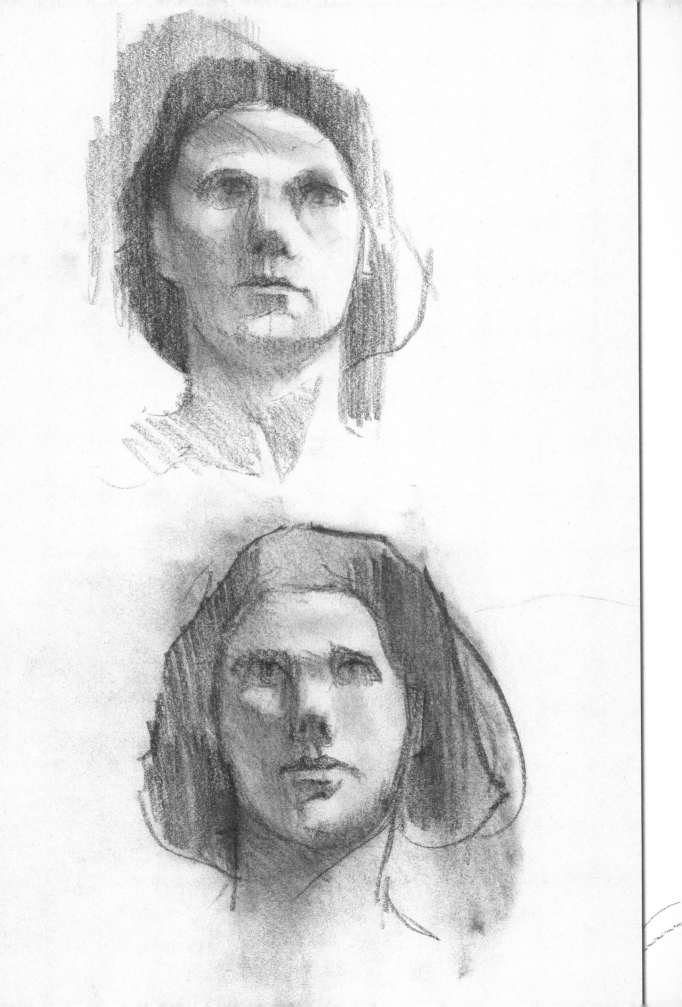

Merle Rosen

Cincinnatian Merle Rosen has taught at the university level and for community arts organizations for more than forty years, including workshops on painting, drawing and collage. Her teaching philosophy and style, she says, "came about as I was correcting the inadequacies of the college art education I paid for and received." A lover of travel and the garden ("I think of it as a large sculpture"), Rosen admits that the direction of her creative life has shifted somewhat in recent years, as she focuses on caring for her aging parents. "I stopped showing work, but not making it."

Drawing frequently is more important than drawing well. I believe good drawing evolves from generating a quantity of drawings and getting away from the preciousness of the act or the work.

I draw from life (20 percent) and from my imagination (80 percent). In my early twenties I could draw whatever I wanted to my satisfaction and found that to be disappointing. Now what was I to do for the remainder of my life? I began to uncover within my daily doodles a pathway to my unconscious and a resource to directly tap into images and shapes that interested me.

I carried a sketch pad for 30-plus years and drew in it wherever I was—at a doctor's appointment, the airport, a museum, the riverfront, a restaurant. Drawing in my sketch pad has been a discipline which assists my ability to digest whatever visual stimuli I am presented with.

When sketching, I think about nothing. I look.

How I feel when sketching varies. On vacation, sketching is a serene way to BE in a new place. In a museum, it's like there is never enough time to look at all the wonderful objects in the world. I have to be selective, and pick and choose carefully what to spend my time with. It isn't really about the thing I'm looking at as much as how loose I can get. There is an internal place I want to arrive at that is my real destination. Drawing is just a mode of travel.

I try to be as free when I paint or sculpt as when I sketch. I search for the spontaneous in all materials that I work with, and I try to balance control with an internally directed lack of restraint in whatever I am doing.

Most of my larger works are taken directly from images in my sketch pads or little individual drawings. I am comfortable working quite small, so sometimes I will take a modest-sized work that demands monumentality and enlarge it, possibly changing mediums as well. For example, a small sketch pad drawing (under 6" [15cm]) may morph into a 32" × 40" (81cm × 102cm) painting, a bronze, painted furniture, or be used as source material for a mural.

When I sketch I feel more alive, more engaged, in a more timeless mode. The discipline keeps me connected to my process, which is why I tell students to draw frequently rather than for a long time or demand that the drawings be good. I say go for "quantity" over "quality."

Drawing frequently is more important than drawing well. I believe good drawing evolves from generating a quantity of drawings and getting away from the preciousness of the act or the work.

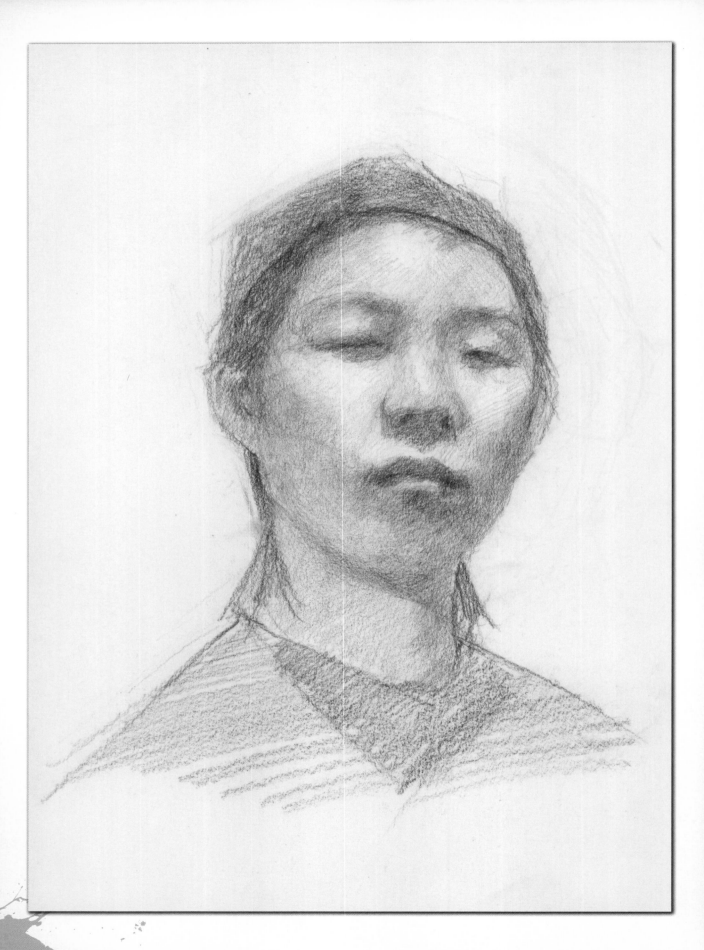

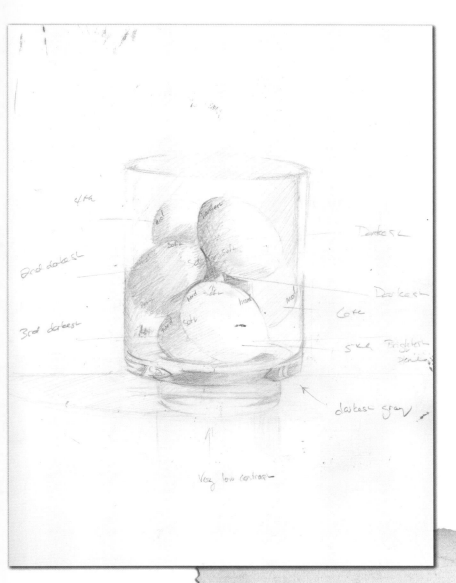

Sometimes I can feel that the ideas are there, but just on the other side of a wall. I use sketching to reach over and get at them.

Kate Sammons

Portrait and still life artist Kate Sammons is a member of the Portrait Society of America and the California Art Club. Born in Seoul, Korea, and raised in Illinois, she moved to Los Angeles to join her partner, who is also a painter. Sammons found Southern California to be ideal in both climate and inspiration for an artist. "The dry and constant temperature is not only pleasant but is also a perfect environment for the making of paintings," she says. "The exhilarating mix of urban and natural, new and traditional is a constant source of inspiration."

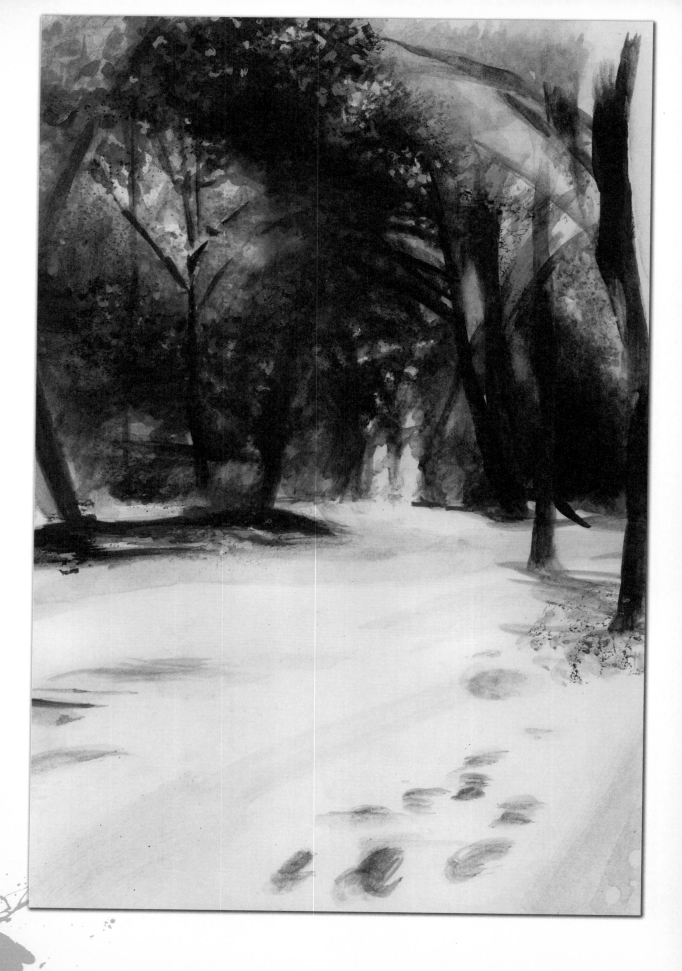

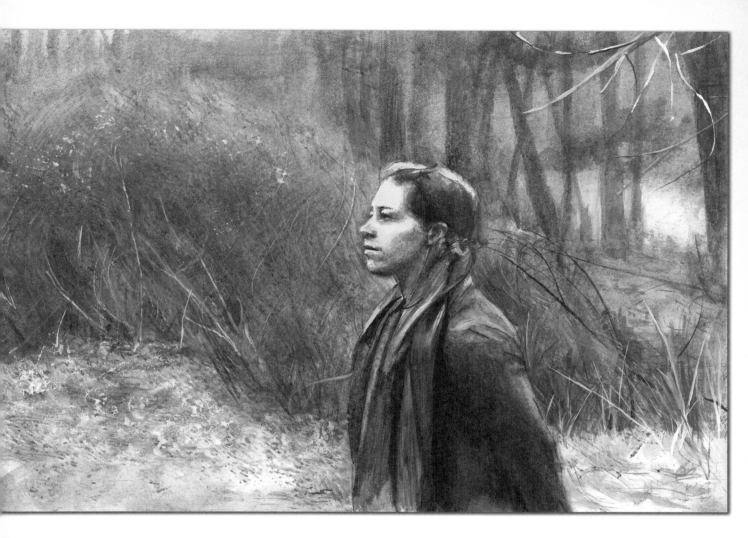

I sketch for different purposes: (1) To jot down an idea, inspiration or memory, (2) To practice a sketching technique that exercises the ability to create a quick but personalized impression of an event or subject, or (3) To work out a visual problem through organizing, simplifying and analyzing individual components of the problem.

Ideally, my daily work would be comprised of 50 percent sketching and 50 percent production.

Sketching is another way for me to examine and analyze ideas, to get in touch with my imagination and bring it to creation. Sometimes I can feel that the ideas are there, but just on the other side of a wall. I use sketching to reach over and get at them. At other times there is an urgent idea that I need to get down, and sketching helps me do that, too.

Sketching is messy, unfinished and noncommittal. When I work on finished art, I have a clear production goal and tend to take everything that goes into it very seriously. Sketching allows me to have more fun and to think about things more unconventionally, without the expectation that it has to lead to anything at all. I see my sketches as by-products and castoffs of a thought process.

My sketches relate to my finished work in an abstract way. My sketches address isolated components of the finished work rather than the whole piece.

When I sketch it feels rejuvenating, like I've had a chance to communicate with a part of myself that doesn't get a chance to talk often. I'll have new ideas, new enthusiasm, and a clearer idea about the approach I need to take with a project.

Apple
Tree?
Pear?
Butterfly
Swarm
Sheer
Sleeves

Vine?

Keyhole

Arch.
Michael
Peacock
Butterfly

White
Rose:
Divine
Love
Red Rose:
Divine
Passion

If anything, sketching has taught me how to slow down and appreciate what I see and have patience to perfect my art before rushing headlong into an imperfect finished product.

Angela R. Sasser

Fantasy artist Angela Sasser grew up "absorbed in mythology, particularly tales of tricksters, elves and winged beings," she says. "While other kids were out playing, I was in the library gobbling up stories of myths and monsters." Today, Sasser holds degrees in English, studio art and arts administration ("I could never choose between my love of writing, of illustration, and for helping other artists"), and she's written her own art instruction book, ANGELIC VISIONS. Sasser lives in Atlanta and runs a blog dedicated to giving advice and inspiration to other artists.

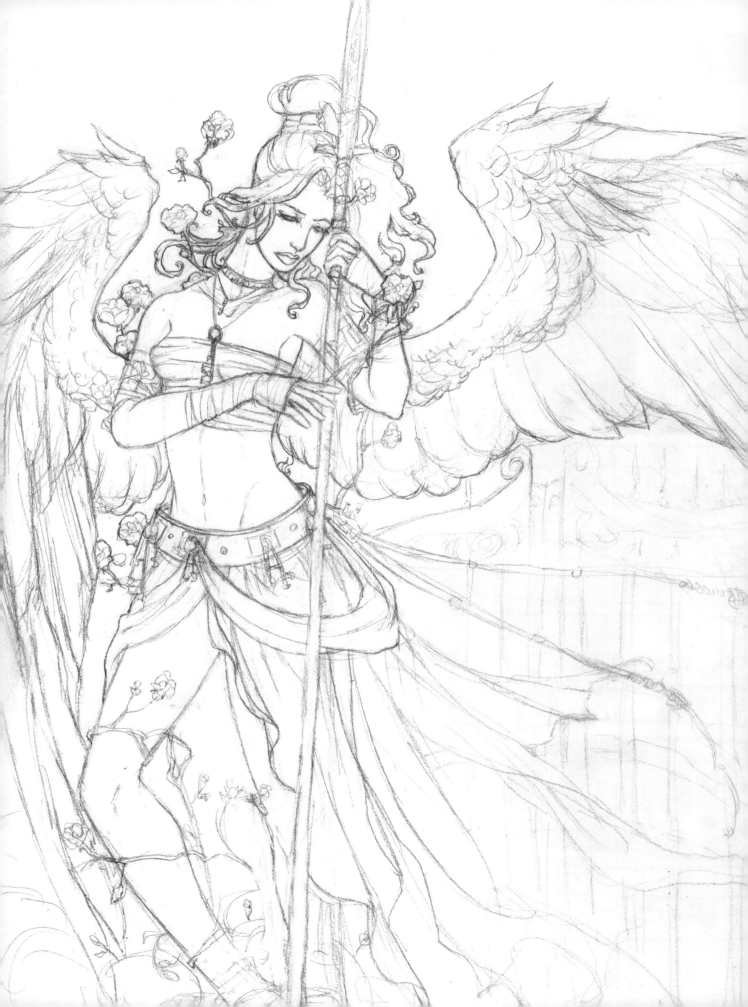

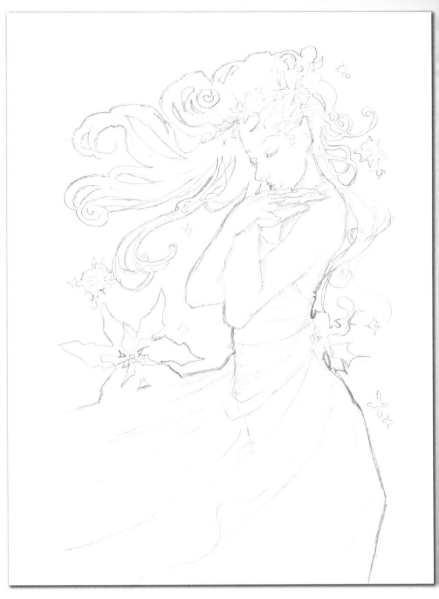

I try to sketch every day, either digitally with my tablet or in my sketch journals.

Most of the time, I sketch to keep track of the characters in my head, to tell parts of their stories or simply to discover their visual look by feeling it out with multiple drawings. Other times, I don't sketch with any purpose in mind but to practice a certain skill with rendering a subject or experimenting with new techniques.

The most creative inspiration comes from making correlations between unrelated objects, images and concepts for a piece of art. Sketching ensures that I'll record those correlations for posterity and my own nefarious purposes!

I have a dream journal at my bedside to capture those runaway fragments from a night's worth of dreaming, and a travel journal that goes with me everywhere just in case I have an idea on a shopping trip. Dreams, music and the need to tell my own stories inspire my sketching habit, plus I need to write things down before I forget them. When you have an overactive imagination like mine, it's hard to keep track of ideas after awhile!

Sketching helps me to create a greater number of concepts more quickly than I can finalized works of art for every idea that comes to mind. Sketching is a great way to quickly get that flood of ideas out, especially when making a more complete piece of art would take infinitely longer. It also serves to help you perfect your technical skills and to refine your ideas before coming face to face with the monumental task of creating a finished piece of art.

Sketching gives you an appreciation for the beautiful forms in this world that I think most people take for granted. The perfect petals of a floating lotus, the graceful curve of a model's figure and the way light hits it, raindrops on a car window—these things are so mundane, yet so beautiful if you take the time to observe them. I think if we could all learn to take the time to appreciate the little things in life, as we do in sketching, we'd all feel a little less stressed by the world we live in.

If anything, sketching has taught me how to slow down and appreciate what I see and have patience to perfect my art before rushing headlong into an imperfect finished product. The same applies to my philosophy of life. If one can appreciate the smaller victories, every task is an accomplishment towards the greater goal of inner peace.

Angela R. Sasser

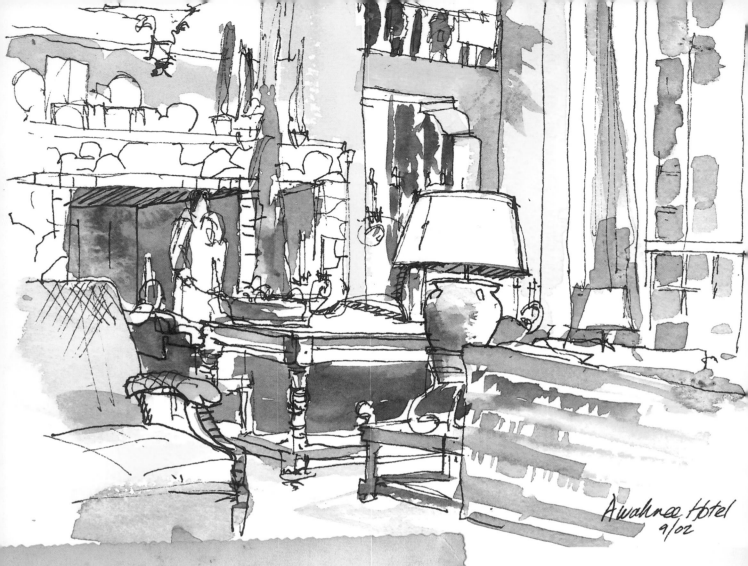

Awahnee Hotel
9/02

David Savellano

An Oakland, California, native and UC Berkeley graduate, David Savellano has practiced architecture for over thirty years, and is a self-taught artist now teaching travel sketching and plein air painting classes. He holds signature memberships in both the National Watercolor Society and the California Watercolor Association, and has been featured in WATERCOLOR ARTIST and WATERCOLOR magazines. "My ideal woodland vacation," says Savellano, "would include fly fishing and sketching in the early morning, picnics and naps at midday, then more sketching and fly fishing at sundown, when the stream hatch is at its peak."

I am empowered by a sketch to explore and alter or personalize the vista in front of me.

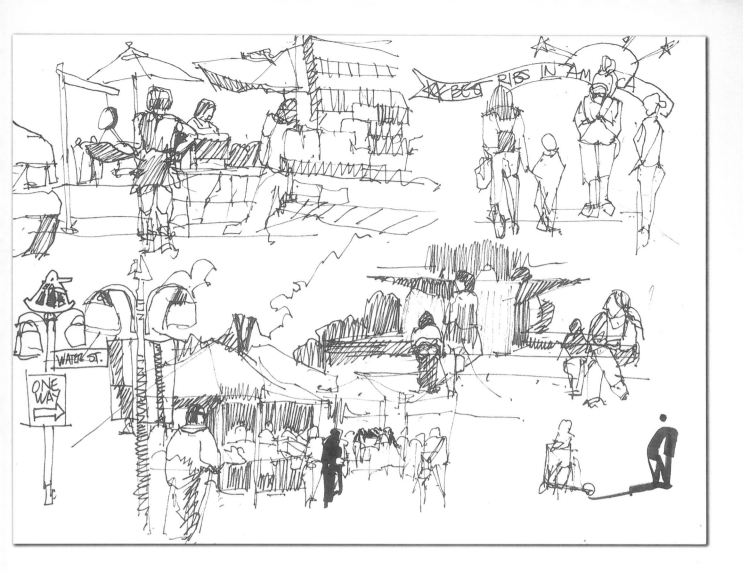

As an architect, my daily work is well defined; my sketching represents freedom. This freedom allows me to discover the vantage point which will lead me to make ordinary scenes look extraordinary. Sketching permits me to leave the complexity of architecture behind and deal with the spirit of a scene. As a plein air artist, I sketch quickly, laying out the fundamental composition of the landscape. The "spirit" of the scene emerges as the sketching progresses. Making choices in the process often leads to less detail, less "reality" in my final image. Extracting the spirit of the scene leads to the artist as a storyteller.

When I am sketching, first I think about how to approach the scene and what is attracting me. The attraction *is* the story. Storytelling is an underappreciated facet of art. If I am able to create a simple statement, focusing on one major idea, it will result in a more successful work.

Sketching heightens my senses, and I soak in the sights, sounds and smells of my surroundings. When I am focused in the present, other worldly burdens vanish. Any pressure is self-imposed, with my internal clocks determining time limits and my art sensibilities reminding me not to overwork the sketch.

Sketching enables me to explore ideas nonjudgmentally. A sketch can be an end unto itself or a preliminary step towards a watercolor painting. Sketching develops my confidence as the street scene changes, allowing me to capture a "visual diary" that will outlast my memory.

Mac & Cheese w/ hot dog topped
w/ potato chips

homeroom
mac + cheese

really cream
cheese

AP w/ Trailer Mac 23/FEB/11

138

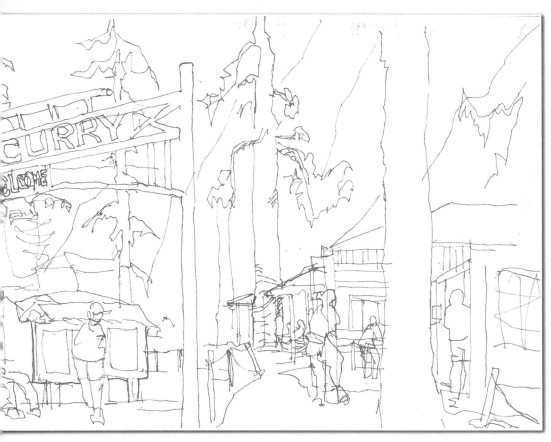

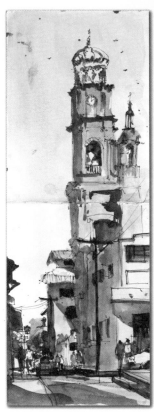

Last but not least, sketching enhances the coordination and synchronization between your "mind-eye" domain (what you see and experience) and your artistic hand.

Sketching permits me to capture scenes that interest me; slowing down allows me to absorb and see details. Unlike photography, not everything is important; in a sketch I need to prioritize and focus on things that are important. Initially, the scene that attracted you may change as you work, and you may discover new interests.

I am empowered by a sketch to explore and alter or per–sonalize the vista in front of me. There is very little risk in sketching and only a small amount of time invested.

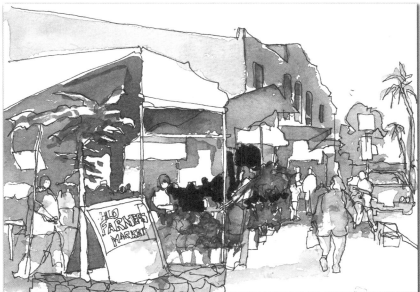

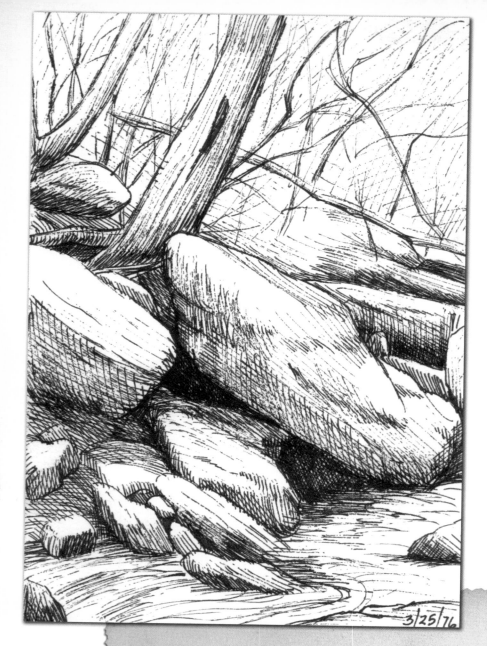

3/25/76

In a sketch, the combination of abstracted lines and shapes can reveal things about a subject that would not be apparent if the subject were rendered in great detail.

Jeanne Filler Scott

Jeanne Filler Scott's favorite subjects have always been animals and nature. In 2010, she authored her fourth book, DRAW AND PAINT REALISTIC HORSES. Several of her paintings have been published as limited edition prints, three of which are sold out, and she is a member of the Society of Animal Artists and Artists for Conservation. Scott lives on a farm in Kentucky, surrounded by woods, fields and the Beech Fork River, with her husband, son and lots of dogs, cats, horses and other rescued animals. Many wild creatures, including deer, wild turkeys, songbirds and coyotes, make their home there and provide constant inspiration.

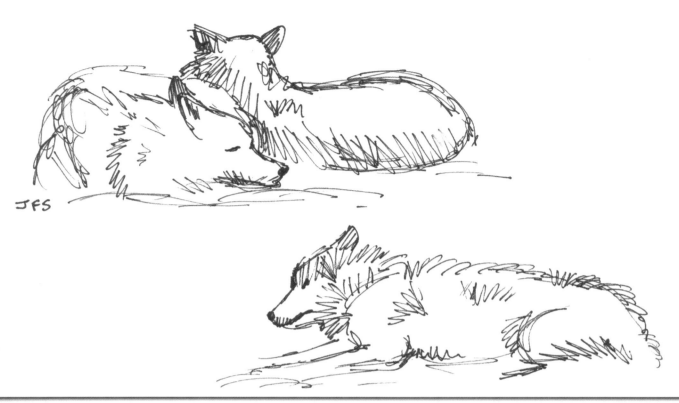

Wolf Park 5/95

JFS

I carry my camera and sketchbook with me everywhere. I take thousands of photos but, of course, sketches take more time, so I have fewer sketches compared to photos. I find both photographs and sketches to be great working tools that are complementary for creating my finished work.

I would like to sketch every day, but I don't always have the time, so I sketch whenever I have the opportunity. Most of my sketches are done during the day when I am out hiking around our farm or in a park or wilderness area. At times, I may do sketches when I am a passenger in a car on the way back from a day hike—very quick sketches of interesting scenes out the window or more detailed sketches of found objects I picked up, such as acorns, rocks or snail shells. Occasionally, I'll do sketches of our dogs, cats or plants at home, of birds at the feeder, or of the view of our farm from our front porch.

Sketching forces you to simplify the subject into fewer lines. Obviously, while out in the field, you don't usually have the time to render every detail with precision,

especially if the subject is an animal. Animals move constantly, even when resting. Also, sketches and finished works reveal different aspects of the same subject, a little like the difference between a string quartet and a symphony orchestra—both are interesting and valuable. In a sketch, the combination of abstracted lines and shapes can reveal things about a subject that would not be apparent if the subject were rendered in great detail.

Since things are simplified in a sketch, you can suggest, for example, using parallel lines and short strokes, rather than do a detailed drawing of textures such as rock surfaces or large clusters of leaves on a tree. With an animal, you can capture a movement with just a few expressive lines.

While sketching, I'm enjoying what I'm doing, but I also feel that I'm in a race against time, since I can't stay in any one spot for a really long time. I'm usually on a hike with my husband, my son and some of our dogs, and they don't always like to hang around waiting for me for too long! The time constraint can be beneficial, since it

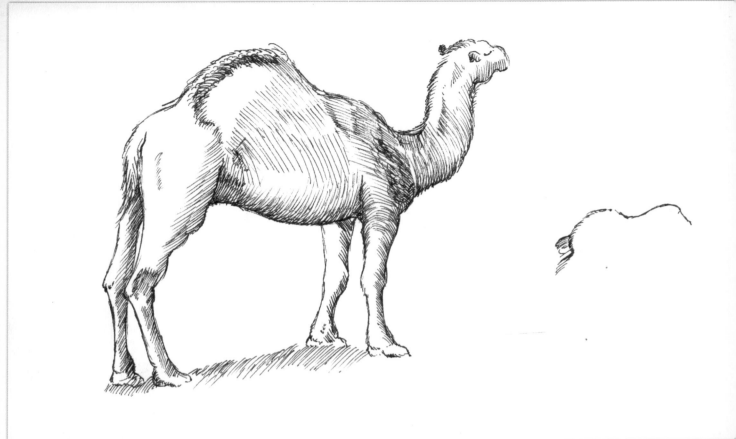

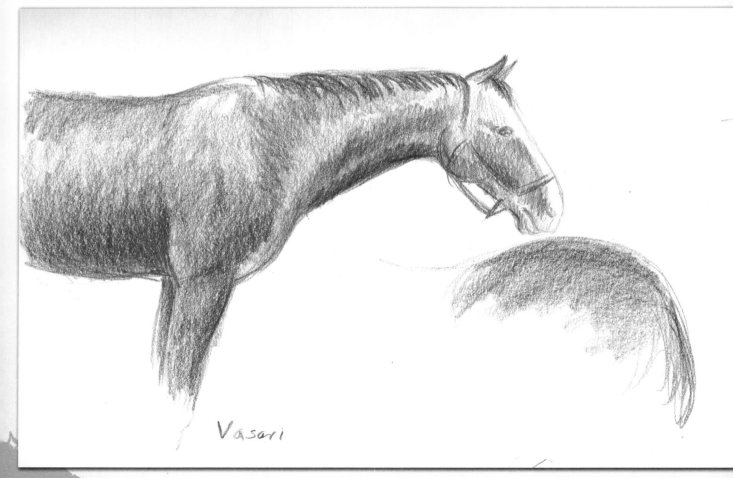

Vasari

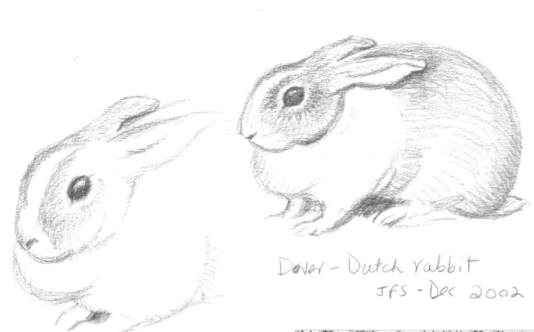

Dover – Dutch rabbit
JFS – Dec 2002

compels me to sketch more rapidly and not sink into my tendency to do a very detailed, finished drawing.

Sketching gives me ideas about what I would like to paint or draw in my studio. It also can be useful in trying out different compositions before I commit myself to the many hours it will take to render a finished piece. Another use for sketches is, for example, when I am commissioned to paint a horse portrait. A horse's coat color is an important aspect of a portrait, because there is so much variety in individual horse colors. Since colors can look somewhat different in photographs and under different lighting conditions, if it is an option, I like to visit with the horse and do color studies using colored pencils or acrylics, making notes on various aspects of the color relating to the different parts of the horse's anatomy.

I also feel that sketching animals from life teaches you more about the living creature—the individual personality and the many small details you might not notice otherwise—than if you just watch the animal or take photographs.

Jeanne Filler Scott

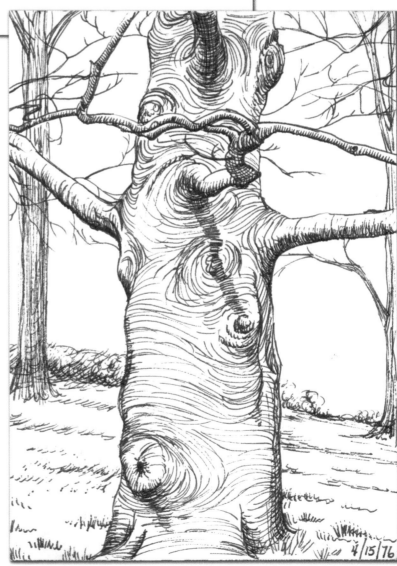

4/15/76

143

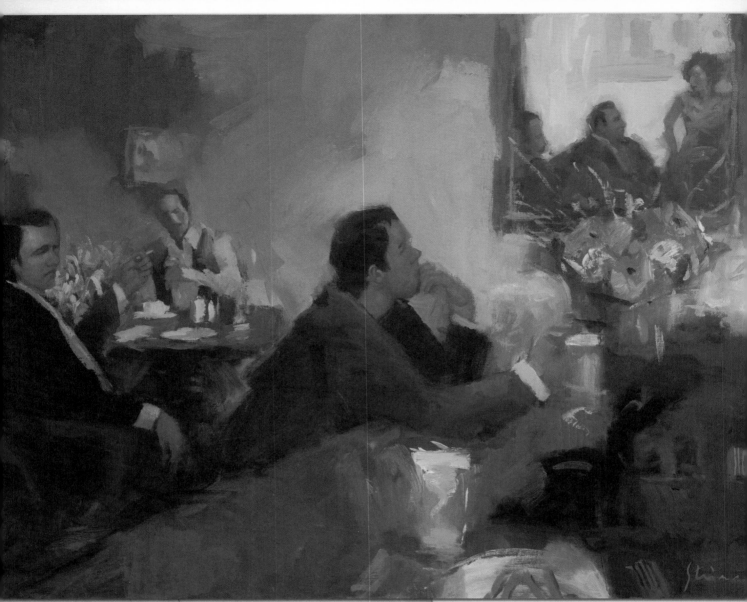

Bar Stories
Michael Steirnagle
Oil on linen (finished painting)
30" × 40" (76cm × 102cm)
Collection of Lowell Hamburg and Robert Gibson

Michael Steirnagle

Born and raised in El Paso, much of Michael Steirnagle's West Texas influence is evident in his palette and subject matter. He studied art at the Art Center College of Design in Los Angeles and earned his BFA from the University of Texas at El Paso. His art career has taken him from graphic design to illustration and eventually to fine art and teaching painting at Palomar College in San Marcos, California. He and his wife, Adele, currently divide their time between their homes in Escondido, California, and near Nosara, Costa Rica.

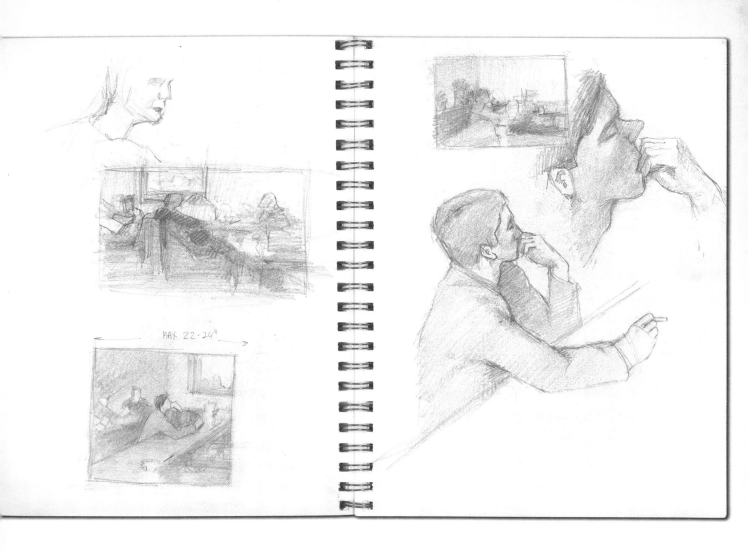

I sketch when I am stuck or am incapable of thinking my way out of a compositional dilemma—which is usually the case, as it is almost impossible to think one's way to a creative solution to any problem.

I must confess that I often sketch at home away from the studio over a strong espresso or even a beer. I am not advocating an artificial stimulant to be used as a device to awaken our sleeping right brains, but I do find that occasionally it helps to get the brain firing. I remember reading in a book about Gary Larson (creator of "The Far Side" comic strip) that when asked where his ideas come from, he said he didn't know but it had "something to do with caffeine." I identify with that. (Again, just to be clear, I am not advocating the abuse of drugs, legal or illegal.)

When sketching, I think about abstract shapes. Values. Size relationships. Those are the foundation elements in a painting. And all painting, as I relate to painting, begins at the abstract level and moves toward the representational, if so desired by the artist. So those are the things I think about when sketching. Oh, and of course there are also those sketches necessary in painting the figure, such as a detail of a face, hand or the twist of a foot. Sometimes those things have to be worked out in sketches.

It is an amazing journey that I go through when I sketch. I can feel my mind moving to my right brain. It is a physical sensation if you are tuned into it, and sometimes I am. Those are the times when I make the most progress in my painting. If I have worked something out in a sketch, then I am freer to express myself with the delivery of paint. It is a great feeling, not unlike the runner's high I used to get when I ran.

On a practical level, sketching is beneficial to me because I resolve issues on a painting I am getting ready to start, or in sketches I produce during the painting process. Usually every night, I load up the painting I

am working on in the studio and take it home and haul it into the living room, where I can sit back and allow the painting in progress to tell me what is wrong with it. Some artists call this a "dialogue." For me, dialogues are two-sided. Here I am only listening. If I leave my painting alone long enough, then eventually the solutions present themselves, and this is when the sketching is most valuable to me. Over the years I have filled many sketchbooks with ideas and value studies. These are valuable to me, as they are a sort of documented history of many of my paintings.

Sketching has taught me to see in a different way. I no longer look at the world in terms of objects. I don't design my paintings by assembling people and things into a pleasing composition. Rather, I design my images by assembling a series of abstract shapes that make up these objects and people. And a shape does not necessarily stop at the edge of an object. It may fuse with a background value and shape, thereby making a bigger shape that may link to another shape. In sketching I seek these shapes and how they relate to one another to form my composition. This is how I see the world around me.

Most artists will probably tell you that their sketches, whether graphite or paint, usually come out better than the finished painting. I believe that this is because as we work on a sketch, we are much freer and open in our approach to making art. This is because we tend to spend more time in the right brain when sketching. When I then try to translate the sketch or study to a larger format, I often get hung up on just creating a

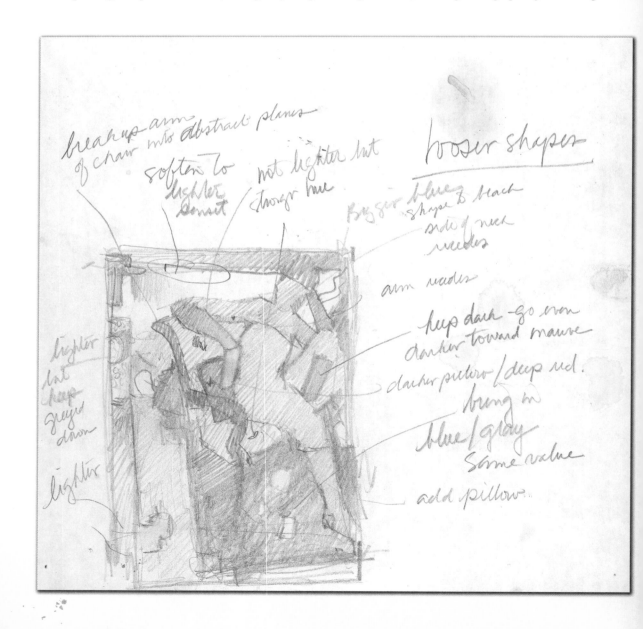

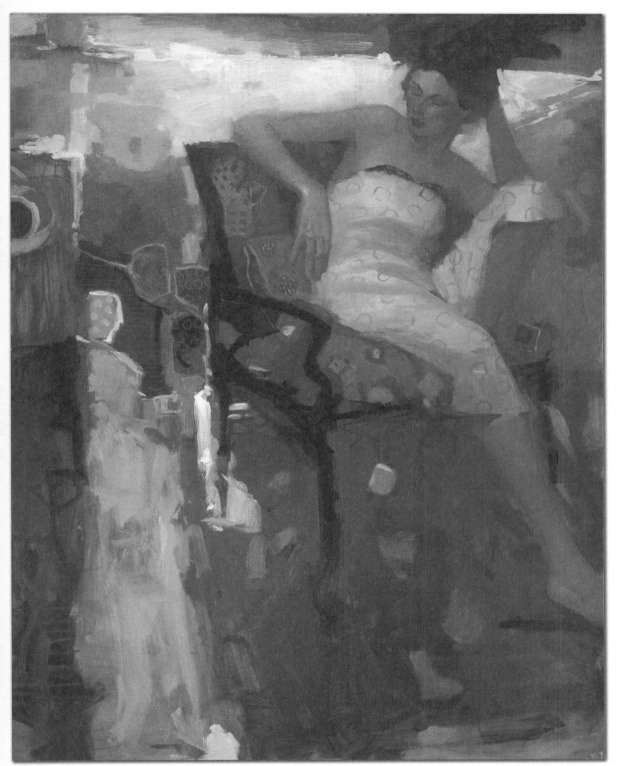

Yellow Dress
Michael Steirnagle
Oil on linen (finished painting)
60" × 48" (152cm × 122cm)
Private collection

I don't design my paintings by assembling people and things into a pleasing composition. Rather, I design my images by assembling a series of abstract shapes that make up these objects and people.

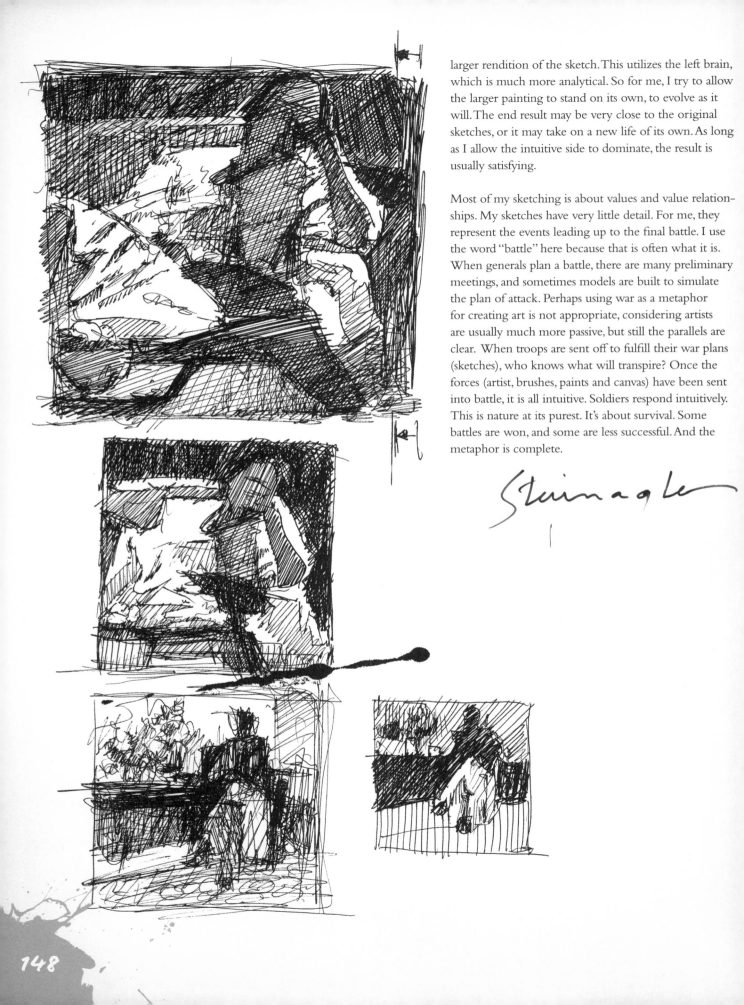

larger rendition of the sketch. This utilizes the left brain, which is much more analytical. So for me, I try to allow the larger painting to stand on its own, to evolve as it will. The end result may be very close to the original sketches, or it may take on a new life of its own. As long as I allow the intuitive side to dominate, the result is usually satisfying.

Most of my sketching is about values and value relationships. My sketches have very little detail. For me, they represent the events leading up to the final battle. I use the word "battle" here because that is often what it is. When generals plan a battle, there are many preliminary meetings, and sometimes models are built to simulate the plan of attack. Perhaps using war as a metaphor for creating art is not appropriate, considering artists are usually much more passive, but still the parallels are clear. When troops are sent off to fulfill their war plans (sketches), who knows what will transpire? Once the forces (artist, brushes, paints and canvas) have been sent into battle, it is all intuitive. Soldiers respond intuitively. This is nature at its purest. It's about survival. Some battles are won, and some are less successful. And the metaphor is complete.

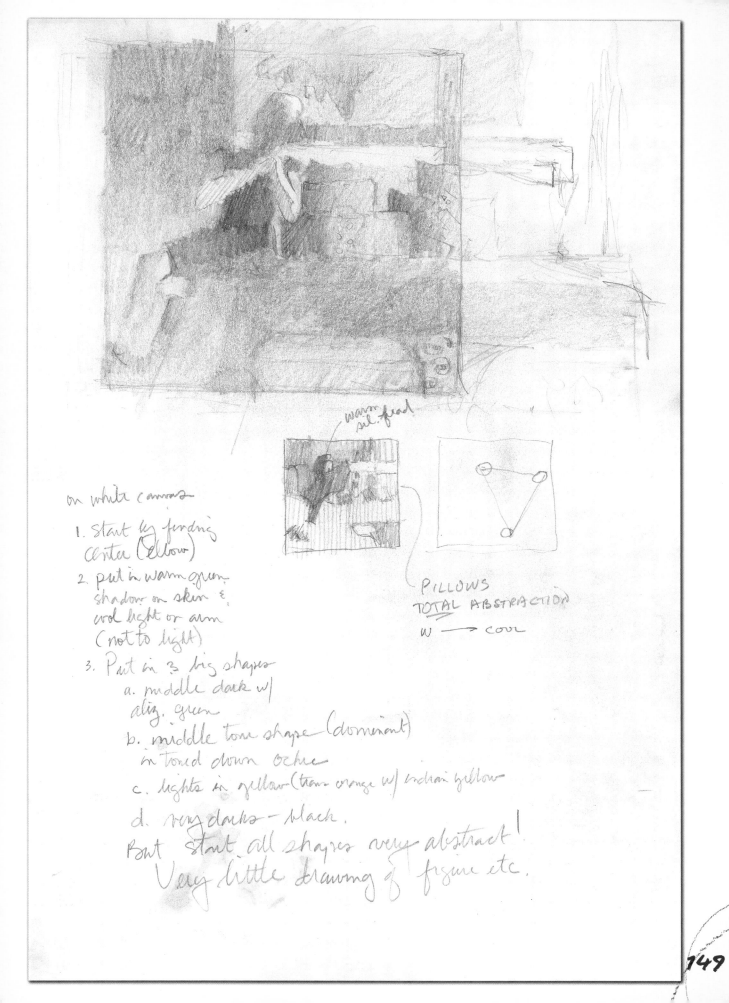

warm
sel. feal

on white canvas

1. Start by finding
center (elbow)

2. put in warm green
shadow on skin &
cool light or arm
(not to light)

3. Put in 3 big shapes
 a. middle dark w/
 aliz. green
 b. middle tone shape (dominant)
 in toned down ochre
 c. lights in yellow (trans orange w/ indian yellow
 d. very darks — black.

But start all shapes very abstract!
Very little drawing of figure etc.

PILLOWS
TOTAL ABSTRACTION
W ⟶ COOL

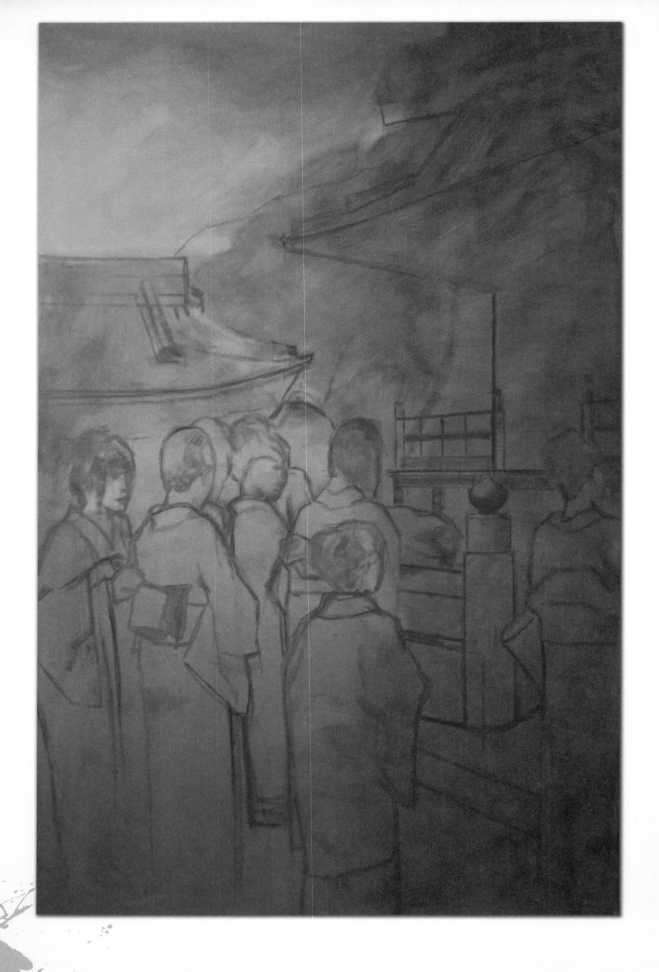

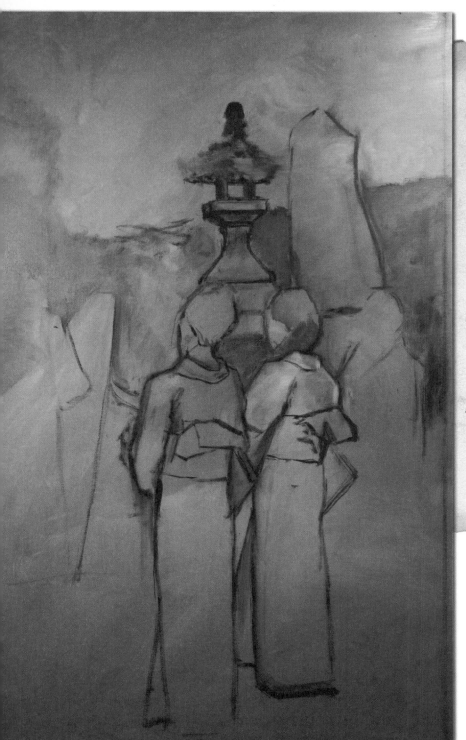

Kyle Stuckey

At age 18, Kyle Stuckey turned his attention from sports to art and began studying drawing and painting privately, supplementing his education with art videos. Strongly influenced by such historical artists as William-Adolphe Bouguereau and John Singer Sargent, Stuckey is now a member of The Putney Painters, an invitational group mentored by Richard Schmid and Nancy Guzik. He won the best-of-show award in the September 2010 BoldBrush national online competition, and he earned a place on SOUTHWEST ART'S "21 Under 31" list in 2009. Stuckey lives in Keene, New Hampshire.

Sketching helps me to understand what makes paintings powerful.

that are unrelated to a large project, in order to clear my head. The majority of my sketch time is done prior to a large painting in order to plan the overall composition and accurate drawing.

When I am sketching, I think about how I can most simply capture my subject's overall structure. If I am sketching for a painting, it gives me the ability to quickly test variations of a composition. Usually when I sketch, I start just by asking myself a few basic questions and then answering them. The first thing I want to ask is, "Why am I sketching this?" and secondly, "Am I doing it accurately?" Thirdly, I ask, "What can I get away with not including in the drawing, without losing the strength of the overall design?" I think about finding what is important to me and capturing it accurately.

When sketching I feel relaxed, knowing that if it doesn't come out the way I intended, I can easily start fresh. It's exciting to be able to capture the simplistic motion or movement of an object; a certain attitude, a tilt of a person's head, or the way hair falls. I capture the disposition in a simple form in a matter of minutes and then move on to something else. I get excited about capturing the raw identity of the subject.

Sketching greatly improves my drawing skills; it helps me to learn more quickly and capture my subject. Sketching also teaches me how to design compositions. The more I sketch, the more confidence it gives me in knowing how to recognize subtle changes in the drawing.

If you want to accomplish great things you must start at an accurate, simple beginning. Sketching helps me to understand what makes paintings powerful.

Sketching allows me to leave the drawing at its most raw state, if I wish to. It enables me to only concern myself with capturing what makes your subject matter powerful, rather than worrying about a finished product. It's incredibly freeing and more fun.

My sketches are the blueprints for my paintings; they determine whether I begin a painting in the first place. If I don't have a powerful sketch, how can I ever have a powerful painting?

Sketching, for me, is inspired by objects, scenes and overall compositions of light, which make me say to myself, "I need to capture what I am experiencing." Most of my sketching inspiration comes from an idea or concept for a painting. A quick sketch puts the initial idea on paper and sends it in the right direction.

I do a lot of pencil and paint sketches prior to what will become a finished painting. I make a conscious effort to sketch on a regular basis; however, my sketching is more sporadic than an everyday habit.

I sketch when I feel inspired by something and want to get it down on paper. I also like doing small sketches

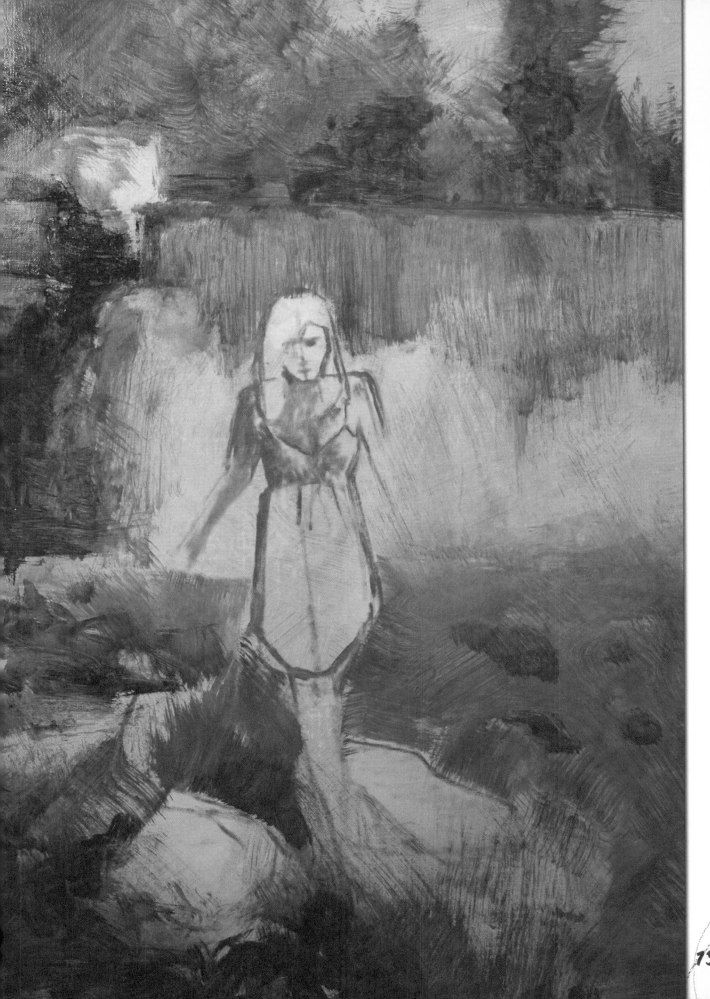

Bill Teitsworth

Bill Teitsworth has earned more than thirty national awards and honors for his work. He teaches watermedia for Coastal Maine Art Workshops and at the studio he shares with his wife, artist Renée Emanuel, in Moscow, Pennsylvania. Though he has studied art in painting workshops over the years and drawing and artistic anatomy at the Art Students League, he considers himself largely self-taught. Quoting fellow watercolorist Frank Webb, Teitsworth says: "Every artist is self-taught. You don't become a painter by graduating from a system of lessons, but by drawing and painting."

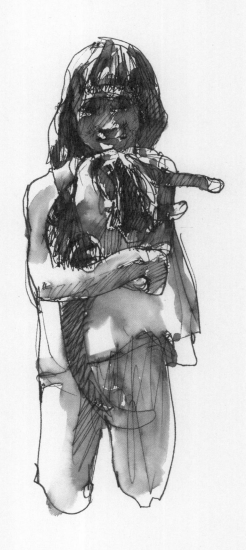

1.22.06 Food Court —

Many times I'm able to find my way out of a dry period just by getting the sketchbook out and drawing.

154

My first experience of the arts as a practitioner was as a musician, when I was a teenager. So I thoroughly buy in to the concepts of practice and rehearsal. Carrying a sketchbook and using it means to me exactly what individual practice and rehearsal meant when I was a musician.

There are times when I carry my sketchbook every single day, in my backpack or under my arm, and get my Sharpie out at every opportunity. Then there are other times, when I'm working a lot in the studio, or when I'm undergoing that inevitable dry period, when I don't work much in my sketchbook. My practice of dating my pages keeps me honest, though, so if I'm stuck or I'm getting rusty, I know where to place the blame.

Many times I'm able to find my way out of a dry period just by getting the sketchbook out and drawing. I find it

to be the perfect way to reconnect to my work, because there is no great commitment to a finished product. What I gain from the experience, what I keep, is the experience of looking and drawing. I came across a quote recently from the great Irish artist Sean Scully, where he talks about "creative innocence." In effect, he says that your best chance of "making art" is when you're not thinking about "art" at all.

I find it essential to do a certain amount of teaching—not so much that my creative well runs dry, but enough to feel that I'm giving something back. So I frequently find myself talking about the utility of the sketchbook. It often happens, when helping a student to solve a problem, that there's a noticeable shift in my seeing and thinking as soon as I open my sketchbook and pick up a pencil. I can talk all day about shapes and patterns, but as soon as I pick up that pencil, I'm actually seeing the subject and not just thinking about it!

In my own sketchbook work, it seems to me that there are only two kinds of drawings. The first are the "studies," which are the kind of free-floating drawings of figures or objects or details that make up the bulk of my, or anyone's, sketch work. The second is what you might call "compositional roughs," or "value sketches," where I panel off a rectangle on the page, and the figures or objects take their places as shapes along with back-ground and negative shapes. It's hard to get students to make the second kind of drawings, but usually as soon as they do, their work takes a turn for the better.

Very few of the pages in my sketchbooks relate directly to my finished work, but there are some exceptions. My acrylic painting *Swimmer*, winner of the American

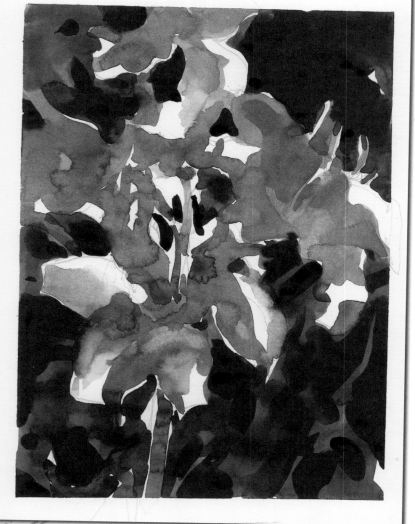

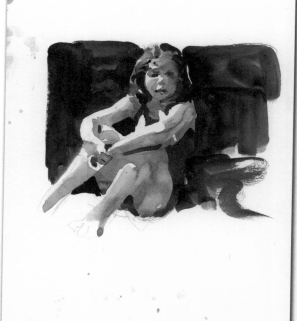

9.9.05 Crocquet

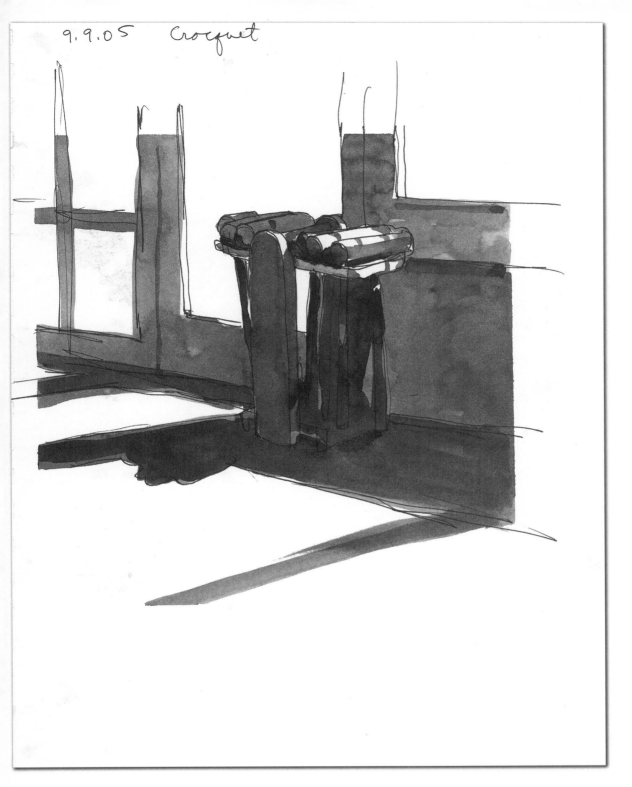

Watercolor Society Silver Medal of Honor in 2005,
had its inception in a tiny sepia watercolor sketch that
included all the important elements of the final work.
And sometimes I rehearse a pesky problem in a sketch-
book drawing before committing it to the finished
painting. But mostly I use my sketchbook as a tool to
connect my thinking with my seeing in a jazzy way, in
the process of "flow."

Bill Teitsworth

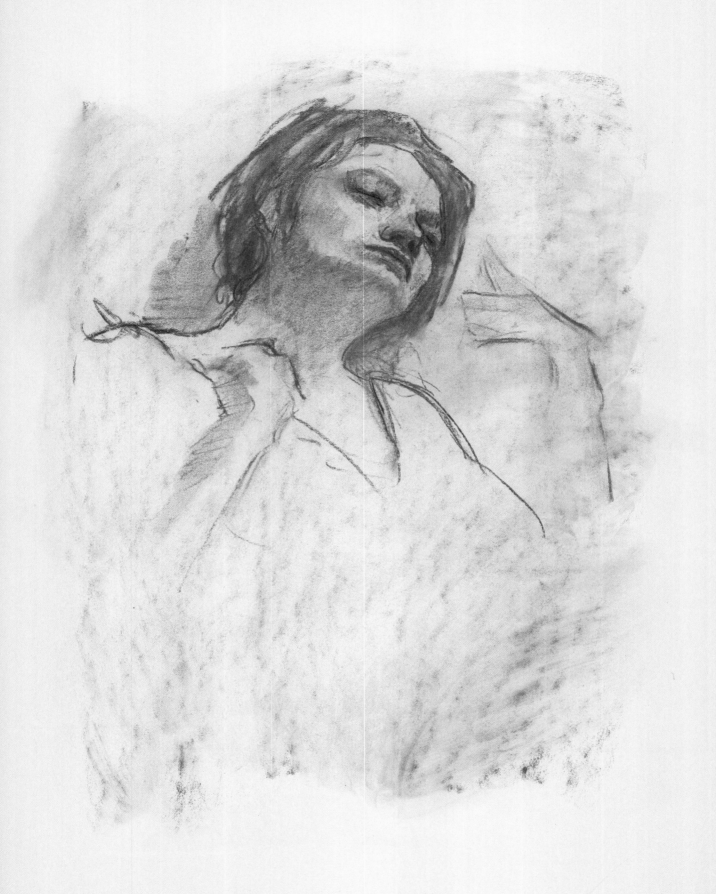

Joy Thomas

Joy Thomas is the author of THE ART OF PORTRAIT DRAWING and a popular workshop instructor and yoga teacher. She earned the top prize for portrait painting in 1996 from the American Society of Portrait Artists and won first place in THE ARTIST'S MAGAZINE's "The Best Paintings of 2000" competition. She has also garnered numerous awards from juried shows, among them the historic Salmagundi Club and the National Arts Club of New York. She paints portraits for leaders of business, government and academia, and her official portraits are in many state and federal collections, including the Pentagon. Thomas lives in Kentucky with her husband, Fredrick, a frame maker.

I use my sketchbooks to experiment with concepts, record ideas, work out my struggles and keep track of my growth.

Drawing is my lifelong love and a key component to my vocation as an artist. I thrive on the intellectually challenging and emotionally stimulating experience of working from life and then writing about the experience. It is also a quick, cheap and fun pastime!

There have been periods in which I have worked in my sketchbook every day. Recently I've been more of a batch feeder, filling many pages over the course of a few hours, not to return to my sketchbook for another week or so.

I attend a life drawing session at my local art guild where a group of artists share the cost of a nude model for three hours each week. During that time, I work in my sketchbooks and sometimes create oil sketches. I also like to draw and journal while traveling. My favorite way to practice gesture drawing is to sketch people as they relax on the beach, fish from a riverbank, wait for a bus or read in the airport. I carry a small sketchbook into art museums to make notes about, and studies of,

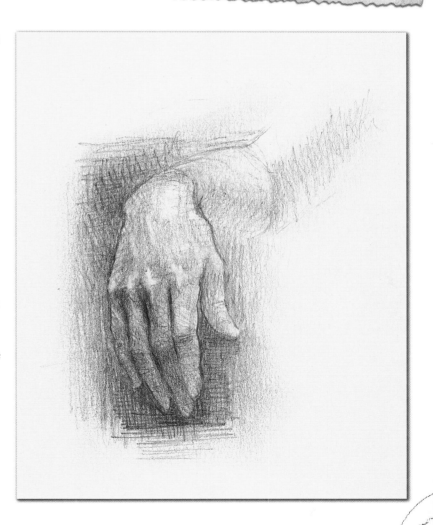

159

my favorite pieces. When painting en plein air, I typically complete a number of thumbnail sketches before I paint a particular view.

Before sketching, I think about paper, drawing tools and how much time will be dedicated to the work at hand. I also think about how I intend to communicate, through line, mass, color and so on. Once I have determined the tools and the approach, I spend the initial drawing time working out the composition, perspective and the general shape map. Everything that follows is more intuitive as I start doing as opposed to thinking.

When I am sketching, I feel alert and connected to the world around me. My aim is to enter "the zone," where instantaneous decisions can be made, drawing issues resolve themselves, and the artwork simply appears, as if creating itself, with what seems to be little or no effort on my part. One arrives at that blissful state through many hours of practice and study. Upon my return to

reality, I typically feel that I fell short of what I originally hoped to achieve, which compels me to try another study, then another. Mastery is a never-ending process and an ongoing quest.

Drawing from life leads to immediate, raw and honest statements. When sketching, I work quickly, allowing little time for corrections, second guessing or "finishing." The results appear fresh and expressive, which I find compelling.

The practice and discipline of drawing enables me to develop my skill set. Sketching from life is the way I internalize my knowledge of the formal elements of art (line, shape, direction, size, texture, hue and value), along with the principles of art (balance, gradation, repetition, contrast, harmony, dominance and unity). I use my sketchbooks to experiment with concepts, record ideas, work out my struggles and keep track of my growth. I hone my skills through sketching, just as musicians hone their skills by practicing chords and playing scales.

Sketching helps me see and work in terms of unified wholes, as opposed to compiling individual details. It serves as a metaphor for life, encouraging me to acknowledge "the big picture," and keeps me in the habit of looking at the world with attentive, appreciative eyes. When I look through my sketchbooks, I recall each experience in a visceral way. Each drawing serves to transport me to that time and place—then, as the memories of sites, smells and sounds wash over me, I am inspired anew. The formal elements and principles of design are everywhere; sketching is the first step I take toward recognizing, harvesting, and presenting that visual information through my artwork.

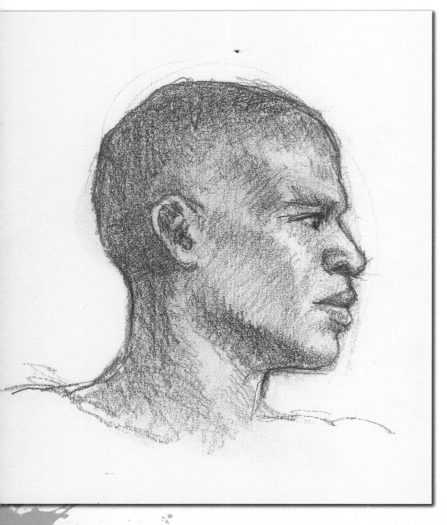

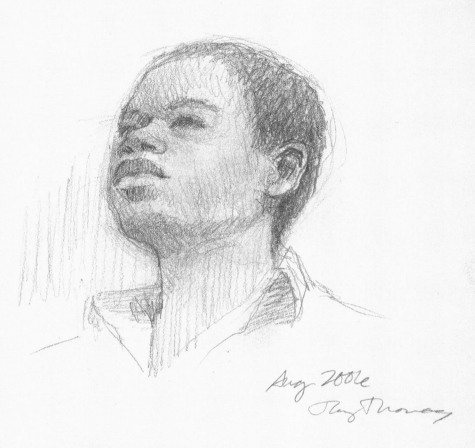

Aug 2006
Tony Thomas

For Long you live and
high you fly
And smiles you'll give
and tears you'll cry
And all you touch
and all that you see ...
Is all your life
will ever be

Pink Floyd

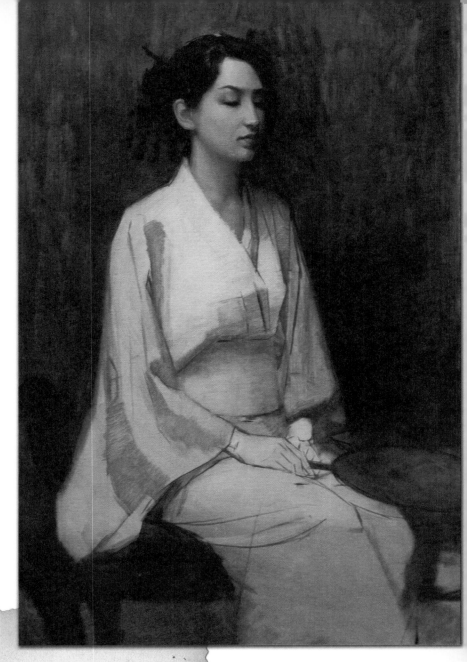

Most of the time my sketches are just for me, so they are done in a way to benefit me. It's like my own secret language.

aaron Westerberg

A native Californian, Aaron Westerberg taught at the California Art Institute from 2000 to 2005 and currently teaches at the Los Angeles Academy of Figurative Art. In 2002, he made SOUTHWEST ART's annual "21 Under 31" list, and he was named one of the best twenty-four artists under forty in 2007 by THE ARTIST'S MAGAZINE. Westerberg received an honorable mention in 2010 from the Oil Painters of America National Exhibition in Scottsdale, Arizona, and his artwork appears on the cover of STROKES OF GENIUS: THE BEST OF DRAWING by North Light Books.

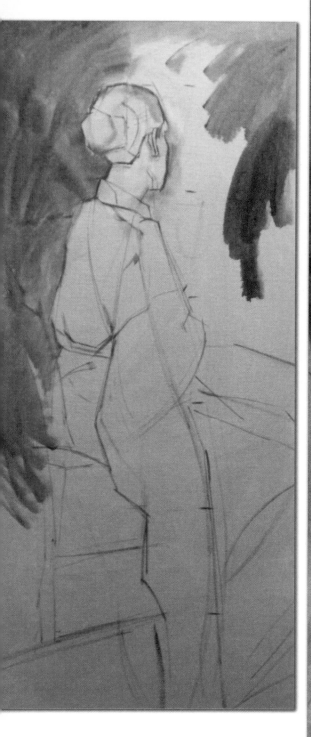

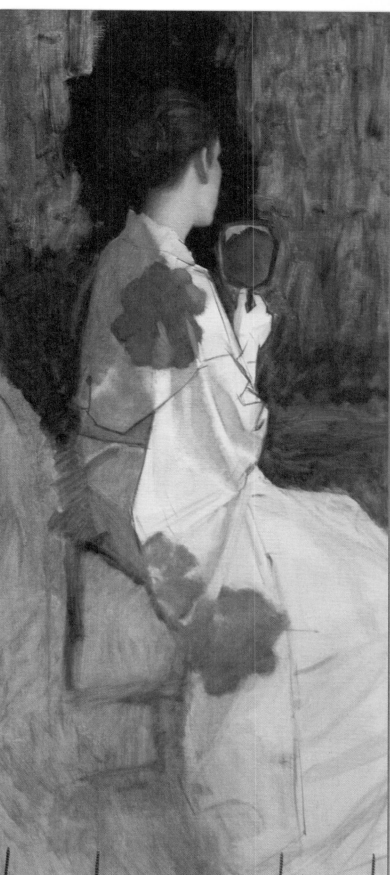

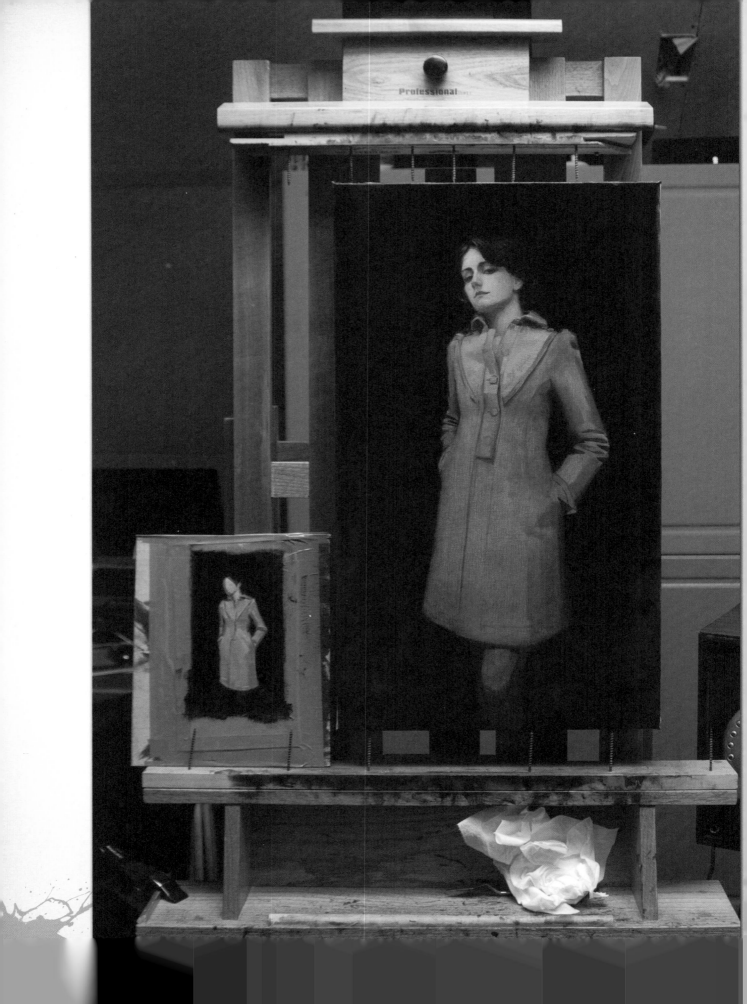

My sketches are my thoughts and the "CliffsNotes" to my larger studies. They are the underpinnings of my paintings.

When I have an idea I want to hang on to, or before I start a painting, I sketch out my subject. Whenever I have an idea in my head, I like to sketch it out and see it. It could be anything—a particular pattern of shapes or colors, whatever. Often I am inspired by nature, but a lot of times I get inspired by people-watching. Sometimes things just pop into my head and I want to remember them, so I sketch.

I try to sketch daily; sketching gets me thinking and my creativity going. Sketching for me sometimes is a way of brainstorming—it activates my creative side. I get into this zone where words don't mean anything; there are just colors, values and shapes. Even if I know exactly what I am going to do as far as how I am going to paint my next painting, I like to do a sketch of it in black and white first.

While sketching, I'm thinking about compositional aspects mainly, how the big things are working together and how they relate to one another. I try to stay away from too many details. Sketching allows me to see my ideas and sort through them. This way, I can try out different ideas and concepts I might have and see how they look before I commit the idea to a larger work.

For me, sketching is a way of increasing my visual vocabulary. It's training. Most of the time my sketches are just for me, so they are done in a way to benefit me. It's like my own secret language.

Sketching allows the viewer to see how I see the world. When I sketch, I am interpreting what I see no matter how faithfully I think I have rendered it. Every drawing or painting is a self-portrait.

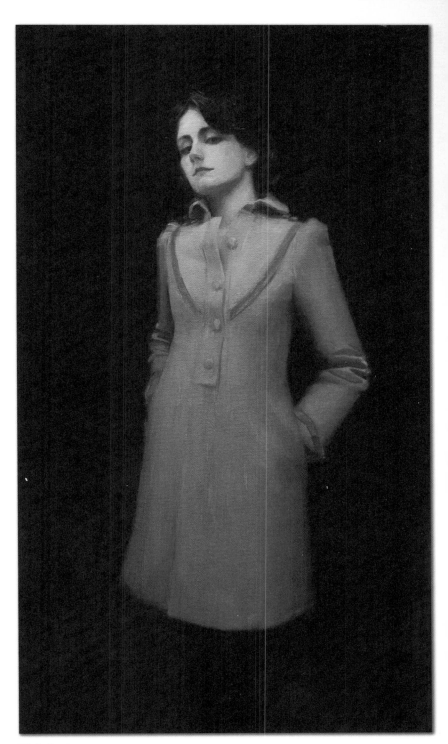

Pink Coat
Aaron Westerberg
Oil on linen (finished painting)
30" × 15" (76cm × 38cm)
Private collection

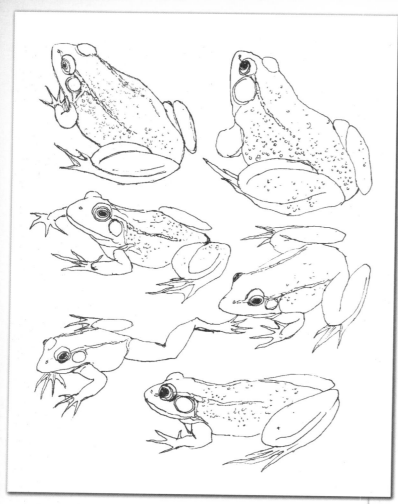

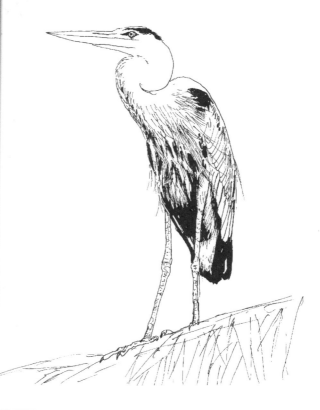

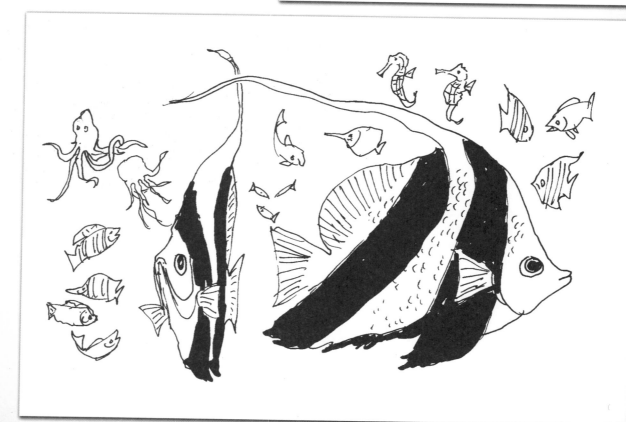

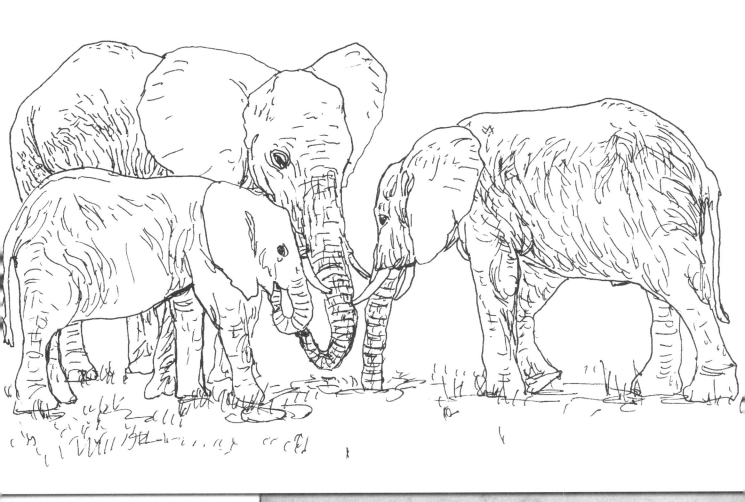

Sketches help me to understand more about the things around me.

Lian Quan Zhen

Painting became a hobby for Lian Quan Zhen when he was a family physician in China, which he continued after he immigrated to the U.S. in 1985 and became an architect. Ten years ago he began painting full-time and teaching workshops nationwide and internationally, including eight years of watercolor outdoor sketching classes at the University of California, Berkeley. Zhen has published three books on watercolor and Chinese painting, and among his collectors is his alma mater MIT, whose museum houses fourteen of his works.

When I was about ten years old, I was inspired by my friends who did wonderful sketches. I thought I could do it too and started sketching things around me with pencil. The more I did sketches the more I loved art, and finally I decided I wanted to be a painter, an artist.

By the time I was in high school, I had little pocket sketch-books and did about twenty sketches per day. Despite my desire to be an artist, life took me to another path: I became a family physician in China and an architect in the U.S. During those times, sketching was my habit.

During my youth in China when the Cultural Revolution was dragging on, I did sketches whenever I was sit-ting at the meetings, which happened frequently. Also, I walked about five miles to and from high school on the weekends, and I sketched the landscape on the way. Later I did fewer on-site sketches, but instead painted a lot of spontaneous-style Chinese paintings. To me, it was like sketching, only without pencil or pen on sketchbooks and instead with brushes and colors on rice papers. Now I do watercolor sketches when teaching plein air work-shops and preparing watercolor painting compositions.

When I sketch, it is like entering into a meditative state. I enjoy doing it very much—so much so that most of the time, nothing enters my mind. I feel relaxed and joy-ful, and don't notice the passing of time.

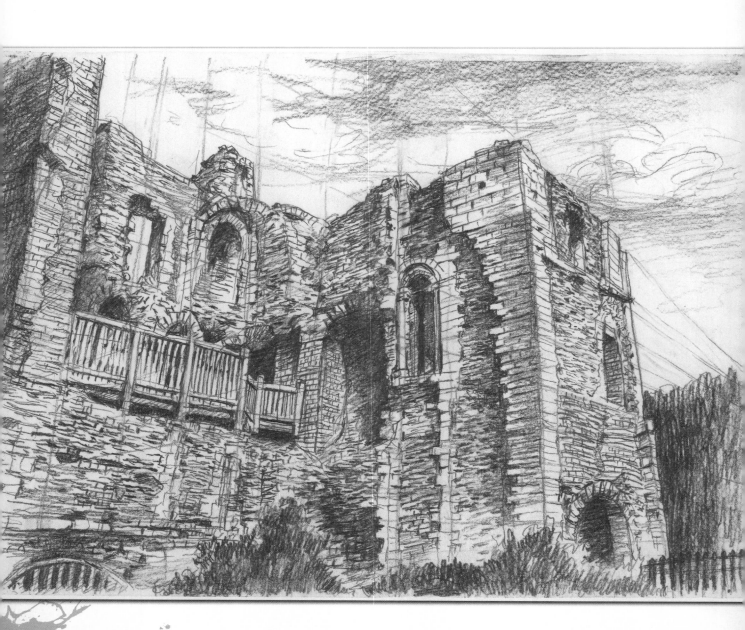

I think the benefits of sketching, to me, are (1) My eyes can see things more clearly, (2) My brain can remember the shapes and essence of the objects after a short time observing them, (3) My hands are more "handy" when painting, and (4) Since it is like meditation to me, my mind calms down and, in the long run, I am healthier.

Life and sketching have some things in common. At the beginning it is difficult and takes a lot of effort, but I am full of joy and happiness in harvest time. Also, the more experiences I have, the better I can be.

Sketches help me to understand more about the things around me. It helps me to paint the objects easier, espe-cially in capturing the essence of them. It is hard for me to paint things on my finished works without studying them first via sketches.

What sketching provides that working on finished art doesn't is the close relationship and spontaneous touch between the objects I sketch and myself.

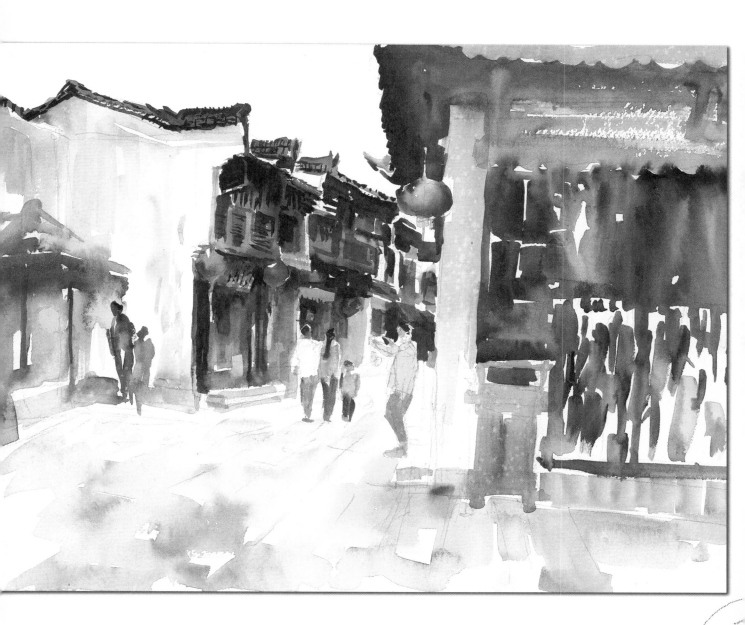

More on the Artists

JOE ANNA ARNETT
www.joeannaarnett.com
Email: joeannaarnett@earthlink.net
Represented by Zaplin Lampert Gallery (Santa Fe, NM)
See website for DVDs and workshops

MARLA BAGGETTA
www.marlabaggettastudio.com
Blog: marlabaggetta.blogspot.com
Email: mbaggetta@comcast.net
Represented by RiverSea Gallery (Astoria, OR), Studio Seven Arts Gallery (Pleasanton, CA), Galerie Gabrie (Pasadena, CA), Gallery KH (Chicago, IL) and Katie Gingrass Gallery (Milwaukee, WI)

JIM BECKNER
www.jimbeckner.com
Email: jamesbeckner@yahoo.com
Represented by Abend Gallery (Denver, CO) and CODA Gallery (Park City, UT)

ROBERT LOUIS CALDWELL
www.rlcaldwell.com
Blog: rlcaldwell.blogspot.com
Email: info@rlcaldwell.com
Represented by Lovetts Gallery (Tulsa, OK) and Berkley Gallery (Warrenton, VA)

LINDSAY CIBOS
www.jaredandlindsay.com
www.lastpolarbears.com
Email: lcibos@jaredandlindsay.com

ELAINE G. COFFEE
www.elainecoffee.com
Represented by Trailside Galleries (Scottsdale, AZ; Jackson Hole, WY), S.R. Brennen Galleries (Palm Desert, CA; Santa Fe, NM), Morris & Whiteside Galleries (Hilton Head Island, SC) and Tree's Place (Orleans, MA)

LISA L. CYR
www.cyrstudio.com
www.facebook.com/pages/Lisa-L-Cyr/93726883271
www.twitter.com/LisaLCyr
www.youtube.com/user/lisalcyrstudio
Blogs: lisalcyr.wordpress.com,
lisalcyr.blogspot.com
Email: lisa@cyrstudio.com

MICHELLE DUNAWAY
www.dunawayfineart.com
Email: michelle@dunawayfineart.com
Represented by The Legacy Gallery (Scottsdale, AZ; Jackson, WY), InSight Gallery, (Fredericksburg, TX) M Gallery of Fine Art (Charleston, SC) and Sage Creek Gallery (Santa Fe, NM)

STERLING EDWARDS
www.sterlingedwards.com
Email: sterling@sterlingedwards.com
See website for workshops, DVDs and signature line of watercolor brushes

IRENE FLORES
www.beanclamchowder.com
Blog: beanclam.tumblr.com

GRANT FULLER
www.grantfuller.ca
See website for DVDs and workshops

MOLLY HASHIMOTO
www.mollyhashimoto.com
Blog: Molly Hashimoto Artist's Journal, at www.mollyhashimoto.com
Email: mollyhashimoto@comcast.net
Teaches at the North Cascades Institute (Sedro-Woolley, WA), Sitka Center for Art and Ecology (Otis, OR) and Yellowstone Association Institute (Gardiner, MT)

CARLYNNE HERSHBERGER, CPSA
www.etsy.com/shop/hershbergerhuff
Blogs: hershbergerhuff.blogspot.com, carlynnehershberger.blogspot.com
Email: hershbergerhuff@hotmail.com

JARED HODGES
www.jaredandlindsay.com
Email: jhodges@jaredandlindsay.com

RUSSELL JEWELL, NWS, TWSA
www.russelljewell.com

DORY KANTER
www.dorykanter.com
www.chezmirabel.com
Email: dory@dorykanter.com

DAVID N. KITLER
www.davidkitler.com
Email: info@davidkitler.com
See website for DVDs, art classes and workshops

NITA LELAND
www.nitaleland.com
Blog: nitaleland.blogspot.com
Email: nita@nitaleland.com
See website for books, DVDs and workshops

VICTORIA LISI
www.vjlisi.com
www.facebook.com/pages/Victoria-Lisi-Artist/238527417733
Email: vjlisi@comcast.net
Represented by Max'ims of Greeley (Greeley, CO)

LAURIN McCRACKEN, AWS, NWS
www.lauringallery.com
Email: laurinmc@aol.com
Represented by Southside Gallery (Oxford, MS) and Jack Meier Gallery (Houston, TX)

SYDNEY McGINLEY
www.sydneymcginley.com
Email: sydmcginley@mac.com
Represented by The Artists' House (Philadelphia, PA; www.artistshouse.com)

MARK E. MEHAFFEY
www.mehaffeygallery.com
Email: mark@mehaffeygallery.com

VIRGIL ORTIZ

www.facebook.com/virgilortiz
www.youtube.com/user/
madeinnativeamerica
www.twitter.com/VirgilOrtiz
Email: info@virgilortiz.com
Represented by King Galleries of Scottsdale (Scottsdale, AZ) and Shiprock
Santa Fe (Santa Fe, NM)

SANTIAGO PÉREZ

www.santiago-perez.com
www.santiago-western.com
Email: santiagocaballo@aol.com
Represented by Nüart Gallery (Santa
Fe, NM) and Mary Martin Gallery of
Fine Art (Charleston, SC)
Appears in *Chicano Art for Our Millennium* and *Triumph of Our Communities:
Four Decades of Mexican-American Art*
(Bilingual Press)

ROBIN POTEET

www.robinpoteet.com
Blog: robinpoteet.blogspot.com
Email: robin@robinpoteet.com

JONATHAN QUEEN

www.jonathanqueen.com
Represented by Miller Gallery
(Cincinnati, OH)
Appears in *100 Artists of the Midwest*
(Schiffer Books)

IAN ROBERTS

www.ianroberts.com
See website for books, videos, workshops and paintings

MERLE ROSEN

www.merlerosen.com
www.goldenpaints.com/artist/wap/
artist.php?uid=44
Email: merlerosen@fuse.net
See website for DVDs

KATE SAMMONS

www.katesammons.com
Email: ks@katesammons.com

ANGELA R. SASSER

www.angelicshades.com
Online gallery: www.angelic-shades.
deviantart.com
Blog: blog.angelicshades.com
Showing at Studio B of ArtWorks on
the Square (Fayetteville, GA)

DAVID SAVELLANO

www.davidsavellano.com
Email: eastshoreart@gmail.com
See website for workshops offered
throughout the year

JEANNE FILLER SCOTT

www.jfsstudio.com
www.facebook.com/people/Jeanne-
Filler-Scott/1266173183
See website for books

MICHAEL STEIRNAGLE

www.steirnagle.com
Email: msteirnagle@hotmail.com
Represented by Paul Scott Gallery
(Scottsdale, AZ) and Petris Fine Arts
(Sausalito, CA)

KYLE STUCKEY

www.kylestuckey.com
Email: kyle@kylestuckey.com
Represented by The Legacy Gallery
(Scottsdale, AZ) and Monadnock Fine
Art Gallery (Keene, NH)

BILL TEITSWORTH, AWS, NWS

www.etstudioart.com
Email: bteitsworth@gmail.com
Workshops: www.coastalmaineart-
workshops.com, www.lacawacsanctu-
ary.org

JOY THOMAS

www.portraitartist.com/thomas
www.joythomasart.com
DVDs: *Drawing the Clothed Figure with
Joy Thomas* and *Portrait Drawing: 5-
Minute Head Studies with Joy Thomas*
See website for workshops

AARON WESTERBERG

www.aaronwesterberg.com
Email: aaronwesterberg@yahoo.com
Author of *The Artwork of Aaron Westerberg* (available through www.blurb.
com)

LIAN QUAN ZHEN

www.lianspainting.com
Email: lianzhen@yahoo.com
See website for books, DVDs and
workshops

Index

Other fine North Light books are available from your favorite bookstore, art supply store or online supplier. Visit our website at www.fwmedia.com.

16 15 14 13 12 5 4 3 2 1

DISTRIBUTED IN CANADA BY FRASER DIRECT
100 Armstrong Avenue
Georgetown, ON, Canada L7G 5S4
Tel: (905) 877-4411

DISTRIBUTED IN THE U.K. AND EUROPE
BY F&W MEDIA INTERNATIONAL, LTD
Brunel House, Forde Close, Newton Abbot, TQ12 4PU, UK
Tel: (+44) 1626 323200, Fax: (+44) 1626 323319
Email: enquiries@fwmedia.com

DISTRIBUTED IN AUSTRALIA BY CAPRICORN LINK
P.O. Box 704, S. Windsor NSW, 2756 Australia
Tel: (02) 4577-3555

Art edited by Pamela Wissman
Content edited by Stefanie Laufersweiler
Production edited by Vanessa Wieland
Designed by Guy Kelly
Production coordinated by Mark Griffin

ABOUT THE EDITORS

Pamela Wissman is Senior Content Director for North Light Books, IMPACT Books and ArtistsNetwork.TV, all imprints of F+W Media, where she has worked on hundreds of titles over the course of her eighteen-year career there. She has been working in the arts for over thirty years in various capacities, with a Master of Arts in Arts Administration and a Bachelor of Fine Arts from the University of Cincinnati.

Stefanie Laufersweiler is a freelance editor and writer living in Cincinnati, Ohio. She was a senior editor for North Light Books and IMPACT Books before becoming a freelancer, and she has spent over thirteen years editing nearly seventy-five titles specializing in fine art, comics and crafts.

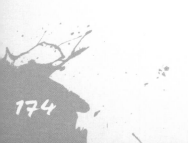

METRIC CONVERSION CHART

To convert	to	multiply by
Inches	Centimeters	2.54
Centimeters	Inches	0.4
Feet	Centimeters	30.5
Centimeters	Feet	0.03
Yards	Meters	0.9
Meters	Yards	1.1

Ideas.
Instruction.
Inspiration.

These and other fine North Light products are available at your favorite art & craft retailer, bookstore or online supplier. Visit our websites at artistsnetwork.com and artistsnetwork.tv.

Find the latest issues of **The Artist's Magazine** on newsstands, or visit artistsnetwork.com.

Receive **FREE** downloadable bonus materials when you sign up for our free newsletter at **artistsnetwork.com/ Newsletter_Thanks.**

Visit www.artistsnetwork.com and get Jen's North Light Picks!
Get free step-by-step demonstrations along with reviews of the latest books, videos and downloads from Jennifer Lepore, Senior Editor and Online Education Manager at North Light Books.

Follow us!